KANSAS
BEER

KANSAS
BEER

A Heady History

BOB CRUTCHFIELD

AMERICAN PALATE

Published by American Palate
A Division of The History Press
Charleston, SC
www.historypress.com

First published 2019

Manufactured in the United States

ISBN 9781467140119

Library of Congress Control Number: 2018960978

CONTENTS

CONTENTS

DEDICATION

This book is dedicated to my non–beer drinking wife, Barbara, who escorted me to more breweries than she wanted—some of which were for actual research. If I could insert a picture of her, jokingly rolling her eyes, when I talked about that new brewery we were going to visit and the awesome new hoppy beers they had just released, I would. She frequently accompanied me on the many, many miles of open space between Kansas breweries and got to see and appreciate the Kansas heartland I grew up with. On top of this, she was my initial manuscript editor and constant cheerleader on this project. Cheers, Barbara! Have a…mojito?

ACKNOWLEDGEMENTS

I could not have pulled this book together without time, advice and assistance from the following people. They all contributed in different ways, either by giving me their time, teaching me about certain subjects related to the book, fact-checking historical aspects, joining me on some of the beer adventures around the state or simply not falling asleep and listening to me drone on about beer with them.

Jim Crutchfield, my Wichita brother, who traveled with me to many of the breweries and helped me with initial interviews. He also gave insight and tips on his experiences in homebrewing.

Charley Crutchfield, my Overland Park brother, who also accompanied me to many of the breweries around the state. He's always a great wingman and up for a beer!

Pat Teeter, my Lenexa sister, who along with her husband, John, supported me with insight and Kansas history books from their personal library.

Sarah Swaim Redford, my friendly Kansas history teacher, kept me honest.

Kristi Switzer from Brewer's Association, who gave me a lot of guidance and encouragement. Cheers!

Andy Boyd and Ian Crane, Central Standard

Mathew Bender and Dylan Sultzer, Defiance Brewing

Eric Craver, Happy Basset

Ian and Shayna Smith, Three Rings Brewery

Geoff Finn and Augustino Iacopelli, Augustino's Brewing

Dale Kaiser and Austin Bell, Beaver Brewery at Mo's Place
Jay Ives and John Dean, Blind Tiger Brewery and Restaurant
John Goertzen and Monte Shadwick, Blue Skye Brewery and Eats
Bryan and Barbara Ritter, Boiler Room Brewhaus
Matt Johnson, Brew Lab
Larry Cook, Dodge City Brewing
Brett Wichers and Clinton Offutt, Down Under
Chuck Magerl, Free State Brewing
Jeff "Stretch" Rumaner and Jeff Horn, Grinders High Noon
Torey Lattin, Hopping Gnome
Ryan Triggs, Kansas Hop Company
Brad Portenier, Kansas Territory
Matt Williams, Lawrence Beer Company
Brendan Arnold, Lb. Brewing Co.
Alex Lent, Limestone Beer Company
Kelly Loub and Shawn Howard, Little Apple Brewing
Jared Rudy and Adam Rosdahl, Norsemen Brewing
Dan and Becky Norton, Nortons Brewing
Jeremy Johns, Radius Brewing
Ryan Kerner, River City Brewing
Jonathan and Charles Williamson, Sandhills Brewing
Jeff Gill, Tallgrass Brewing
Dr. Tom Kryzer, Third Place Brewing
Rick Goehring and J.B. Hunt, Walnut River Brewing
Kyle Banick, Wichita Brewing
Tucker Craig, 23rd Street Brewery
Lance Minor, Aero Plains Brewing
Hank and Steve Wiser, Hank is Wiser Brewery
Clay and Linda Haring, Props & Hops Brewing
David Heinz and Angelo Ruiz, Yankee Tank Brewing
John Randtke, Wakarusa Brewing
Steve Johnston, who offered up some great cover photo options

INTRODUCTION

The genesis of this book came about when I visited Wichita again after so many years away. I had family who had relocated there and, while visiting, took me to check out several of the breweries. I was amazed at the quality of the craft beers they were serving as well as the growing number of new breweries popping up in town. It seemed like each year a couple more were starting up and needed to be visited—you know—for research. And once we hit most of the breweries in Wichita, it seemed necessary to check out Walnut River Brewing just outside of town in El Dorado. On our first visit, it was in a gutted building with only a small brew system back behind a wall near the alley. But they served great beer. "There are a lot of good beers here!" I commented to my brothers. After a couple beers, it became, "Maybe, for the sake of research, and the love of Kansas, we should document all of the breweries in the state?" Just like many of the breweries in our state were started over a couple beers, this book began in the same way.

It took over a year before all the breweries were finally "researched." The more that I visited, the more appreciation I gained for the hard work and industriousness of the people behind each brewery. The best part of this project was that nearly all the brewers or owners interviewed had interesting stories. This is the stuff you only get with homegrown start-up establishments.

When I discuss the number of breweries being started in the state, I continually get comments contrasting the craft brewing industry in Kansas to other states, especially Colorado or California, where it seems there's a

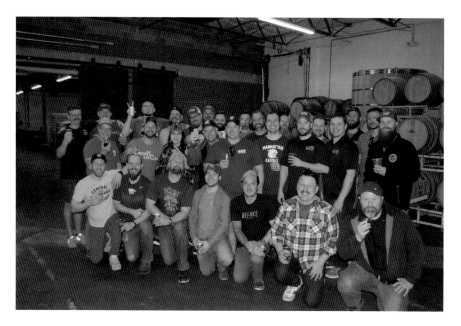

A number of Kansas brewers got together at Wichita Brewing to make a collaboration beer called Prairie Land Delight 2018. It was a great time, and you can see they all worked quite hard that day. *Bob Crutchfield.*

brewery on every corner. Running some comparisons, which are discussed in a bit more detail later in the book, the reader should see that the state's population and demographics appear to be able to handle the growing number of breweries and more. Even in Wichita, where there are over a dozen breweries (counting the ones in Cheney and El Dorado), it seems the craft beer drinking market will support them. Then you wonder about competition. What is it like to start up a new brewery in the same area as others? I'm not sure if this is a Kansas thing or not, but nearly every brewery owner I talked to about this said the brewers in the state are more of a "brotherhood" and each brewer helps the other, making sure "they get on their feet." Once established, the cooperation continues, as evidenced by all the collaboration beers the breweries make each year. The brewers in Kansas are a very friendly and giving group. As one of the major brewers in the state put it, "The Kansas brewing business is 99 percent asshole-free, plus there's beer." You can't ask for much more!

Acknowledging that the craft brewery scene in Kansas is growing at a healthy pace with new breweries being established each year, some breweries were not able to be detailed in this version of the book for a variety of reasons.

For instance, a just-established brewery that is not yet open for business, a brewery that could not legally discuss operations at the time or a brewery in the process of reestablishing itself under different ownership or in a new geographic area. Two such breweries, which I visited and enjoyed, are Salt City Brewing in Hutchinson and Red Crow in Spring Hill. If an updated version of this book is released, I'll make sure to thoroughly research and review their offerings.

It's hoped that, after reading this book, you'll want to make a visit to as many of these fine breweries as possible. All the owners and brewers have a passion for the craft and have taken the risk to pursue this passion by giving up other potential employment opportunities, investing their savings and putting in many long hours to bring you the best craft beer they can. Please enjoy the book! Preferably over a beer.

PART I

KANSAS STRUGGLE WITH ALCOHOL AND OPEN SALOONS

1
OVERVIEW OF CRAFT BEER IN KANSAS

A craft beer boom is happening across the country, but no state can boast new beer-related businesses as unique and interesting as the microbreweries and brewpubs popping up in the great state of Kansas. Playing catch-up to the rest of the nation it seems, homegrown craft breweries are opening all over the state. At current count, there are nearly forty Kansas homegrown and active breweries located in twenty-two towns in the state, with a new handful opening each year. This book covers the current state of craft brewing across Kansas and gives a bit of insight into the brewmasters' or entrepreneurs' philosophies on craft brewing, as well as each brewery's own history and the distinctive offerings for the community it serves. Many of these breweries are situated in historic buildings that have been renovated to preserve the building's historic nature while accommodating the development of the brewery. Nearly all of these breweries are actively supported by local chambers of commerce and have become catalysts to revitalizing these city's downtown centers. Some breweries have become quite large, employing many people and distributing across a multistate area, while others brew small batches to serve a dedicated local following. For instance, the reader will learn about the nanobrewery and diner located under the shade of a grain silo in the tiny town of Beaver and the popular Sylvan Grove brewpub in north Kansas, which only opens on weekends, yet regularly has a line around the block drawing patrons from miles away to great craft beer and chef-prepared foods. The reader will also learn about the large regional brewery in Manhattan producing

enough beer to supply stores and restaurants from the Canadian border down to the Gulf Coast. One brewer is the descendant of a twelfth-century German brewer whose beer was a favorite of Martin Luther's. All these breweries were started by entrepreneurial-minded Kansans with a desire to bring you the best of what they brew. This book provides a distinct description of how and why they started and what their vision was and is for serving their local communities.

But first, let's begin with the unique history of beer brewing in the state: starting with the early 1850s Leavenworth breweries in the days just before Kansas became a territory through the turbulent years of "Bleeding Kansas"; on to statehood and the great immigration years when many German and other immigrants arrived, bringing their own brewing techniques

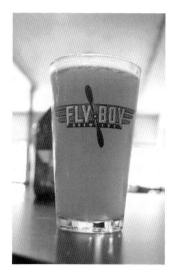

A fresh IPA from Props & Hops Brewing at Fly Boy Restaurant in Sylvan Grove. *Bob Crutchfield.*

and beer styles; continuing with the years of cow town saloons and breweries; then the increasing and flagrant accounts of alcoholic overindulgences, which underscored the rising calls for temperance that resulted in the nation's first state amendment prohibiting "intoxicating liquor"; through the national Prohibition years; and finally to present-day Kansas, which only relatively recently reversed its alcohol laws, allowing the current growth in local breweries to exist.

The current Kansas craft beer market is certainly making a return to form—over one hundred years ago, the state had as many as 130 known breweries which had opened, scattered through most population centers. The exact number and identification of breweries have been researched and disputed by several Kansas scholars over the years. Many breweries have been documented with confidence, yet others became obscured over time, and the reasons for this are plenty. Some breweries opened, closed and reopened under a different name and owner/partner. Some opened and advertised their existence at the time, while some didn't and are only found through footnotes in the local directories or newspaper commentaries such as "a mule was stolen last night from Joe's brewery down by the river." Some were illegal breweries that opted not to pay barrel taxes or acquire any permits while others were glorified homebrewing operations. As Kansas

really was the Wild West in the early days of its existence, record keeping for early breweries was not well documented.

Brewing grew in these early years as more settlers poured in to the state. To compare the relative number of breweries back then versus now, we have the U.S. Census figures to help us. When Kansas's breweries were at their zenith around 1880, just before the state outlawed alcohol, the population of Kansas was just under 1 million residents, with roughly one brewery for every 7,600 residents. The latest revised estimate of the state's population in 2016 was 2.9 million residents. With the current independent breweries licensed by the state at 37, the resulting ratio is one brewery for roughly 78,400 residents. To reach the 1880 ratio of breweries to total population in Kansas, there would need to be nearly 344 additional breweries in the state. One can play with the numbers many different ways, but the point is that on both a relative and actual basis, the state had a *lot* more breweries per capita back in the day than exist today. We're not even close.

The 2016 beer sales statistics recently released by the Brewers Association show the statewide impact to the economy for Kansas craft beer sales is $480 million but ranks only thirty-first in the nation.[1] The statewide production of 51,542 barrels of beer makes Kansas fortieth in the nation, with the resulting gallons of brew per adult aged twenty-one or over at only 0.8. As a point of reference, from the same data set, a look at our neighboring states shows Nebraska produced 1.1 gallons per adult, and near the bottom, Oklahoma produced 0.5 gallons per adult. However, Missouri produced 2.6 gallons per adult and Colorado produced a whopping 11.1 gallons per adult. Kansas breweries, with their comparatively small production, are vibrant and growing, with an observable and positive economic impact to the state through craft beer sales, jobs and taxes paid to both the state and local communities. As consumers continue to push for great locally crafted beers, the local microbreweries and brewpubs should continue to meet that demand and generate additional revenues for the state.

When the first brewpub in the state, Free State Brewing in Lawrence, opened in 1989, it was among the vanguard of small independent brewers in the United States. The first in the nation though came in the late 1970s, when a handful of microbreweries appeared, ushering in the beginnings of the craft beer industry in the United States. In 1976, California's New Albion Brewing Company was the first to sell craft beer since Prohibition ended.[2] The founder was impressed by Fritz Maytag's resurgence with Anchor Brewing Company in the same state. Then, with homebrewing nationally legalized in 1978, a resurgence of craft beer making began. Homebrewing

supplies and equipment began to be more available as more and more people began to try making their own beer. As the national beer companies began to consolidate, shrinking the available beer styles and tastes, the homebrewing hobby began to accelerate and pick up momentum. So, when Free State Brewing began serving craft beers, it was forced to create its own market and differentiate itself by making great beers with a high level of quality and consistency. The community had to be educated on distinct beers styles and tastes. There were no other breweries in the area to follow, so Free State had to lead in all aspects of the business. It was critical to market its beer in a way that would expand the minds of the classic "big beer" drinkers and get them to try out their new craft offerings. At this time, most people had never tried a wheat beer, or hefeweizen, for example. As Free State Brewing was forging the way in Lawrence, others in the state began to enter the market. River City Brewing in Wichita, 23rd Street Brewery in Lawrence (under a different name) and the Blind Tiger Brewery and Restaurant in Topeka all opened in the early 1990s and began to have a positive impact on their communities. In addition to the business revenue, full-time employment and tax revenue for the communities, over time, there the new breweries drew visitors from outside of the immediate community. Noticing this, new local businesses were born to support the breweries. The areas surrounding the breweries became attractive for new establishments to open and take advantage of the flow of people to the brewery or brewpub. City planners began to catch on to the revitalizing impact of having a new microbrewery start up in the middle of a largely vacant or blighted downtown area and began to promote this as a way to give an economic boost to targeted areas. Craft breweries became influential in reversing the downward course of underutilized real estate by injecting money and traffic in the area, thereby enhancing the character of the often fringe or forgotten vicinities of some towns. Prime areas for brewery start-ups are often warehouse districts, vacant downtown buildings and even unique and specific buildings that may have a difficult time finding a suitable occupant. It's typical for these buildings (churches, firehouses, train stations and the like) to have below-average real estate costs.

THE FIRST BREWERIES IN KANSAS

The first breweries in Kansas appeared in the early 1850s in Leavenworth around the time of the city's incorporation into the territory. Being the oldest county in the state, Leavenworth's growing population and activity at the time was able to support brewing. Fort Leavenworth had been long established and was critical in protecting the vast numbers of immigrants who gathered there to begin their journeys along the roads leading west to Oregon, California, and Utah—"Upwards of 70,000 men, women and children, with wagons, horses, flocks and herds innumerable, passed over this road in 1849–50."[3] The city itself was formed in June 1854 by citizens living in or near Weston, Missouri. Among the first sale of town lots in October 1954 was to Charles Mundee, who, along with a partner, established the Charles Mundee & William Fritzlen's Brewery in the fall of 1855. "It was a two-story stone structure and was located along the bank of the river immediately adjoining what is now the South Esplanade."[4] Another contender for the first brewery in Leavenworth, and hence the state, was the Scott Brewery, announced in 1854.[5] With the establishment of the Great Government Overland Transportation Company, Leavenworth became the starting point for many wagon trains making their way west. This resulted in the creation of an enormous building boom with new blacksmith shops, wagon manufacturing and repair shops and other provisioners and suppliers focused on outfitting pioneers for the long journey. They alone employed over 1,800 men at the time, making Leavenworth a boomtown by the late

1850s. It makes perfect sense that with a growing town and the large influx of travelers stocking up for a long journey, there was the understandable need for locals to have a drink.

During the tumultuous time between when Kansas was incorporated as a territory and finally became a state in 1861, often described as "Bleeding Kansas," there were as many as twenty-five different breweries started, mostly in the northeast in and around Leavenworth and Atchison, but some taking root as far away as Ogden and Junction City. Many of these made their investments and began operations only to go under soon thereafter. As is still the case today with any upstart business, poor business experience, competition and overconfidence certainly can contribute to a brewery's early demise.

But it's clear that brewers in the mid-1800s knew exactly what was needed to brew beer. Books on beer making from that time look very much as they do now, with formulas discussing brewing times, fermentation efficiencies, CO_2 ratios, cooling rates and so forth. However, one of the most difficult to manage at the time, and absolutely critical in the success of a brewery, was the ability to employ some method or source of refrigeration. In the brewing process, refrigeration is essential, and above all other steps in the process, it is important to brewing a good-tasting beer. A cool environment was not only desirable to store the finished beer but also crucial in the proper fermentation of ales and, especially later on, lagers. As such, most breweries were located near a stream or river, but some used large underground caverns or cellars to provide the cooling needed. Some breweries would even try to make do by stocking up on ice from local streams and packing it with straw in special cellars, but until refrigeration was invented, brewers had a difficult time manufacturing and keeping a consistent product.

During this time in Kansas, supplies and equipment needed for brewing ale were either made on-site or brought in overland by cart or wagon. Barley, corn, rice and other grains were purchased locally or grown and malted at the brewery. Yeast was another story. It wasn't until the late 1800s that single-strain yeast was isolated and could then be grown and used exclusively for brewing beer. Until then, the brewer would harvest and reuse the yeast from good batches, which were also unwittingly augmented by the use of the same yeast-impregnated wooden casks or "magical" wooden stirring paddles (the paddles became yeast-impregnated over time). Without a supply of yeast from a previous batch, the new batches of beer had to rely on baker's yeast and vice versa, as the two professions often leaned on each other since brewer's yeast was largely the same, *Saccharomyces cerevisiae*.

Brewers would continue to harvest their yeast as they went along, attempting to prevent any wild yeast or bacteria from infecting it. Over time, the brewer's yeast became a mixture of previous batches and not one distinct variety. In these early days of the Kansas Territory, most beer was dispensed in kegs in taverns or saloons. Early on, bottles were still rare, expensive and often the property of the brewer and not to be sold, as in "I'm selling you the beer, not the bottle! And don't even think of breaking it!" Wooden kegs were a commodity at the time and usually made by the local cooper. The brewery would deliver newly filled kegs and bring back the used ones.

Many of the people who came to the territory came for inexpensive land and the opportunities that came with it. As the brewers and other merchants were experiencing growth in the territory, there also was a great cultural and political change afoot. With the Missouri Compromise still fresh in the minds of the country's legislators, the assumption was that when Kansas and Nebraska were to become states, Nebraska would be a free state and Kansas would be a slave state, thus keeping the precarious balance. However, after much debate, the final version of the Kansas-Nebraska Act was written such that Kansas was *free to choose* whether to be a slave state or not by vote

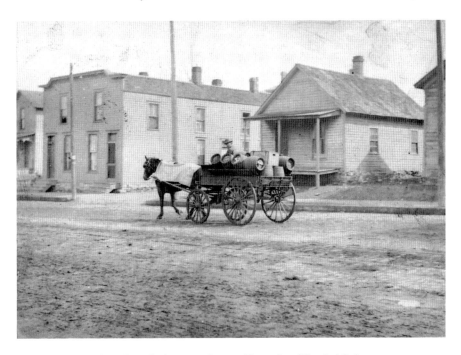

Returning empty barrels to the brewery. *Courtesy Kansas State Historical Society.*

of the residents. This decision instantly became an enormous national controversy. If the state residents were to choose, it created an opportunity for proponents and opponents for each side of the issue to rush to the state in order to sway the vote to their interests. Partisans from each side of the issue began flooding the state to affect the outcome. Many southerners, including those in neighboring Missouri, felt that Kansas should come in to the Union as a slave state. They believed that if Kansas became a free state, it might threaten their slave state status and act as a nearby haven for escaped slaves to flee to. On the other side of the issue, the northern, abolition-supporting states began heavily promoting Kansas to potential settlers to go out and establish homesteads there. Financial assistance was even offered by many northern societies to potential colonists. The New England Emigrant Aid Company, in particular, was quite successful in promoting and financially assisting anti-slave settlers to the state. For example, it provided reduced fares on steamboat rides from St. Louis to Kansas City and was rumored to also offer support getting work once here. In short order, there was a mad rush to the state by the pro and con activists that set up what many believe was the genesis for the country's Civil War. With all the new politically biased immigrants to the state taking one side or the other, conflict was inevitable.

Much is written on the tensions and the border war fighting of this time in Kansas's history. The stories of John Brown and the Pottawatomie Massacre, Missourians by the hundreds crossing over to vote in the territory, the Wakarusa War near present-day Lawrence and Bushwhackers fighting Jayhawkers highlight Kansas's terrible struggle for statehood. It was a turbulent and passionate time in the state's history. Eventually, with the passing of the Wyandotte Constitution in late January 1861 (helped by the fact that eleven slave states had already seceded from the Union along with their respective senators), Kansas was admitted into the Union as a free state. As the rest of the Union was beginning to tear itself apart, tensions in the newly formed state of Kansas subsided enough to get on with the rigors of day-to-day living in the rural existence on the prairie. However, the influx of new settlers, most of whom were from bordering or northern states, was largely unabated. Kansas was now a free state after all, and the South was quite preoccupied gearing up for the war with the North.

3

STATEHOOD AND THE EXPANSION OF THE 1860s

Even after the struggle for statehood, Kansas remained busy. In spite of the difficulties of establishing a new homestead in a new frontier and the record-making drought of 1860, more and more tough and determined settlers poured into the new state for the economic opportunities it provided.

The early years of statehood also saw the start of the Civil War (1861–65) and its demands on the state. Kansas was a strong supporter of the Northern cause but had no organized militia or industrial supplies with which to contribute except through the participation of those willing to fight. By the time the troops from the state were needed, the population had actually *decreased* (due to an extended drought where a large number had given up and left) down to roughly 107,000 residents.[6] From this, Kansans still exceeded their quota of 16,654 troops to the Union by nearly 3,443 men.[7]

One of the major outcomes the Civil War had on American beer and brewers was the growth in the popularity of lager-style beers. Almost 10 percent of the Union army was composed of German American soldiers spread among various regiments and posts across the nation. Lager beer was their obvious preference, and their desire for this style of beer was largely met along the way by traveling storekeepers, or sutlers, who followed the armies (North and South) from encampment to encampment and provided necessities and luxuries not available through the supply chain of the army. Hard liquor was often also available but

generally restricted by the commanders. But beer, with its lower alcohol content, was often viewed differently. Even though there was a ban on liquor sales to many army units, Union brigadier general Louis Blenker, as one example, made an exception by allowing sutlers in camp to sell beer to his units, many of which comprised German American soldiers, to improve morale.[8] As is often the case in war, much of the time was not spent in battle, but in holding a position for many days at a time, drilling and practicing, but with the rest of the time taken up with playing cards and drinking beer, if available. As beer was an "approved drink" in camp, the demand was high, and it was generally accepted across many regiments as "the drink that relieved the tedium and terror between combat."[9] In fact, army commanders would requisition beer be brewed and supplied for use of the army.[10] One Union soldier wrote the that nearly all of the troops were drinking beer and "among the German troops, especially beer…is consumed in great quantities."[11] After many months in camp, the taste for lager rubbed off on the rest of the troops during this long conflict and soon became the beer style of choice for the returning soldiers.

By the end of the Civil War, historical research shows a greater number of existing and new breweries in the state. Those identified by this author were in the towns of Atchison, Beattie, Chetopa, Council Grove, Ellwood, Fort Scott, Granada, Iola, Junction City, Leavenworth, Neuchatel, Ogden, Old Robinson, Solomon, Topeka and Wathena. As the names and long-term viability of towns and counties were still changing through this period, this obviously impacted the success of any breweries or businesses started there. The railroads had just begun to appear and were extremely influential in whether a town thrived or even survived during this time in Kansas. People even invested in establishing new towns betting on their growth and predictions as to whether a railroad would be built through them. Some early, and relatively promising at the time, Kansas towns soon became greatly diminished once residents learned the railroad was not coming. (As an interesting illustration of this, the 1880 Kansas census counted more residents in Fort Scott, 5,372, than Kansas City, with only 3,200 residents.)[12]

The era of railroads in Kansas was just beginning to make a foothold even before the Civil War ended. The Kansas legislature had chartered the St. Joseph and Topeka Railroad Company to build a direct line from St. Joseph, Missouri, to Topeka and then toward either the western or southern border of the state toward Santa Fe, New Mexico. After

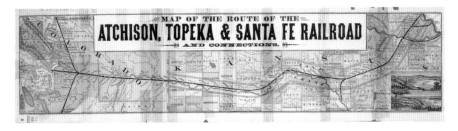

This banner map shows the routes of the Atchison, Topeka and Santa Fe Railroad, indicating each station from Atchison, Leavenworth and Kansas City westward to Denver, Canon City and Walsenburg, Colorado. It also shows the AT&SF land grant boundaries through Kansas. A number of communities, not on the route, are identified, including the location of three Mennonite settlements. The map also includes two inset illustrations of Atchison, Kansas City and Wyandotte, Kansas, possibly by Topeka artist Henry Worrall, 1875. *Courtesy Kansas State Historical Society.*

changing the starting route to Atchison, the railroad formally changed its name to the Atchison, Topeka and Santa Fe Railroad (AT&SF). Another railroad company was chartered as the Leavenworth, Pawnee and Western Railroad, which later changed to the Union Pacific Eastern Division and then again to the Kansas Pacific. By April 1864, Kansas Pacific had already laid tracks from Wyandotte (Kansas City) to Lawrence and was quickly approaching Topeka.[13] Railroad growth in Kansas was greatly encouraged to provide an economic benefit to the state by connecting it to markets in the East. Although Kansas was not selected as a route along the Great Transcontinental Railroad, the nation was nonetheless interested in securing a safe and efficient interstate railway to the growing commerce centers in both Colorado and on the West Coast.

As the railroads began reaching towns in Kansas, they spurred the opportunistic advantage of moving cattle from here, where they were relatively inexpensive, back east to Chicago and points beyond, where there was a large demand for beef. The first to take advantage of this trade was an enterprising individual named Joseph McCoy in Abilene, Texas. The Kansas Pacific had reached the town where he had built a large stockyard and began purchasing cattle to ship back to the East. The first trainload successfully left Abilene for Chicago in late 1867 and, by this event, ushered in the short, but transformative era of cattle drives, the Chisholm Trail and Kansas cow towns. Word spread that if you could get your cattle to one of the railroad-linked cow towns in Kansas, they could be sold for a profit. This opportunity was especially interesting to Texans returning from the war, who found longhorns and other cattle, which had been left largely unattended,

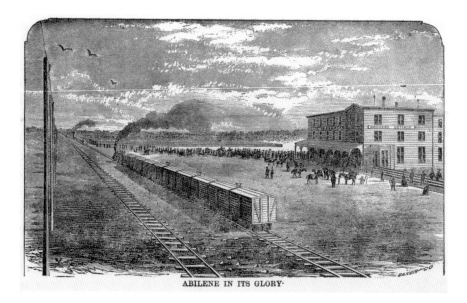

ABILENE IN ITS GLORY·

An illustration from Joseph G. McCoy's *Historic Sketches of the Cattle Trade of the West and Southwest*, 1874, of a train of cattle leaving Abilene, Kansas. *Illustration by Henry Worrall; courtesy Kansas State Historical Society.*

had multiplied and roamed freely throughout the state. They could be rounded up and driven north along any of a number of trails to railroad-linked Kansas towns such as Abilene, Ellsworth, Hays City, Newton, Wichita and Dodge City. From 1867 until the 1880s, millions of cattle and cowmen, purchasing agents, businesspeople and families moved into Kansas to take advantage of this trade.

As the Kansas cow town populations swelled with cattle, so did the number of businesses "at the end of the trail." When the cowboys reached their destination, and with their cattle successfully delivered to the stockyard, they finally received their compensation. Of course, every business in these young Kansas towns was vying for the cowboys' newly earned riches. As has been seen so many times in history, up sprang the saloons, gambling houses, dance halls and brothels to quickly separate these cowpokes from their hard-earned money. But that which made for a booming cow town was not always an ideal environment for a brewery. The beer at these saloons was typically brought in by rail and served at room temperature from the barrel. Therefore, to most, hard liquor ruled the roost.

As the railroads grew and opened up new areas of the state, so did the growth of new settlers from eastern states as well as a flood of immigrants from England, Ireland, and Germany. With the many new settlers came opportunities for new breweries. In fact, during the 1860s, historical records show nearly thirty new Kansas breweries on the scene, many spurred by the demand for German-style lagers.

4

IMMIGRATION AND THE GROWING TEMPERANCE MOVEMENT

With the Civil War over, the booming cow towns and the railroad spreading across the state and beyond, it seemed like Kansas was the place to be. The Kansas Homestead Act (1862) and the railroads attracted many settlers to take advantage of state's free and cheap lands. Advertisements to come to Kansas for new opportunity were popular across the country. The Kansas State Bureau of Immigration was established in 1865 and began promoting the state with pamphlets and other promotional material to all potential immigrants, but it initially targeted England, Germany and Scandinavia.[14] The railroads also advertised for people to come to the state. As a way of compensation, the federal government had given the two main railroads in Kansas almost four million acres of land along the rail routes for building the lines, and once built, the rail executives were quite interested in recouping their costs by selling off their grants. For example, the Atchison, Topeka and Santa Fe Railroad company had almost three million acres in grants and advertised heavily across the nation. Most of the promoted land was between Emporia and Dodge City and right along the rail line. As intended, the sale of the AT&SF and the Kansas Pacific lands significantly encouraged settlement across the state.

As the rail lines expanded across the state and their lands were sold, the growth of towns and settlements rapidly increased. Of course, the railroad companies promoted any new towns along their lines as a way to stimulate business for their rail traffic. Over time, rail towns began to thrive as the

settlers and goods poured in. With the new opportunity the railroads had provided, many different immigrant colonists were drawn to the state, either to newly formed communities or, as was the case of many religious communities, new towns wholly formed for their purposes.

By the 1870s, the state had experienced its largest growth in history by more than tripling its fledgling population to nearly 364,339 residents as counted by the 1870 Census. Settlers poured in from everywhere it seemed. Some were from other states, but many international settlers showed up to take advantage of the new lands. German immigrants—not all of them directly from Germany—became the largest ethnic group to arrive during this period. Some German settlers come from other states such as Pennsylvania, but many more were encouraged to emigrate from Russia and from German-speaking nations across central Europe such as Switzerland and Austria. In many cases, the impetus for coming to Kansas was part of a push-pull situation. The pull was obvious in that there was ample and inexpensive land upon which to settle, a rail line facilitating travel and commerce and, in many cases, existing German communities in which to reconnect. The push was often due to either an undesirable political situation or poor economic prospects. Once here, they often wrote back to their families and friends in Europe proudly touting the good land, ample opportunities and the freedoms found here. News of the great state traveled back and was disseminated widely, prompting even more settlers in a chain migration manner. One of the largest single influxes of German settlers brought the Mennonite Germans, who had been living in the Tauride region of southern Russia. These were followed by the predominantly Roman Catholic Germans living in the Volga region.

The Germans traveling to Kansas during this time were distinct from other groups of newcomers in that that they "moved in large groups, settling whole areas, founding their own social and religious communities."[15] These immigrants, many of whom had not actually lived in Germany for years, were a tight-knit group and acted very much like religious sects. The reasons for the Russian Germans to come to Kansas were many and not necessarily what is often cited regarding their loss of exemption from Russian military service. Most were proud farmers and, of course, desired their own land, but they also had a nudge to leave because of Russia's declining grain prices, increases in taxes and the withdrawal of economic rights, such as exclusive licenses for brewing beer.

The Russian Germans were able to sell their farms and crops before departing and thus had enough money to purchase land and supplies upon

arrival, giving the Kansas economy, and especially the railroads, a much-needed injection of hard currency. Each German group that arrived fanned out to different areas of the state based on what land might still be available. Some went where certain community members had already settled and some to those areas that seemed more likely to prosper based on their land scouting reports. Once they arrived, they didn't sit long before securing the needed equipment and supplies and getting to farming and building their homes. In fact, after becoming established and "having their feet under them," they began branching out away from the land adjacent to the railroads and expanding out and into central and western areas of Kansas, establishing new towns and communities based largely on their religious principles.

Kansas was, despite the notorious and widely published stories of cattle drives and rowdy cow towns, quietly creating for itself a strong religious foundation of distinct denominations. "Of all the western states and territories, only Mormon Utah became more religiously politicized than Kansas."[16] Earlier, Kansas had been populated by new settlers assisted by the New England Emigrant Aid Company and other Union states in such numbers as to assure the state would not allow slaves. But these new religious settlers also espoused temperance. In the 1870s, the total number of breweries in the state peaked,[17] but like a shadow keeping pace, the national temperance movement was growing, becoming more and more vocal and emboldened.

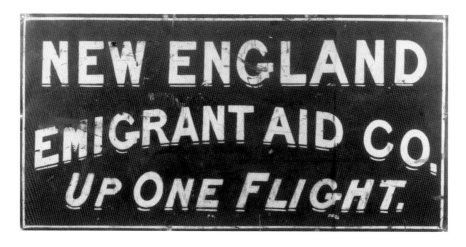

Trade sign made of sheet metal, painted black with gold lettering. The sign was most likely used at the Boston headquarters of the New England Emigrant Aid Company between 1855 and 1858. *Courtesy Kansas State Historical Society.*

Kansas followed the nationwide trend in new breweries and, bolstered by many new beer-drinking German communities, new breweries started across the state in at least thirty-four towns.[18] On top of the fact that Kansans had significantly increased the number of homegrown breweries, the railroad was now competing by facilitating beer brewed outside of the state by large breweries in St. Louis, Milwaukee, Chicago, and other large brewing cities in "reefer" freight cars, as they were known. These had insulated walls packed with ice and could ship cool beer along the existing rail lines into Kansas year-round. The larger breweries had economies of scale and could directly compete with the local breweries. Thus, more than at any previous time in Kansas history, beer was becoming a commodity and in ample supply across the state. If your community had access to one of the rail lines or a local brewery, you were set.

However, as always with too much of a good thing, storm clouds were forming on the horizon. With a growing and passionate religious and temperance-minded population, contrasted against the rowdy nature of many saloons with greater access to alcohol, the situation was predictably on a path toward confrontation.

Although the temperance movement was in existence since the early days of the territory and state, it did not reach any kind of momentum until the 1870s. Long disregarded by businessmen and entrepreneurs involved in the Kansas brewery and whiskey business, it was beginning to get a foothold. Certainly, it was preached about on Sundays and promoted, in large part, by the (non-voting) women in the state but was paid little heed by many political leaders for years. However, things began to change when stories of alcoholic excesses were more and more publicized in the papers and preached against from the pulpits across the state and country.

Concurrently, a national temperance movement was growing and, because of the heavily religious communities established across the state, seemed to find fertile ground here in Kansas. As the decade was coming to a close, a national temperance meeting and revival of sorts was held on a farm called Bismarck Grove just north of Lawrence. This bit of land had originally been a repair depot on the railroad, but a grove of timber along the property became a great place for picnics. It soon attracted others in the area who also began using it for outings, church meetings and the like. As its popularity increased, the Kansas Pacific Railroad improved and promoted the site by installing walkways, buildings, gas lights and even a large tabernacle capable of seating as many as five thousand.[19] It was also encouraged as a site to hold fairs and other events, and in time, as word of this easily accessible spot

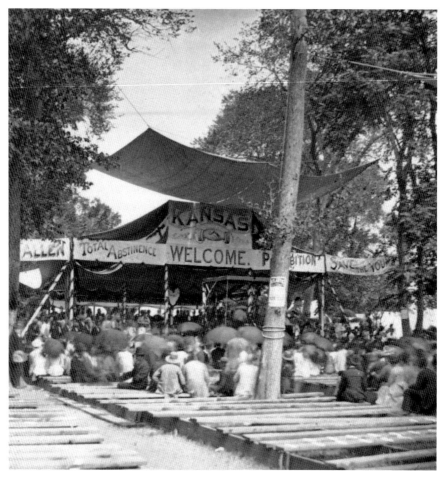

View of the First National Temperance Camp meeting held at Bismarck Grove near Lawrence, Kansas, 1878. *Courtesy Kansas State Historical Society.*

along the rail line got out to promoters, this local getaway was selected to be the site for one of the largest temperance events in the nation during the last two weeks of August 1879.

The temperance rally spanned two weeks and attracted between twenty and twenty-five thousand visitors by the last Sunday of its second week. With a full daily itinerary published in the local paper, people would make day trips from surrounding towns by buggy or rail to attend. The event had a notable list of speakers who energized the attendees with rousing speeches denouncing the evils and dangers of alcohol.

Well-known preachers and ministers of the time drew large crowds, as did the current and up-and-coming politicians of the day, including the pro-temperance gubernatorial candidate John P. St. John and even several of the local Indian tribal chiefs from their nearby reservations. All promoted the merits of an alcohol-free society to the throngs of people attending. By all accounts, the event was a rousing success and left the Bismarck goers energized to carry on and support temperance in their communities and organizations. It was a significant turning point for the state, which had, at that time, more breweries and access to alcohol than ever before. This was obviously the point to many on the prohibitionist side of the argument. As it was, and in large part due to the momentum from this rally, the state easily voted in the temperance-leaning St. John to the governor's office the following year.

An interesting side note in Kansas history to the nomination of St. John was the fact that a Private Fritz Schnitzler and "sundry others too numerous to mention" were brought before an army court-martial in September 1880 for "mutinous conduct in refusing to ratify the nomination of our great and noble Capt. General John P. St. John, as required by General orders" issued from the Headquarters of Army of Occupation. The army had the gall to

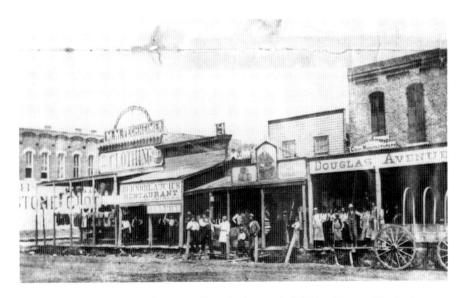

A photograph of several businesses on Douglas Avenue in Wichita, Kansas. The business three doors to the right is Fritz Schnitzler's Saloon, with a portrait of him above the porch, 1878. *Courtesy Kansas State Historical Society.*

convene the court at Fritz Schnitzler's saloon on Douglas Avenue in Wichita and make the indicted soldiers pay for the court costs and any resulting fines. Obviously, Fritz and his buddies knew what might be coming around the corner and were not fans of Governor St. John.[20]

5
PROHIBITION!

Kansas already had a largely ignored law, drafted as part of the Territorial Legislature of 1855, requiring municipal votes to allow a "dramshop" or tavern to be able to sell intoxicating liquors. It was amended again in 1859 with additional provisions (making it a misdemeanor to sell on Sundays and certain other days of the year and barring any approved purveyor from selling to "any married man against the known wishes of his wife"). These laws were completely rewritten and updated by the state's General Statutes of 1868—all of which were largely overlooked or wholly ignored across the state. Enforcement was lax, and besides, communities made money on licensing revenues from any legal establishment selling or making liquor.

However, many settlers in the state were familiar with the 1851 Maine Law, on (and off) the books since 1851, which prohibited the sale or possession of intoxicating liquors, and wanted to strengthen Kansas regulations with a similar law. The Maine Law had many holes in it and was largely unenforceable, so, learning from their efforts, the abstinence-leaning Kansans of the day wanted a well-drafted *constitutional amendment* to be enacted, giving it more legal weight and, hopefully, more enforceability.

With Governor St. John now in office, swept in by the large number of temperance supporters, he soon began work with the legislature to craft, and quickly put before the voters, a prohibition amendment to the state's constitution. By March 1879, the draft of the amendment was worked out and approved by the legislature for the next general election on November 2,

1880. After publishing the details of the new law and debating the proposition across the state, voting day finally came: 176,606 votes were cast on this amendment with the result 92,302 *for* and 84,304 *against*, making Kansas the first state in the country to ratify an amendment to its constitution officially enacting prohibition. The results were largely as expected, with the counties having the largest number of dissenting votes from cities with the most saloons and breweries—Atchison, Jefferson, Wyandotte, and Leavenworth. The counties representing Topeka, Lawrence and the large Mennonite communities in McPherson, Marion and Harvey Counties provided strong support for the amendment.

The amendment took effect on January 1, 1881. Soon after, the legislature also passed a law in May 1881 prohibiting the manufacture of alcohol (breweries, distilleries and the like). However, the laws in effect did not immediately dry up Kansas.

The saloons, the main target of the prohibition law, didn't go away immediately or easily. Initially, most saloons ignored the law or settled for the fine. If caught, the fine for operating an establishment caught selling alcohol was $100 per month, so many of the larger saloons stayed in business, opting to pay the fine on a regular basis. Remember that the municipalities enjoyed the license fees as well as the fines, so saloons and breweries became a bit quieter but stayed open. For the establishments that did not (or could not) remain publicly open, evasion became the fallback option—going underground as blind tigers. But most simply adopted a farcical charade with local enforcement officials with periodic fines or prearranged raids. In fact, many saloons remained in operation for years after the law was in place due to lack of enforcement. In a 1916 article, American Libertarian author Albert J. Nock looked back on the past thirty-five years of prohibition in the state and underscored this, stating, "In 1883, two years after prohibition was established, there were forty open saloons in Topeka, doing business under a license to sell certain specified liquors 'and other drinks.' A town the size of Fort Scott had as many as thirty-two places operating under such licenses."[21] In fact, right in the heart of the state's capital, a popular drinking establishment called the Senate Saloon famously flaunted the law made just down the street and opted to stay open and simply pay the monthly fine.

However, while some breweries and saloons were forced to close in the early months of 1881, depending on the community's propensity to enforce the law, there were still new establishments being opened across the state opting to either pay the fine or simply act in defiance of the new laws. There's a story of a particular community in which the town sheriff would

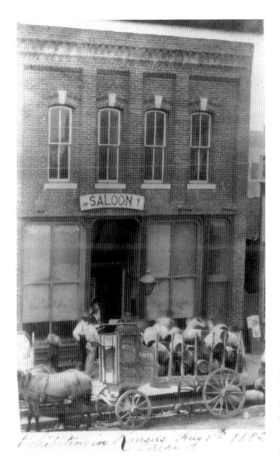

A horse-drawn wagon filled with beer kegs in front of the Senate Saloon in Topeka, Kansas, 1882. The saloon was located between Third and Fourth Streets on Kansas Avenue. *Courtesy Kansas State Historical Society.*

adhere to his duties and show up at the local brewery and "arrest" one of the brewery partners and bring him down the jailhouse, where they played cards or dominoes for the afternoon, before releasing him. Knowing that arresting *both* brewers would be detrimental to the tasks of brewing, he'd detain only one of the two, and the next time he'd arrest the other partner to hang out at the jail.

Some breweries sought to legally challenge the amendment outright. A famous case that resulted from Kansas's decision to prohibit alcohol, and in particular, its manufacture, was that of *Mugler v. Kansas*,[22] which went all the way to the U.S. Supreme Court. Peter Mugler had built a brewery in Salina in 1877, prior to the state's 1881 amendment. He spent upward of $10,000 (over $250,000 in today's dollars) on construction and the purchase of specialized brewing tanks and equipment only to have the law passed preventing the brewery from operating legally. Defying the law because he

had just made such a large investment, he was fined numerous times and indicted late that year for multiple counts, including manufacturing without a permit (how was he supposed to obtain one?). He was fined $100 plus court fees but appealed to the Kansas Supreme Court, which affirmed the lower court. Both the brewery and the case continued until December 5, 1887, when the Supreme Court finally ruled 8–1 against Mugler, citing, among other specifics, that the state could prohibit nuisances and that it was not actually taking his property and that it could be disposed of or repurposed at the owner's discretion. Other breweries in the state that had struggled to stayed open or were lying dormant waiting to potentially reopen received the news and saw this as the nail in the coffin for any chance of remaining open legally. Only a handful of breweries that remained open did so by going underground, disguising themselves as chemical factories (such as Schulz Chemical Works Factory Brewery in Fort Scott) or selling supplies for people to brew their own. All scaled back substantially. Sad times indeed.

Interestingly, German immigrants—many of whom saw beer and having a community brewery as instrumental to their being—continued to come to the state. Perhaps because of the momentum and lack of news, between 1880 and 1890, those identified as German in the U.S. Census still rose by over eighteen thousand. Certainly not all were abstinent minded, yet they still settled here across the state. Obviously, there was beer brewed inside the community for personal consumption.

To many, Kansas had become too stringent against alcohol. Instead of working with the wine and spirits manufacturers as well as the state's brewers, seeking some sort of compromise on the how commercial retail could be conducted, it banned alcohol across the board. Many Germans became fed up and wrote to inform family and friends of the outrageous law passed here against even beer. A potential immigrant from southern Germany wrote back to a Kansan soon after prohibition was enacted, remarking, "None of my friends can imagine themselves living under such stringent laws and they think it cannot be good where such laws are considered necessary."[23]

With victory at the polls and their new governor seated, much of the prohibitionists' fervor and enthusiasm for meetings began to subside and was now focusing only on the enforcement aspects of the new laws. It was difficult and rare to prohibit individuals from drinking their own spirits at home, for example, and obtaining alcohol for personal consumption was no problem in most cases. But it had an opposite effect on the intended goals in that it became easier to conceal and transport spirits and wine into the state and more difficult to legally keep a brewery open or transport and sell

beer. Prohibitionists were largely in favor of moving people to beer over whiskey, as the former has a lower alcohol content. However, now that the state, with the main intention of shutting down the saloons, banned all intoxicating spirits, it inadvertently made it more difficult to purchase the more tolerated beer and easier to obtain contraband whiskey. Grain alcohol was often sought out from the local druggist, who, with, or often without, a prescription, could sell it to individuals seeking relief from a myriad of maladies (wink, wink). Looking back on the papers of the day reminds us that this was the heart of the era when medicine wasn't exactly founded on sound scientific principles. Traveling medicine men prospered, going town to town selling magical potions (a.k.a. snake oil remedies) that promised to cure virtually anything. And the local druggist was certainly kept afloat selling cures to everything ailing you. So, it was not at all uncommon to purchase a bottle of pure grain alcohol to mix with something you had at home for your evening drink.

6
DAMN IT, CARRIE!

Despite Kansas's intention to become a dry state, it was anything but. Enforcement was lacking, and hundreds of illegal liquor establishments selling high-alcoholic spirits sprang up. Sadly, on the other hand, the breweries across the state began to quickly fade away as the years of prohibition rolled on. They were too visible and consequently unable to stay open by either going underground or paying minor fines to the local town officials. However, supply and demand kept meeting up and satisfying each other—now mainly with only the hard stuff. This went on for years across the state until one woman out of Medicine Lodge, a radical devotee of the temperance movement, decided she'd had enough of it.

In 1900, Carrie Nation entered the scene in Kansas. Born in Kentucky, she was raised and married her first husband in Missouri—he died shortly after from alcoholism. Using his inheritance to sustain her for a while, she became a teacher and taught at a school in Holden, Missouri, for a few years. She eventually met and married David Nation, an attorney, journalist and minister. They purchased land in Texas but, after their cotton farming enterprise failed, moved to Medicine Lodge, where he practiced as a minister and she operated a hotel.

Obviously affected by her first husband's death, Carrie Nation became active in the local temperance movement and started a local chapter of the Woman's Christian Temperance Union. She began campaigning against Kansas's lax enforcement of the prohibition laws by pestering local saloon patrons with hymns, then ratcheted things up with pointed greetings like

"Good morning, destroyer of souls."[24] Not unexpectedly, the kind greetings and live music she provided didn't go over well or get her what she wanted. She decided to discuss this all with God, and the result was to step up her actions by packing some rocks and taking a buggy ride some twenty-five miles south to visit a couple saloons in Kiowa. On June 5, 1900, she first approached Dobson's saloon and, after professing her desire to save the patron's souls, began smashing the saloon's stock with her rocks. She then went on to hit the other two saloons in town. Thus starting her famous campaign against the select remaining saloons in Kansas by showing up unannounced and destroying any liquor she could hit with a rock. This, of course, had her arrested on many occasions without much of the intended effects. Widely publicized in the state's newspapers, her popularity among those who sympathized with her began to grow. After she hit a saloon in Wichita, her husband jokingly remarked that she should use a hatchet for maximum damage, to which she agreed (then promptly divorced him). She moved south of the Kansas border in 1902 to Guthrie, Oklahoma, but kept returning to raid Kansas saloons.

For this, she was arrested over thirty times between 1900 and 1910 for what she called "hatchetations," where she would show up, sing hymns and smash the place. She paid for her fines through lecture fees and souvenir hatchets provided to her by a Topeka pharmacist (perhaps trying to corner the medicinal alcohol sales market?). She even ventured outside of Kansas to preach her craft, amassing even more "good will." In Kansas City, *Missouri*, where saloons and alcohol sales were completely legal, she showed up at several downtown bars, where she confronted the patrons and owners. This resulted in a large disturbance with so many people descending and following her that, at one point, she caused a standstill blocking cars and sidewalk traffic on Walnut Street. She was consequently arrested for obstructing the sidewalk, brought to court and fined a substantial sum at the time, $500. The judge cautioned her that he meant business but would let the fine go if she would leave town by 6:00 p.m. that day. Carrie remarked that Kansas City shipped all the "hell-broth" to Kansas but finally agreed to his terms and thanked the judge by reminding him that she had left one of her souvenir hatchets on his desk. She finally departed, but calculated she still had enough time to disrupt one more place at a saloon fifteen minutes away on Walnut Street.[25] She escaped without arrest though and made it out of town by the judge's deadline.

She had her fanatical devotees for sure, but many didn't think highly of her and thought her mostly impressed with herself and what had become

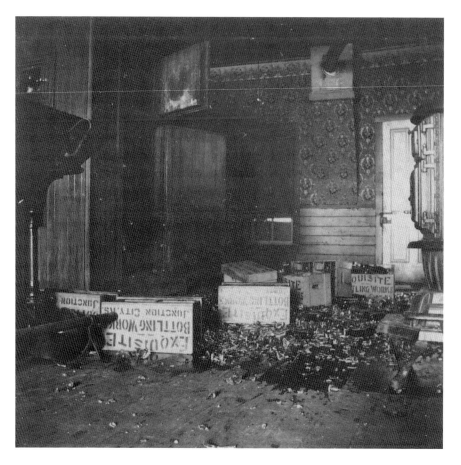

Interior of a saloon in Enterprise, Kansas, destroyed by Carrie Nation and her followers. The wooden cases are labeled Exquisite Bottling Works, Junction City, Kansas, 1901. *Courtesy Kansas State Historical Society.*

for her a source of income: speaking fees and the selling of souvenirs. Soon after her Kansas City escapade, the editor of the *Atchison Globe* wrote that he agreed with the judge and thought she was actually a "disgrace to womanhood, Christianity and temperance and entitled to no respect because of her sex."[26] He went on to compare her manners to a baboon and wondered why the Kansas towns did not treat her as she was (treated) by Kansas City officials.

Now going as Carry, as in "Carry A Nation," she went about her business intermixing the destruction of whatever she could shatter in saloons and traveling on speaking engagements and selling souvenirs to help pay for her

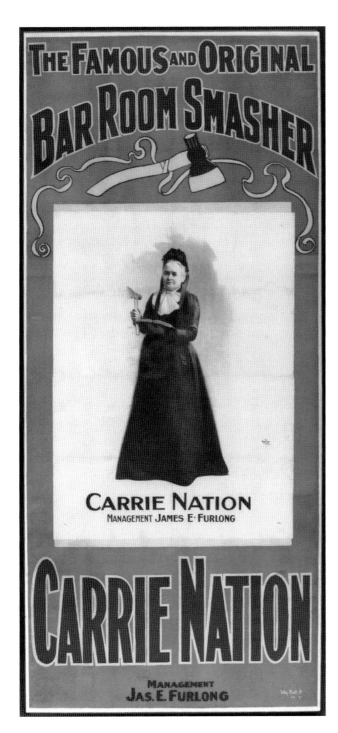

Large rectangular color poster advertising an appearance by Carrie Nation, a temperance advocate who gained notoriety by attacking saloons. *Gillin Print Company, 1901–02; courtesy Kansas State Historical Society.*

fines. She continued getting arrested, sometimes being locked up for days on end until she was bailed out by supporters. Her rage against alcohol became notorious across the nation and even in Europe. In 1909, she decided to take her show to England. Once there, she failed to garner much support other than the curiosity factor. At an event at the London Music Hall, she received a bit of her own hatchetations via an egg thrown by an audience member. Enraged, and getting a bit of a wake-up call, she left posthaste for America to seek profits elsewhere.

Shortly before her death, she moved to Eureka Springs, Arkansas, into a home she dubbed Hatchet Hall. Nation suffered a nervous breakdown, reportedly over the nonpayment of speaking fees, and after collapsing at a speech, was taken by her family to a Leavenworth, Kansas sanatorium for several months of relaxation and rest. Her health never recovered, and she eventually died there on June 9, 1911, at the age of sixty-four.

Apart from bringing a lot of attention to the fact that Kansas had open saloons, Carry Nation's hatchetations were not attributed with having reduced the number of open saloons in the state. However, the threat of legal enforcement did increase in 1907, pushed by Attorney General Fred Jackson. He agreed to step up enforcement across the state with threats to oust local officials if they did not comply. This new "ouster law" actually worked to some degree, and by 1910, there were only a few counties in the state with open saloons. In addition to this, a new law was passed prohibiting the state's druggists from selling alcohol for medicinal purposes in 1909. Prior to this, they had license from the state to sell and manufacture pure grain alcohol. Now it could only be sold if mixed with other substances rending it undrinkable. Not surprisingly, the number of druggists in the state dropped by 25 percent from the prior year.

Again, a Kansan during this period could still get liquor for personal consumption from mail order and through cross-border exchanges; however, the drugstore and saloon access were slowing going away. To make matters even worse, acknowledging the reality that anyone in the state could still get alcohol if they wanted, the legislature sought to tighten the laws a bit more by drafting and passing on February 24, 1917, what was called the Bone Dry Law, which made it a jailable offense for any person, except ministers and priests, to have in their possession, for any reason, any intoxicating liquor. It also made it unlawful to have liquor shipped by any manner to you, regardless of use. The bill even allowed authorities to use search and seizure on personal baggage or packages crossing the state border on any vehicle, train or the like.[27] Other states

passed similar laws in the same month, including neighboring Oklahoma and Iowa. Obviously, a rising sentiment across the country against alcohol was appearing to take root. In fact, a similar *national* law was discussed in the halls of Congress in Washington, D.C., during the same year. A wave of acceptance to temperance laws was gaining ground from state to state, setting up an impending nationwide prohibition in the near future.

7

THE GROWTH OF BLIND TIGERS AND SPEAKEASIES

With the national sentiment growing in the belief that drying out the whole of the nation would cure the social ills of alcoholism, political corruption, and family violence, Congress proposed the Eighteenth Amendment to the Constitution for states to ratify in August 1917. It didn't make consumption illegal but made the *production* and *sale* illegal. Since many states had already passed some sort of prohibition laws, it easily passed the necessary thirty-six state legislatures needed to ratify it. Mississippi was the first on January 7, 1918, and Nebraska put it over the finish line early on January 16, 1919. Later that same year, separate legislation called the National Prohibition Act, or Volstead Act (after Andrew Volstead, who was chairman of the House Judiciary Committee) outlined the definitions and penalties associated with the new national amendment. The act, passed officially on July 22, 1919, allowed for the manufacture of alcohol for use in scientific research and associated endeavors but otherwise outlawed intoxicating liquors defined as that which is 0.5 percent alcohol by volume or greater.

Interestingly, since the amendment came with a deadline for its ratification, there was pressure to get it voted on while there was the opportunity. And since the amendment did not specifically define the phrase "intoxicating liquor" until after the Volstead Act defined it, many states logically thought they were voting on whiskey only and not beer and wine. Their inclusion came to a great surprise to the great brewers in Milwaukee, St. Louis, Chicago and other larger brewing communities in the nation. This surprise resulted in

many northern states not agreeing to enforce those provisions. Many beer or wine drinkers, who condoned their own moderate drinking and voted to enact the amendment against "those other guys" drinking the "big stuff," were shocked to see their evening beer or glass of wine with dinner was now classified, and included under the ban, as intoxicating liquor.

Going back to the supply-and-demand principle of economics, eliminating the supply and manufacture of alcoholic beverages did not necessarily mean the demand would also be eliminated by decree. With *legal* retail distribution of booze eliminated, out sprang the *illegal* supply guided by economic realities to meet the inherent demand. As has been understood over and over though history, where *there's a will, there's a way,* and in this case, the way was through bootlegging. Not just on a small scale, it became a massive industry run initially by individuals but soon controlled by the mafia and other large gangs.

With all the money the mafia was making during this period, bribing local officials and police became commonplace. Because of this, hideaways for brothels, gambling and drink were protected and thrived. It was a sophisticated and lucrative business operation run by the likes of Al Capone and Dean O'Banion and other notorious mobsters. The age of the speakeasies and blind tigers (sometimes called blind pigs) and other Prohibition-era bars greatly increased across the nation. In New York City alone, there were as many as thirty-two thousand known speakeasies, which using the 1930 Census, translates to one for every 390 residents.[28] And these were the *known* ones. It was estimated that there were as many as twice this amount at this time. Some were closed by the feds only to have several others pop up to replace them. And it wasn't just the big mafia types running these. Without any requirement to adhere to licensing standards, and with the ample supply of liquor, mom-and-pop drinking establishments were starting up by anyone and everyone willing to take the risk—some in their home basements, cellars, garages and the like. It was definitely a high-risk, high-reward business model that thrived in this time. The local police and federal enforcement officers couldn't keep up and focused most of their attention to catching the mafia heads as well as stopping the import of the larger shipments into the United States. When local raids did occur, it wasn't uncommon to have among the arrested drinkers a local official, a congressman, a judge or a notable celebrity. And even if one was arrested, being convicted was not always a sure thing. There's an interesting story of a case in San Francisco whereby a hotel clerk was arrested and brought to trial. However, the case was dismissed

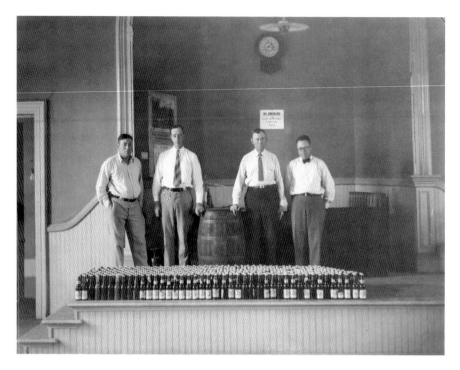

This black-and-white photograph shows a group of gentlemen standing inside a courtroom with confiscated bottles of beer at the Greenwood County Courthouse in Eureka, Kansas, 1929. *Courtesy Kansas State Historical Society.*

when the jury drank the incrementing evidence because they needed to make sure it actually contained alcohol.

Suffice it to say that national Prohibition was a failure and had the very opposite effect of its intentions. Kansas, having a head start on Prohibition, surely benefitted from the increased national traffic of greater volumes of liquor into the United States. The state was now essentially on equal footing with the rest of the country. Straddling the border between Kansas and Missouri, Kansas City was largely unchecked during Prohibition (Tom Pendergast, the famous political boss, made sure no enforcement happened under his watch) and was thus an even larger source of alcohol for the region. It was perhaps easier under national Prohibition to drive to Kansas City and pick up whatever alcohol was needed back in Kansas. It's estimated that a greater number of people were drinking than before and that each drinker was consuming more than he or she had done previously.

By the late 1920s, the calls for repeal had risen across the country, as public sentiment for the Eighteenth Amendment waned. Even the previous

and outspoken supporters of the law were now quietly coming around to the fact that it was a mistake. In 1932, Franklin D. Roosevelt even included a plank on his election bid calling for a repeal and later remarked, "What America needs now is a drink."

Finally, on February 20, 1933, the Twenty-First Amendment was sent to the states to ratify through their state conventions (it was the first amendment to be sent to state conventions, as opposed to their legislatures, because of the still vocal temperance lobbies) and was ratified, with Utah being the thirty-sixth state to agree. The only state to reject it was South Carolina, with North Carolina deciding not to hold a convention. Eight states took no action that year, including Kansas, and for the time being, it remained dry under its own previous amendment passed back in 1881. While the rest of the country began opening up shuttered breweries and bringing bars and saloons out of the dark, Kansas opted to keep its past ways.

8

KANSAS FINALLY COMES AROUND

I n 1934, Kansas decided to offer a repeal amendment on the November ballot that would essentially repeal the past amendment yet still allow the legislature to permit, prohibit or regulate the manufacture and sale of liquor in the state. The effect was to substitute the regulatory amendment to the state's constitution with the legislative control. With an abundance of negative and confusing press on the issue, the amendment failed to pass at the polls by a wide margin. Kansas remained dry.

In the middle of the Great Depression, the state looked for a way to increase revenue and came upon the notion of allowing the sale of low-alcohol beer. It was decided that 3.2 ABW (alcohol by weight) beer wouldn't be so detrimental and that it could be licensed in a way to enrich the city, county and state coffers. To get around the overriding state amendment preventing "intoxicating beverages," the legislature shrewdly agreed to define 3.2 beer as a "cereal malt beverage" (CMB) and not really something on which you could get intoxicated. The backers of the bill estimated the revenue to be gained and distributed across the state would top $1 million per year. Also, CMBs could be purchased and enjoyed on premises—not just taken home for consumption. This was quite a change and raised a bit of ire with those worried about the return of those "damn saloons." However, the bill was crafted with many provisions regarding the age of a licensee (minimum of twenty-one years of age), the hours and days of operation, where places could and could not reside to obtain a license, as well as jail time, fees and fine structures. Persons allowed to purchase or consume were

Kansas vs. Repeal

The repealists have not presented *any* satisfactory plan of liquor control

In other States the wets promised that—

REPEAL WOULD—

Keep the saloon out
Reduce Taxes
Reduce Drunkenness
Stop the Bootlegger
Reduce Crime
Save our Youth
Reduce Law Violation
Protect dry territory.

The results in other States show that—

SINCE REPEAL—

The saloon is back
Taxes have increased
Drunkenness has increased
Bootlegging has increased
Crime has increased
More young people drink to excess
Law violation has increased
No protection given dry territory.

All their promises have failed; until they make good somewhere

VOTE AGAINST REPEAL IN KANSAS

Alcohol is a poison. Repeal means the unlimited sale of alcohol.

All plans for liquor control in other States have failed.

No Plan of control has been presented for Kansas.

Our present plan in Kansas is better than that of any other State.

Why vote away a good plan for a poorer plan.

Liquor dealers violated the Prohibition law.

Liquor dealers will violate any license law.

A FEW people will buy from the bootlegger,

But the open saloon is a temptation to ALL.

Prohibition is the best method ever discovered to control alcoholic liquor.

A vote for repeal is a vote to have the open saloon

PROHIBITION REPEAL AMENDMENT Yes ☐
VOTE NO No ☒

Issued by the Kansas Prohibition Emergency Committee, Topeka, Kan.

A Kansas Prohibition Emergency Committee pamphlet asking voters to vote against the repeal of Prohibition in Kansas, 1930s. *Courtesy Kansas State Historical Society.*

restricted to those over the age of eighteen. With all of the restrictions put into the bill and the attractive—and badly needed—revenue carrot dangling out there, the bill was passed by the legislature. Finally, a Kansan could go to one of the approved establishments across the great state and get a watered-down beer. Actually, a CMB—not really a beer. But things were starting to look better for Kansas beer drinkers.

The law allowing bars and stores to sell CMB was largely unchanged until after the troops came back from World War II. Coming home with a different mindset, they had different expectations for obtaining a legal drink in the state. The laws forbidding strong drink seemed arcane and backward by then. Most young adults had lived an entire generation without the influence and negative attributes of the "much hated" saloons. On top of that, the booze they wanted seemed to be quite readily available—it was just against the law and a pain in the rear to worry about when purchasing and traveling within the state. There remained enforcement activities in an uneven manner from county to county and city to city.

In 1946, Ed Arn became the attorney general for the state. As a Republican, he had run on a strict enforcement plank regarding the porous flow of liquor into the state. He was against the hypocrisy of the state's current situation. His stance was to either completely enforce the existing laws and crack down on the bootleggers and bars selling liquor or bring up new laws to the people for a vote to repeal the amendment. Many people in the state agreed with him and were ready to readdress the issue after so many years. His campaign led the legislature to finally draft a new amendment repealing the state's prohibition. It was put before the state's voters in 1948 and passed by a vote of 422,294 to 358,310. Hallelujah! The amendment repealed the longtime ban and brought the authority back to the legislature to regulate and tax the sale and manufacture of intoxicating liquor. In an odd, very Kansas way, the last line of the amendment stated, "The open saloon shall be forever prohibited." Ok. There were also definitions regarding what was a "saloon" and what constituted a "drink," but essentially this meant that packaged (and taxed) liquor could be purchased at your brand-new corner, and heavily scrutinized, liquor store, but not sold at public drinking establishments. The drinking age was twenty-one years of age for the hard stuff and eighteen for CMB.

Early the following year, the state legislature created the almost-twenty-four-thousand-word Liquor Control Act (LCA), which is the legal document controlling and defining how the repeal amendment would be codified into actual law. It also created the Alcoholic Beverage Control (ABC) to enforce

the new law as well as outlined how the taxes and fees would be shared. The gallonage taxes would go to the state, and the licensee and distributor fees, including the 2 percent "enforcement" tax, would go to the cities. Signed into law by Governor Frank Carlson on March 9, 1949, it officially terminated sixty-nine years of prohibition in Kansas. At this time, forty-five of the forty-eight states had already enacted similar liquor laws. Also of interest was that the new ABC still did not control CMB licenses or sales. These were still approved and controlled by the cities and counties.

One of the first cities to get rid of its liquor ordinances was Leavenworth. Apparently excited to cast off the dry laws in the city, just four hours after the ABC law was signed by the governor, the city attorney presented the municipal officials with an ordinance repealing their years-long dry law. On the other end of the spectrum, Frank Leibert, then city attorney of Coffeyville, unenthusiastically commented that he didn't expect much reaction down there, as "people in general will accept the legislations as something that merely legalized a practice that had been commonly carried out for a number of years."[29]

Obtaining a license still wasn't easy due to strict residency requirements and a long list of questions regarding moral character. (The state was very concerned with preventing organized crime from running the stores.) However, the first batch of 279 licenses was finally mailed out mid-July across the state, with Wichita receiving the most, with 41 licenses, followed by Topeka with 21 and Kansas City, Kansas, obtaining 6.

Liquor by the drink was still banned, but the temptation to continue the Prohibition-era practices of brown bagging (bringing your bottle to a restaurant and mixing your own drink) as well as opening a local blind tiger or speakeasy with all the newly legal liquor stores and bottles available remained. The ABC had its hands full tamping down on this over the coming years. By the 1960s, the problem with some bars and restaurants selling drinks as "private clubs" had grown extensively. Sometimes, patrons would bring in their own bottles and allow the establishment to sell them mixers with their alcohol. Many of these private clubs began using a coupon system whereby the club would feature a few bottles of whiskey, for example, and the patrons would simply buy a coupon for a drink from one of these. As such, the club would act as a buyer's agent for the patrons and purchase the bottles for them. This was all legal since they were private clubs. And, as one might guess, gambling and prostitution began to appear at the clubs.

The state response to this was to pass in 1965 the Private Club Act, which licensed and regulated the clubs in return for allowing the ABC enforcement

officers inside for inspection. In addition, the state license also required a membership fee and a ten-day waiting period before members could be served their first drink. The fee would go into a "liquor pool" account whereby the club owner would purchase liquor for the patrons at a local liquor store. People had to purchase a separate membership for each club in which they wanted to drink. While this law essentially allowed liquor by the drink in the state (or "liquor-by-the-wink," as some called it), it was seen by many as still being too strict. Travelers through the state were nixed out, as they had to apply ten days in advance *at a particular establishment* to legally get a drink there.

In 1970, the state tried again to legalize liquor by the drink, but it failed by a very narrow margin of 50.8 percent against and 49.2 percent for. But by 1978, the legislature passed a law allowing private clubs that also were restaurants (defined as earning greater than 50 percent of gross sales from food) to sell liquor by the drink. This law was meant to placate the growing liquor by the drink proponents without violating the dreaded "forever prohibits open saloons" law still in effect.

The next year, the legislature passed a law eliminating the liquor pools from those same clubs and allowed reciprocal memberships with other private clubs. This means a person could purchase a membership to one club and have a drink at another reciprocating club across the state, for example. In fact, people could have access to as many reciprocating clubs as they wanted as long they were a member of one. (As an aside, this became a very profitable enterprise for a select few clubs which issued memberships having many statewide reciprocators. See the story about this in the Blind Tiger Brewery and Restaurant section of this book.)

The next major legislative liquor laws to be passed were in 1985 and had a significant impact on the state. The first was to increase the minimum drinking age for 3.2 beer (CMBs) from eighteen to twenty-one years of age. The second was to prohibit "happy hours." And the third, and again the most significant, was to approve another referendum for the voters on liquor by the drink. From this, a Liquor Law Review Commission was set up to review all current liquor laws in the state and recommend changes should voters approve it.

Since the new drinking age limits were phased in each year, by 1987, no one under twenty-one would be permitted to drink alcohol. It also meant no drink specials—nor was it legal to buy a pitcher of beer for your personal, or your table's, consumption. (Certainly, this had the equal and opposite effect on the increased number of fake IDs and use of big brother's or big sister's ID

at the local college tavern.) But this commission also set in place the ability to finally toss out the state's liquor by the drink ban, albeit with restrictions, and the ability to opt out county by county. The commission's recommendations were put before the voters as a constitutional amendment in 1986 and finally passed by a significant margin of almost 60 percent to 40 percent. After over one hundred years of being officially dry, bars and restaurants could finally sell legal drinks to the public for the first time since January 1, 1881.

The 1987 legislature, with a lot of input and compromises, agreed on the new laws. Important among them, for this book, was the addition of a microbrewery license type.[30] As discussed in the section on Free State Brewing, Chuck Magerl was instrumental in working with key legislators and influential politicians to guide the language and push to get the wording included allowing this. The law permitted something that received very little attention at the time called a "micro-brewery" (what are *those*?) to produce up to ten thousand barrels of craft beer per year. It was such an unknown topic at the time that this author's digital newspaper search of most available Kansas newspapers during the 1986–87 period, in which the law was written by the legislature and passed, yielded only one mention of a "microbrewery"[31] and only one mention highlighting the then thirty-one-year-old Chuck Magerl discussing a "micro brewery."[32]

There have been many tweaks and additions outlining the alcoholic beverage laws to the state since then, and they will surely be modified and tweaked as the years go by. But for the purposes of this book, it was important to place the historical context and importance of where the state originated in its thoughts and beliefs regarding alcohol consumption, how these changes were affected over time by outside historical events and religious mores. The excesses of alcoholic consumption by some and the negative images of the rowdy and boisterous saloons during the late 1800s helped push the deeply religious prohibitionists to rally against the evil "Hell Broth" as Carry Nation reminded everyone. But over time, and with the unintended consequences of both state and national prohibition, the state's laws have evolved to where we are today.

Please enjoy reading about the current, and growing state breweries, knowing that it has been a long struggle to get to where they are today. Each has a unique story and is the result of passion for the craft and a great entrepreneurial spirit. All are homegrown and started by risking a great amount of personal time and debt. None of these breweries highlighted is a national chain or franchise—all were started in the great state of Kansas for everyone to enjoy.

PART II

THE BREWERIES OF KANSAS

WESTERN KANSAS

THE OLD WEST

GELLA'S DINER & LB. BREWING CO.

Category: Brewpub
Address: 117 East Eleventh Street | Hays, KS 67601
Phone: (785) 621-2739
Web: www.lbbrewing.com
Facebook: www.facebook.com/LbBrewing
Hours: Sunday–Thursday, 11:00 a.m.–10:00 p.m.;
Friday–Saturday, 11:00 a.m.–12:00 a.m.

Located about two and a half miles south of I-70 in the heart of downtown Hays is Gella's Diner and Lb. Brewing Company. The red brick exterior along a brick-paved Eleventh Street gives a charming and old-time feel to the building. But once you enter, prepare to be immersed in a wonderfully open and completely renovated interior. Its ten thousand square feet combines four previous and distinct storefronts, or businesses, into one open area, which is unique among all breweries in Kansas. To honor the past businesses, it displays much of the original wood floors and trusses from the previous establishments in one large dining and brewing area. The existing buildings, incorporated and beautifully integrated into the new restaurant and brew house, were solid and built between 1919 and 1938. Much of their individual structures is still observable inside. These past

buildings combine to form a modern and thriving brewery and restaurant space. The interior is wonderfully decorated with murals from Fort Hays State University students as well as Kansas-themed artwork. Of course, the brewers have also posted the many beer banners and medals they have earned over the years.

The establishment itself was part of a specific effort by a private equity company called Liberty Group. Launched by a Fort Hays State alum in 2005, Gella's and Lb. have been instrumental in revitalizing many historic urban areas in Kansas. They saw the opportunity in historic downtown Hays and brought together a number of investors with the intent to build a successful cornerstone restaurant. This establishment would act as a revitalizing agent to further attract businesses to downtown Hays. A restaurant and microbrewery was conceived from the beginning, serving top-notch food and craft beers that meet the exacting standards of the city's German heritage. The name *Gella's* is derived from southern German slang *gell*, which means "yes," "right" or "isn't that so?" and Lb. stands for "Liquid Bread," as beer and bread share many of the same ingredients. We've all wondered which came first—beer or bread—and as beer drinkers, we allow ourselves to believe the first bread was actually spilled fermented beer dried, and baked, on a hot stone.

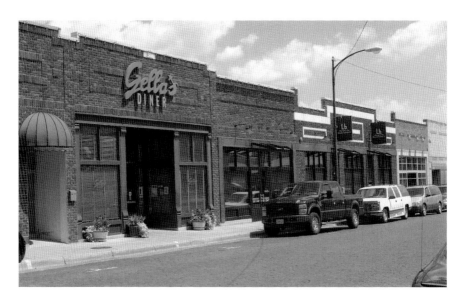

Gella's Diner and Lb. Brewing in picturesque downtown Hays. *Bob Crutchfield.*

Lb. Brewing likes to focus on clean German lagers and ales, nice thirst-quenching Midwest beers for a sophisticated customer base. After all, Hays is a heavily German-influenced city in the middle of the heartland. Because their customers know beer and can detect subtle differences, the brewers at Lb. know they have to make it right. Head brewer and brewery manager Brendan Arnold shared, "Around here, we try to be very traditional with the styles. We're brewing 'liquid bread' here. We try to make really clean, Midwestern, traditional beers. We try to focus American craft beers and German beers to supplement the heritage here. You don't see a lot of people going to the extent of doing the amount of German beers we do." Always striving to keep their beers consistent and true to style as possible, they don't do a lot of beer with adjuncts but do play with these from time to time. "We try to stay true to the roots of the community."

Lb. also feels it has one of the prettiest brew houses in Kansas, very well organized—no fighting for space. The brewers' effort to maintain quality controls is among the highest seen in all of the breweries in Kansas. Everything in the brew house, visible from behind the bar, is rigorously cleaned and sanitized. This includes the floors, tanks, hoses and so on. Clean rubber boots are a must before entering.

The brewers' attention to detail and quality paid off right from the beginning. Former master brewer and co-founder Gerald Wyman had been a homebrewer for over eight years before starting up things here. He developed the main recipes, designed the brew house and brought the system into production. Only four months after opening in 2005, Lb. entered and won its first of nine professional brewing medals at the Great American Beer Festival (commonly just referred to as GABF) in Denver. Competing against fifty-six other entrants in this category, it earned a silver medal for its **Oatmeal Stout**.[33] In an almost unheard of accomplishment for brewers, Lb. Brewing won a gold medal for its **No. 50 Liberty Stout** in both 2009 (twenty-two entrants)[34] and 2010 (twenty-seven entrants).[35] Also, in 2010, Lb. Brewing won a gold medal at the World Beer Cup for its **No. 06 Oatmeal Stout**. In 2012, it beat twenty-nine entrants to earn a bronze medal for **No. 2 American Style Wheat Ale**.[36] In 2013, the brewery won a gold and silver for the **No. 9 American Hefeweizen** and **No. 2 American Style Wheat Ale**, respectively.[37] This double play earned the brewery the Small Brewpub and Small Brewpub Brewer of the Year awards that year. Lb. was the first Kansas brewery to earn such a prestigious award in the professional brewing world.

The brewery recognizes that quality beer must have quality ingredients and, most importantly, the best water you can find. Lb. Brewing brings in

over 1,200 gallons of water from the nearby Ogallala aquifer several times a week. The brewers feel this water provides a superior basis, or foundation, to the malts and hops they use in the brewing process. As evidenced by their numerous awards, it could very well be the thing that allows their beers to excel over others.

All of their brewing output from the ten-barrel system is consumed on-site, either in the bar area or in Gella's restaurant. Anyone wanting their specialty beer has to come in. This is in keeping with the original mission to help drive business to downtown Hays. Gella's and Lb. have up to twenty-two taps serving craft beers at any given time. To no one's surprise, the most popular flagship, or year-round, beer is the 2013 GABF-winning **American Wheat** beer. The other flagship beers are the **No. 1 Pale Ale, No. 3 Amber Ale**, award-winning **No. 6 Oatmeal Stout, No. 8 Lemon Ale**, award-winning **No. 9 American Hefeweizen and No. 61 Grapefruit Radler**. But Lb. also crafts nonalcoholic drinks available year-round such as the **Handcrafted Root Beer** and **Crème Soda**. The brewers make two to three unique and interesting German lagers a year, such as Maibach, Rauchbier or Schwartz Biers. Lb. also likes to offer new and fun seasonals each week on its half-barrel system to keep the craft enthusiasts educated and coming back for more. Each month, they brew a full ten-barrel batch of one of their rotating seasonals. You can check the web page for the great selection of seasonal beers brewed and in rotation. There are between fifty to sixty different kinds with descriptions to browse.

Many feature articles have highlighted Gella's or Lb. Brewing over the years. One of more recent national online publications to recognize them was in 2014 when *Huffington Post* included the brewery/restaurant in a list titled "One Thing You Must Do in Each State." The one thing recommended for travelers to Kansas was a trek over to Hays to sample the award-winning No. 6 Oatmeal Stout at Gella's Diner and Lb. Brewing. Pretty high praise!

Future plans for Lb. Brewing are being discussed, with the possibility to potentially expand if the current capacity becomes an issue. Brendan notes that they have "additional space in the brew house to add capacity when it makes sense." So, until then, you'll want to come in to enjoy the fun seasonals and the large offering of award-winning craft beers.

DEFIANCE BREWING COMPANY

Category: Microbrewery and Taproom
Address: 2050 East Highway 40 | Hays, KS 67601
Phone: (785) 301-BEER
Web: www.defiancebeer.com
Facebook: www.facebook.com/DefianceBrewingCo
Email: info@defiancebeer.com
Hours: Wednesday–Thursday, 4:00 p.m.–8:00 p.m.;
Friday, 3:00 p.m.–9:00 p.m.; Saturday 3:00 p.m.–9:00 p.m.

In an unassuming metal industrial building located on old Highway 40 just before the Hays airport is Defiance Brewing Company. The company was started in December 2013 by partners Mathew Bender and Dylan Sultzer, who met at another area brewery. They had brewing experience and wanted to make a go of it on their own. The two are young and determined and wanted to make beers that similarly represented their notion that any beers they produce should likewise be ambitious and defiant. Not unlike themselves.

One of the largest in the state, Defiance Brewing started big and built a large distribution-focused brewing facility comprising a twenty-barrel brew system with multiple forty-barrel fermenters and matching brite tanks. Bender and Sultzer brewed their first batch of beer on December 2, 2013, and made it available for sale the next month. Their taproom opened the following year, in May 2015. Since opening, they have had very strong demand for their beers, not unlike other brewery startups in the state, and have quickly exceeded planned production goals. Initially focusing on distribution through kegs to area restaurants and bars, Defiance soon added a canning line, which allowed additional capacity to feed distribution and, in turn, grew the brewery's area of availability to a wider area of the state, covering much of western Kansas.

As Defiance has grown, and more people have had a chance to try Bender and Sultzer's beers, they expanded distribution across the state and into Nebraska and

Defiance Brewing Company in Hays. *Courtesy Defiance Brewing Company.*

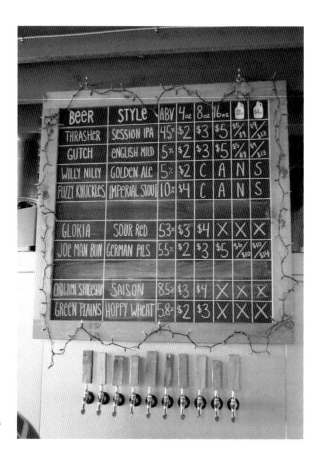

Defiance Brewing taproom board showing off the brews available. *Bob Crutchfield.*

parts of Missouri. In one of those "you could never plan for this" moments, they were surprisingly discovered by a distributor in Pennsylvania of all places. The distributor liked their beer, made the distribution arrangements with Bender and Sultzer and is now a regular client. This puts Defiance Brewing cans in Pennsylvania and New Jersey. It's interesting to see the distribution map on www.ratebeer.com, which shows the beer's availability in a line of stores between Reading down to Philadelphia and even over in Trenton, New Jersey. Defiance has even received feedback from folks who have come across its cans, with their unmistakable eye-catching artwork, as far as New York City.

Once you get to sample Defiance's beers and understand its brewing styles, it should be no wonder why the brewery has become so popular and spread so quickly. Along with nearby Lb. Brewing, Defiance is putting Hays on the map in the beer world. In fact, in 2017, *Thrillist* magazine highlighted Defiance as one of the most underrated breweries in the state.[38]

Defiance beers stand out against the other, more conventional, craft beers on the market these days. They have flagship beers like **Gutch Mild Ale**, **Fuzzy Knuckles Stout**, **Willy Nilly Golden Ale**, **Joe Man-Bun Pilsner** and a popular go-to IPA called **Thrasher**. The brewers love India Pale Ales (IPAs) and like to toy with the hop-heavy brews. They also have a half-barrel pilot system in-house and make one-off variations to try out in their taproom. If it gets enough acceptance, they consider moving it up to a production-level output. Either as a destination stop on your beercation, or if driving along I-70, it makes sense to stop in for a visit to Defiance's taproom and try out one of the awesome seasonal or experimental beers. Oh—they also offer a double IPA called **Awesomeness**!

The owners are planning to get into sours and barrel-aged beers to round out their offerings. These are becoming quite popular after the big IPA market boom over the last few years.

BEAVER BREWERY AT MO'S PLACE

Category: Brewpub/Nanobrewery
Address: 1908 Elm Street | Beaver, KS 67525
Phone: (620) 587-2350
Web: www.beaverbrewery.com
Facebook: https://www.facebook.com/beaverbrewery
Email: Aust.bell@gmail.com
Hours: Thursday–Saturday, 11:00 a.m–9:00 p.m.

A recent favorite for pub crawlers and the adventurous beercation tourists is little Beaver Brewery at Mo's Place. It's probably the smallest community in Kansas, maybe the country, with a nanobrewery—a fun destination for those willing to put in some hours along the Kansas highways and back roads. It's located in the middle of western central Kansas in an unincorporated community called Beaver in Barton County. For reference, to get to it from Interstate 70, it's about thirty miles east of Hays and about eighteen miles south of the Bunker Hill exit a few miles before Russell. There are only about two dozen persevering Kansans living here now (down from 423 back in the late 1800s)[39] but it sports one of the area's favorite destinations for good craft beer and home-cooked meals.

You have to make an effort to get here, but it's well worth it. Beaver Brewery at Mo's Place in tiny Beaver, Kansas. *Jim Crutchfield*.

If you can find Beaver (sometimes incorrectly labeled on maps as Claflin), then you can't miss finding Mo's Place. It's located in the shadow of Beaver Grain Corporation's large silo, which can, like many others in western Kansas, be seen for miles away. If it weren't for the prominent silo, Beaver would be one of those classic "don't blink or you'll miss it" towns.

But fair notice is being given: don't miss checking this brewery off your breweries to visit list. For what it takes in effort to hunt down, it easily pays back with dividends from the great experience gained.

Mo's place started back in 1999 when Linda and Leonard Moeder decided to leave the hectic Silicon Valley area in California and move back to their roots (Leonard was from nearby Hoisington) and live a more laid-back existence away from the rat race. They were able to purchase a home and the bar across the street for a fraction of what it would cost in California. At the time, the bar served food and sold 3.2 beer. The Moeders decided to step up the game a bit by applying for a brewing license and start selling their own beers. Finally, after they were able to meet the Kansas regulations stipulating residency, they were granted their brewing license in 2004 and began brewing. Beaver Brewery was born at this time and remained in operation for about ten years until the Moeders decided to retire. It was put on the market in 2014 and sat until purchased by Dale Kaiser and Austin Bell in 2016.

Austin, whose grandmother lived in Hoisington, recounts the story about her telling him about this brewery up in Beaver. He thought she was crazy.

"A brewery in Beaver?" At her invitation, on his next visit, he met up with her at the brewery and "darn if she wasn't right." He found her at a table with a flight of Beaver's craft beers.

At the time, Austin was working in Kansas City as a teacher and, on the side, at a Westport bar and restaurant with his buddy Dale Kaiser. Dale, who also had roots in Hoisington, had been working as a cook and bartender for twenty-one years. After hearing about the place from Austin's visits and then learning that it was for sale, he told Austin, "If you want to buy it and open it back up, I'll go with you." They both agreed it would be a great change of pace and lifestyle to get away from what they were doing in Kansas City and start a new life out in Beaver. In 2016, they bought the business for $60,000 and have successfully reopened it, to the delight of area residents, who had become accustomed to dropping in for a beer after a long day's work.

Having no beer-making experience, they both got, as part of the sale, two lessons on each of the seven beer recipes the Moeders had been brewing. The brewing system the partners use is classified in the industry as a nanobrewery. (*Nanobrewery* is not an official definition but commonly refers to a brewery that produces no more than three barrels of beer in one batch.) They have two twenty-gallon fermenters and generally brew about forty gallons of craft suds a week, most of which is gone before they are ready with their next batch. With eight taps running their own seven batches and one visitor tap, they just keep ahead of the weekly demand. Dale and Austin are both working longer hours than they did back in Kansas City but enjoy being their own bosses. It's hard but satisfying work to keeping the beer fresh and available for the thirsty ranchers and oil workers in the area. Their year-round beers are the **Beaver Creek Brown** pale ale, **Crazy Hawk Red** ale and the **Harvest Moon** wheat ale. And don't forget to try some of the food. Ask about their signature hamburger: "The Tommy Rocket." You won't leave hungry!

DODGE CITY BREWING CO.

Category: Brewpub
Address: 701 Third Avenue | Dodge City, KS 67801
Web: www.dodgecitybrewing.com
Facebook: https://www.facebook.com/dodgecitybrewing

Email: larry.cook@dodgecitybrewing.com
Hours: Wednesday–Friday, 4:00 p.m.–10:00 p.m.;
Saturday, 11:00 a.m.–10:00 p.m.; Sunday, 11:00 a.m.–8:00 p.m.

As Bill Murray once tweeted, "If cold beer and pizza can't fix your problem, ask yourself if it's a problem that really needs to be fixed."[40] Dodge City now has a place to fix problems thanks to Larry Cook. Dodge City Brewing opened a beautifully constructed eighty-seat craft brewery that also serves brick-oven pizzas. It opened in June 2017 and is located in the historic downtown area at the bottom of what some of the locals affectionately call "Booze Hill." It has an open and airy design with glass garage door–style windows and an outside patio space. The kitchen, with its seven-hundred-degree imported Italian brick oven, and the brewery room are on display for all patrons in the taproom to admire.

Larry grew up in western Kansas but was working in Wichita in the late 1990s as an accountant. One of his clients was Goebel Liquor's owner Rob Miller. Goebel Liquor was, and remains, a popular retailer in Wichita that provides an extraordinary offering of craft beers. Larry started traveling with Rob to various brewers in the region. His goal was to get one thousand beers in his store from wherever they could get them. Larry enjoyed doing this for nearly ten years, and along the way, he caught a serious case of the craft beer bug. At the same time, Larry began homebrewing. His wife was very supportive, and "she allowed me to buy three different freezers to use—two for fermenting, one for kegs," according to Larry. Being interested in craft beers, beer styles, how they were made and what the essential differences were, he set a goal of trying to brew all of the beer styles (which, at the time, was more than eighty different homebrewing classifications). He also studied and became a certified beer judge—an accomplished feat in itself.

He became friends with many in the Wichita brewing community and, because of his craft brew knowledge and enthusiasm, was prodded to start his own brewery by many local friends and beer enthusiasts. This also came with some offers to help from the owners of Wichita's Central Standard Brewing. They were willing to mentor him on anything he needed to get his commercial brewery successfully off the ground. He and his wife figured Dodge City would be accommodating, as theirs would be the only brewery in Southwest Kansas. In fact, Larry said it's the only brewery between Hays (the closest to the north) and Amarillo and the only brewery between Wichita and Pueblo to the west. They decided to take the plunge and opened their

It's a great day to drink beer on the patio outside Dodge City Brewing in Dodge City. *Bob Crutchfield.*

own place in the historic downtown district. Everyone in town bent over backward to help get them open. The brewery name choice was obvious, but the logo and mascot is a unique design of a cowboy with a hop beard. It has become recognizable and fits the historic gunslinging area the Cooks now call home. They had the brewery designed and built on the grounds of a vacant lumberyard at the corner of Third and Spruce. Larry installed an all-electric five-barrel system from the same company as Central Standard's initial brew setup. The chef at Radius Brewing in Emporia hooked Larry up with the same oven the brewery uses. The Cooks had to go to "pizza school" in New York to learn how to make delicious pizzas using their system. The oven was manufactured in Italy and sold to them by the New York Brick Oven Pizza Co.

"Owning and managing a brewery is hard but satisfying work" Larry relayed. He figures he's working more hours than he did as a CPA but admits that owning your own business is a work of love. The result of this hard work has put Dodge City Brewing on the map with a lot of traffic from tourists going to the Boot Hill Museum and the Boot Hill Distillery. They've also had craft beer aficionados from many states, as well as Canada, dropping in to check them out.

Left: Great beer and one of the coolest Kansas beer logos can be found at Dodge City Brewing. *Bob Crutchfield*.

Below: Dodge City's first brewery in over 125 years. (Festus Haggen would be proud to come here!) *Bob Crutchfield*.

Larry personally likes his **Space Cowboy IPA**, but **Uncle Johnny's Cream Ale** is his biggest seller now. "We have some light drinkers out here—got to do some training!" he said with a smile. He offers his own classic pilsner, **Samurai Cowboy**, but the cream ale is the first rung on the craft beer ladder from the widely sold pilsners (Budweiser, Coors and so forth). He's had to double up on the cream ale and pilsner production just to satisfy the local demand. As a brewer, he wants to offer a different take on the wheat beers. "Everybody's got a wheat," but Larry plans to introduce a Helles to replace the Witbier. "We plan to keep four beers on a regular basis and two seasonals based on storage." He has two brite tanks for conditioning and six chilled brite tanks, which directly feed into the taps. Dodge City Brewing doesn't have plans to do a lot of distribution, but Larry concedes he will allow some of his beers to be available on tap at a select few establishments in town. Other than that, you'll have to come in to experience his beers or take them home in a growler.

NORTHEAST KANSAS

WHERE IT ALL BEGAN

FREE STATE BREWING COMPANY

Category: Microbrewery and Brewpub
Address: 636 Massachusetts Street | Lawrence, KS 66044
Phone: (785) 843-4555
Web: www.FreeStateBrewing.com
Facebook: www.facebook.com/FreeStateBrewing
Email: fsb@freestatebrewing.com
Hours: Monday–Wednesday, 11:00 a.m. to 11:00 p.m.; Thursday–
Saturday, 11:00 a.m.–12:00 p.m.; Sunday, 12:00 p.m.–11:00 p.m.

Because without beer, things do not seem to go as well.
—*diary of Brother Epp, Capuchin monastery, Munjor, Kansas, 1902*

Opened in 1989, Free State Brewing was Kansas's first legal brewery
since the state voted in prohibition in 1881. Its main site, and where it all
began, is a brewpub located on Massachusetts Street in Lawrence's historic
downtown district. It also has an auxiliary production brewing and bottling
plant south of downtown on Moodie Street. The downtown building in
which the brewery resides was originally built in 1915 as the Lawrence depot
of the Kaw Valley trolley line and still retains much of the architectural
character from the original brick and stone building. It offers a complete

menu of wonderful food and an extensive lineup of seasonal and year-round flagship craft beers. Its long been a preferred go-to spot for the community, including Kansas University students, to grab a bite and enjoy some of the state's best, and for a long time, *only* locally made craft beer.

Chuck Magerl opened the brewery soon after Kansas voters finally overturned the state's century-old prohibition on liquor by the drink in a constitutional amendment back in 1986. Much can be said about Chuck spearheading the efforts to open Kansas's first brewery after such a long period. But before we discuss Chuck, everyone reading this should raise a glass of your best Kansas-made craft beer, preferably a Free State beer, and give Chuck

Chuck Magerl, owner of Free State Brewing, Lawrence. *Bob Crutchfield.*

a nod of appreciation for helping push and guide the subsequent legislation approving the category of *microbrewery* as an approved licensed entity by the state. The way it happened was that Chuck, back in the mid-1970s, while attending Kansas University, stumbled on to some historical literature on Kansas's early years and the fact that breweries existed in the territory even before it became a state. Intrigued, he began researching the history of brewing in Kansas and learned of the large number of early breweries in the state. As saloons were often one of the first establishments built to provide a place where men could gather to conduct business and share a drink, so arose the opportunity for breweries to support them.

As a young man, Chuck had been homebrewing since before it was even legal (President Carter signed H.R. 1337 legalizing homebrewing in 1978) and had a keen interest in perhaps starting his own place if he could get legislation passed allowing it. He toured some of the country's first microbreweries along the West Coast and thought Kansas could do the same. But first he would have to lobby the legislature to incorporate the language allowing for microbreweries. With the 1986 vote to usher in new liquor laws, the legislature in Topeka had to rewrite everything. The Liquor Law Review Commission was established, and Chuck made it his mission to make sure the new laws coming out of the commission allowed for the formation of craft breweries in the code. It was not an easy

task. Chuck wrote a letter to the commission in favor of microbreweries, and some of his language was accepted in sections of the early legislative draft proposals. After this, he was invited to the table for senate committee hearings. It quickly became his mission to work with and educate the state legislators on the benefits of Kansas having its own breweries. Most of the representatives didn't really understand what a brewpub or microbrewery was. Remember, this was when the big brewers were almost the only source of beer across the country. Everyone knew of Coors, Busch and Budweiser, but starting an independent brewery in Lawrence, for example, was just not something they even understood or cared about. Chuck began to educate every representative on the merits to the local community and cities in which breweries might reside. He finally gained an ally in Topeka with Senator Winter, who introduced a bill that included wording based on Chuck's inputs. Next, the chairman of the committee was sold on the concept and was able to get the bill to the floor. By way of a compromise with the dry proponents and other interests, the legislators changed the value proposition from the "advantages of having the brewery in a given community" to the benefits gained from having at least 50 percent of the products involved in making the beer come from Kansas products, thus benefiting the Kansas farmer. With a compromise made with the Kansas Wholesalers lobby providing that all brewery beer shipped to restaurants and stores must go through distribution, the bill finally crossed the finish line on April 8, 1987, by a vote of 30–10 and was subsequently signed by the governor.

With the long fight over, Chuck was cleared to launch Free State Brewing in Lawrence. The name "Free State" harkens back to early Kansas and its association with the German immigrants who often referred to their homeland. "It [southern Germany] used to be called the Bavarian free state," said Chuck. The name seemed fitting, a way to pay homage to the early immigrants who brought a little bit of Germany with them upon settling here. The slogan seen on many Free State products—"Because without beer, things do not seem to go as well"—comes from the 1902 diary of Brother Epp, who was part of the Capuchin monastery in Munjor, Kansas, southeast of present-day Hays. It was one of several settlements by Volga German immigrants from southern Russia. Brother Epp wrote about the small, and very illegal, brewery and icehouse he and the monks had built years after Kansas was under the state's prohibition laws. In his diary, he stated that the monastery felt justified in doing this because shipping beer into the state would be costly and arouse suspicion. So *of*

Author (*left*) and wingman Allen Broome enjoying some of the fine beers from Free State Brewing at the Kansas City Brew Festival at Union Station. *Bob Crutchfield.*

course it should be established on the premises. Not having beer was not an option for them. The quote just seemed appropriate and is now one of the more famous beer quips cited.

As part of the newly passed legislation allowing for microbreweries, the legislature made another requirement—any county could impose a rule requiring that at least 30 percent of revenue from any brewery come from food sales. Douglas County required this, and thus Free State opened its brewery with a full restaurant in the current location. Visitors can still see the original, and still in use, brick-lined brew kettle though a glass window adjoining the restaurant and bar area. With Chuck's background in biology and engineering, he began brewing beer with the same attention to detail and quality he follows today. Free State keeps the sense of pride in its beers being a quality craft beer. He wants everyone to know you get *great* beer here. Chuck said with emphasis, "Don't think you can just get good beer from California or Colorado." Free State's success and longevity bear this out. It has grown from a small brewery on Massachusetts Street to a leader in the regional craft beer market. It distributes to the entire state in addition to Missouri, Nebraska and Iowa. Chuck relays that he wants Free State's beer to stay in a tight local distribution area so it can control and influence

its quality. If it gets too far away, it's more difficult to assure its freshness. He, and his brewing staff, want to keep a close watch on what they have on the shelves and distributors' inventory to make sure it's always fresh. "You're really not in the brewing business until you have a line item in your ledger to buy back beer" said one of Chuck's longtime brewers.

By 2009, Free State had outgrown its downtown brewery capacity and started a new production facility to meet demand. It bottles its biggest sellers here for the distribution market as well as providing certain fresh kegged beers to the original brewery taproom. The biggest-selling flagship beers are either Ad Astra or Copper Head ale. Ad Astra, by the way, was the first beer brewed in the state since the last brewery in the state stopped brewing over one hundred years prior. The Octoberfest beer is the largest seller during the fall each year.

Free State offers a large variety of great seasonal beers at the brewery downtown, some of which are also available in distribution. In 2015, the seasonal beer **Garden Party** lager won a gold medal in the Herb and Spice Beer category at the Great American Beer Fest. A sampling of other popular seasonals are the **Cloud Hopper IPA, Hy-Wire IPA, Yakamaniac IPA, Freestate Golden** and **Homestand Helles**. Just visit the website to see what is currently on tap. Regardless of your palate for craft beers, you are sure to find one that you will enjoy and that go over well, "because without beer, things do not seem to go as well."

THE BLIND TIGER BREWERY AND RESTAURANT

Category: Brewpub
Address: 417 Southwest Thirty-Seventh Street (Thirty-Seventh and Kansas) | Topeka, KS 66611
Phone: (785) 267-6759
Web: www.BlindTiger.com
Facebook: www.facebook.com/TheBlindTigerBreweryandRestaurant
Hours: Sunday–Thursday, 11:00 a.m.–11:00 p.m.;
Friday–Saturday, 11:00 a.m.–12:00 a.m.

In May 1995, only a few short years after Kansas legalized liquor by the drink and new entities called microbreweries, the Blind Tiger Brewery

and Restaurant was opened by a handful of partners in south Topeka. Taking a risk, they installed a large fourteen-barrel direct-fire system, making it the first brewery in Topeka and the largest brewery at the time in Kansas. The restaurant and brewery were built into a one-hundred-plus-year-old stone farmhouse that the owners have preserved and added onto over the years. The exterior stone walls of the original stone house are still there. But over time, the original structure was modified with a patio and additional rooms to accommodate additional brewing tanks and seating areas for the restaurant.

Their name "Blind Tiger" comes from a Prohibition era (1920–33) custom of the time. In the southern vernacular, a *tiger* was a roaring party, and drinking establishments that sold illicit alcohol after hours would set a stuffed pig or tiger in one of the windows.[41] These tigers were deemed to be *blind* because the authorities "officially" did not know they existed. Of course, many of the town's authorities could be found among the patrons inside.

The current owner, Jay Ives, purchased the Blind Tiger in February 2007 with the notion that the beer was already good but the place needed better food and a larger presence in the community. He met and immediately hit it off with the award-winning brewmaster John Dean. Jay said, "I would not

Main entrance to the Blind Tiger Brewing, Topeka. *Bob Crutchfield.*

have purchased the place unless John stayed," and John agreed: "I wouldn't have stayed unless Jay remained as owner." Both obviously complement each other and are committed to the success of Blind Tiger for the duration. John, now a part owner in the company, has been the brewmaster here since late 1998 and is one of the most awarded brewers in the state. At the time of publishing, John has earned at least twenty-two national and world awards for his beers. He won the prestigious Champion Brewer at the World Beer Cup in 2014 (Large Brewpub division), and the brewery won the Champion Brewery award in the same year. John's Munich Dunkles won a gold award, and his Maibock won silver. In fact, in the same year, John's Basil Beer beat out 150 other beers and won a gold medal at the Great American Beer Festival. He was most recently awarded the Kansas Craft Brewer of the year and another bronze medal at GABF for Blind Tiger Bock in 2018. With the number of awards John has earned, it is apparent he is very confident in his beers and not afraid to compete. "Go ahead and rate us against any other brewery if you want," John boasted. He is not afraid to put his up against anyone's. A list of all of the Blind Tiger beer awards can be found on its website.[42] Jay added, "Brewing is an art—and we have Rembrandt!"

Topeka has a large German community and that is reflected in the Blind Tiger's beers. John has traveled to Germany several times and brewed beer in a wood-fired traditional brewing style. Picking up techniques and tips, he brought them back to Kansas and incorporates them into many of Blind Tiger's seasonal beer offerings.

The building has an interesting history. It was originally a stone farmhouse erected in 1890 and was the heart of a working farm until 1959, when it was converted into a restaurant called McFarland's Hilltop Café. Over time, it went through series of business transformations, closing then reopening as a discotheque, then a dinner theater and eventually a steakhouse. In 1979, when Kansas liquor laws changed, allowing private clubs to offer reciprocal memberships, it became one of the most reciprocated memberships in the state. You could go almost anywhere in the state and drink at the local private dinner club as long as you had a membership to this Topeka steakhouse. Current owner Jay Ives recalled that "the owner at the time issued hundreds of thousands of memberships across the states for $10 apiece. It took a lot of driving and effort to sign everyone up, but the money began pouring in by mail each week." The good times didn't last forever though, because when the 1987 liquor by the drink law was passed, the reciprocal private membership law went away. With this large source of revenue gone, the owners decided to close for a while. Eventually, after seeing what was being

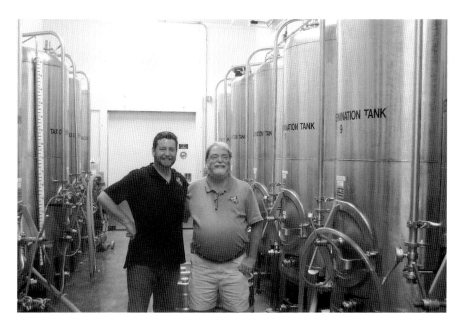

Award-winning brewer John Dean (*left*) and owner Jay Ives at the Blind Tiger. *Bob Crutchfield*.

done by Free State Brewing and others outside of Kansas, they decided to take the risk and reopen as a microbrewery.

As a way to give back to the Topeka community and also pay homage to the tiger behind the logo, the Blind Tiger supports the local zoo's Sumatran tigers. A percentage of all Tiger Bite IPA is given to the Topeka Zoo for their care. Some of the money also goes toward park ranger salaries in Sumatra to help protect the indigenous tigers.

The brewery emphasizes handcrafted beers. Jay proudly stated, "A lot of sweat and care go into making them, so there is not a big emphasis in automation." He and John feel that heavily automated brewery systems lose some of the brewing craftwork and attention to detail. Here, they load the grain by hand and shovel out the spent grain in a wheelbarrow. With all the brewers' hard work, the business continues to grow in beer sales each year with production exceeding 1,500 barrels per year (bbl/yr) with about 90 percent being consumed on premises. John likes to brew his award-winning beers with their original direct-fire brew system. "Steam is a fickle mistress," he said with a smile. With a large menu of seasonal and barrel-aged beers, Blind Tiger keeps customers coming back for more. A recent capacity expansion has increased the cold room area to allow a dozen additional

brite tanks, which serve the taps. This also allows ample space for lagers to condition before being tapped in the restaurant.

Speaking of the quality of Blind Tiger's beers, John noted that "we are blessed with the best water in the country." They need only to filter out the chlorine and it's good to use as a base ingredient. "Water here trickles over limestone, buffalo and dinosaur bones and picks up everything it needs." John added. Speaking of buffalo, all the spent grain is picked up by a local rancher to feed to his bison herd. Every year, several bison from the same herd are harvested for the restaurant. The bones are saved and brought to the Sumatran tigers at the zoo to enjoy. The owners even have one of the harvested bison hides hanging in the restaurant. This is the "circle of life—the Blind Tiger way," according to John.

As part of the brewery brotherhood, John has also invited the two new breweries in Topeka (Happy Basset Brewing Co. and Norsemen Brewing Co.) to gather for regular meetings and drink one another's beers. They call themselves the Topeka Anti Prohibition Society (TAPS) and have a great time with it all. They even collaborated on an inaugural lager beer for their brewery grand openings. They named this beer the Topeka Beermuda

Kansas bison eating spent grain from the Blind Tiger. *Courtesy Brittany Johnson.*

Triangle lager because "if you start here at the Blind Tiger and draw a line west to the Happy Basset, then north to the Norsemen, then back to us you'll see the Topeka Beermuda Triangle!" laughed John. The initial collaboration was brewed employing the old-style brewing methods as much as possible by using whole hops and a lager yeast, but fermented at ale temperatures, then cold conditioned for about seven weeks. It resulted in a delicious amber lager beer.

John has between two hundred and three hundred beer recipes and makes his seasonals based on what he wants to drink that day. With a large number of beers on tap, Jay and John are always talking to the customers to get feedback.

The Blind Pig's flagship beers are **County Wheat**, **Raw Wheat**, **Raspberry Wheat**, **Holy Grail Pale Ale**, **Tiger Bite IPA** and the **Tiger Paw Porter**. Its specialty beers are the **Top Gun IPA** and **Maibock**. All of these are available in distribution to select bars and restaurants in the Topeka area. Of course, there are many different specialty beers throughout the year—whatever John feels like making.

Trying to categorize the biggest sellers for Blind Tiger is "kind of tricky," says Jay. It is generally a foot race between the Wheat, Kolsch, Top Gun (IPA) and Pale Ale. The brewers start with the original Raw Wheat, then filter the yeast in solution to make County Seat Wheat and from this can add natural locally sourced adjuncts to make beers such as Raspberry Wheat. There's always something new and interesting brewing here!

Brew Lab

Category: Brewpub and homebrew supplier
Address: 7925 Marty Street | Overland Park, KS 66204
Phone: (785) 325-3300
Web: www.brewlabkc.com
Facebook: www.facebook.com/brewlabkc
Hours: Tuesday–Thursday, 3:30 p.m.–10:00 p.m.; Friday–Saturday, 11:00 a.m.–11:00 p.m.; Sunday, 12:00–4:00 p.m.

In the heart of historic downtown Overland Park, just across from the farmers' market in Clock Tower Plaza, is a new microbrewer called Brew Lab. It's a unique concept whereby customers have the opportunity to come

Brew Lab in Overland Park.
Bob Crutchfield.

in and make homebrewed beer on Brew Lab's in-house systems and homebrew supplies guided by its experienced staff. It's been a great success and very popular with anyone trying to have fun and learning how to brew who doesn't want the hassle of buying their own equipment or making space at home. One of the four partners, Matt Johnson, explained that it is their attempt to "peel back the veil" of how beer is made in an easy and accessible environment. So far, it's been popular not only with individuals interested in making their own beer but also with corporate functions, bachelor parties and the like.

The concept for the business was hatched by four entrepreneurial professionals: Matt Johnson, Kevin Combs, Justin Waters and Matt Hornung. Among them are a college professor, an IT professional, an industrial real estate broker and developer and an accountant—and all but one with homebrewing experience. Together, they came up with the basic concept and figured it should be successful right here in Overland Park. They were doing "research" at a local pub one evening when they stumbled on a perfect name for the company. Matt relayed the story about sitting there with the guys going over the name and concept when someone at the next table overheard them and chimed in, "It seems like you guys are planning to create a brew laboratory!" Everyone thought the name was perfect, and it stuck. Brew Lab it would be.

The foursome originally opened in a smaller venue a couple blocks away from their current location back in 2013. Business was good and had steady growth until they outgrew that location. They found a larger venue on Marty Street and, in late January 2017, temporarily closed and began work to both expand and transform the business model. In addition to a homebrew supply store and brew lab experience, they planned to offer their own craft beers and in-house restaurant. They applied for, and were granted, the state and federal licensing to be a microbrewery, then incorporated a kitchen space and a dining area. Expanded space was also set aside for customers' brew lab systems. Renovations took approximately six months, and the owners finally had a grand reopening in June of that same year at their current site on Marty Street.

It takes about four hours brewing time for an individual or group to come in and brew up their own beer. The staff will then help transfer to wort into one of their temperature-controlled fermenters. Next up is to return in a couple weeks to bottle it. The team at Brew Lab provides assistance all along the way to ease the experience. Of course, while you are there, you can enjoy the Brew Lab's own variety of beers or food.

Being true to their brew laboratory concept, Brew Lab's flagship beers are still being developed. Matt and the partners, as well as staff, are listening to their customers and taking note of which beers are most popular. As they brew more beers and styles, the year-round beers will get locked in. They have eighteen taps and plan to dedicate eight to ten of them for their own beers, a couple for locally made kombucha (from Tea-Biotics) and the rest for guest taps. You can get growlers and crowlers here.

Not to gloss over the restaurant aspect of the business, Brew Lab has a smaller menu but an in-house chef who puts out some of the best scaled-up comfort food, or as Zagat describes it, "Elevated American Fare," in the area. The food gets great online reviews, including a 4.5-star rating on both TripAdvisor and Yelp.

Brew Lab's own craft beers are brewed on a gas-fired, three-barrel brewing system with six matching three-barrel fermenters and two six-barrel

Brew Lab sampling beers at the Kansas City Nanobrew Festival. *Bob Crutchfield.*

fermenters for the beers when they want to double batch. Each year, it holds a very popular homebrew competition called High-Plains Brew Hoff in the parking lot.[43] Nearly 120 beers were entered into the competition in 2017, with nearly nine hundred attendees. All of the beers are judged by the attendees. The winners are offered the opportunity to scale up their recipes on Brew Lab's three-barrel system and put it on tap for customers. What a great opportunity and experience.

Plans for the future for Brew Lab are to potentially release the more popular beers to limited distribution. But the owners primarily want to continue to grow in Overland Park while teaching the science of brewing to all who are curious and want to come out and have a good time.

23ʳᵈ STREET BREWERY

Category: Brewpub
Address: 3512 Clinton Parkway | Lawrence, KS 66047
Phone: (785) 856-2337
Web: www.brew23.com
Facebook: www.facebook.com/brew23
Email: Contact via Twitter: @23rdStBrewery
Hours: Daily, 11:00 a.m.–12:00 a.m.

Sharing the parking area of a strip mall in the south part of Lawrence but conveniently just a few miles from the University of Kansas is the popular 23ʳᵈ Street Brewery. It originally opened its doors under a different name, Sports Page Brewery, in 1995 soon after Free State Brewing paved the way for breweries in the state. The place changed names a few times since opening, and at one point, it had the same name—75ᵗʰ Street Brewery—as its well-known sister brewery in Kansas City. Eventually, it was bought out and reopened under the current name in 2006. It was the second brewpub in town offering fresh craft beer as well as a full restaurant and catering services. It has been successful and consistently offering great food and craft beer at this location ever since.

What its street presence may take, the brewpub's interior certainly gives in abundance. It is an architectural splendor with a soaring vaulted dome with beautifully organized metal trusses and warmly accented wood ceiling planks. A ring of wood-shuttered windows surrounds the dining

The beautiful interior of 23rd Street Brewery in Lawrence. *Bob Crutchfield.*

area, giving one the feel of a grand university reading room. Immediately upon entering, the patrons' eyes are drawn upward to take in the great space created for their experience. It perhaps gives them the impression they are entering the inside of a large grain silo or a small domed church. However, the most impressive feature of this brewpub is that the brew part of it is located above patrons' heads. 23rd Street has set up the entire brewing operation on the second level above the restaurant eating area for all to see. In a mastery of both available space and arrangement is a fifteen-barrel brewing operation. Several of the stainless steel brewing tanks are beautifully displayed for the patrons below, while part of the brew system is tightly tucked away from sight. Due to the tight space constraints upstairs, the brewery system and layout are arranged with just enough room to get the brewing work accomplished. It may be beneficial for any new brewing assistants here to first apprentice in a submarine in order to work in the available brewery space!

Many college town brewpubs become an extension to the school, and 23rd Street Brewery is no different. It closely tracks and promotes all sports and school events from nearby Kansas University. Ample "Rock Chalk" and Jayhawk logos and banners are prominently displayed throughout the restaurant. Seating here fluctuates wildly based on university attendance, with huge standing-room crowds prior to all KU basketball games. But this is not just another college town brewpub. Head brewer and longtime homebrewer Tucker Craig strives to provide premium-quality craft-brewed ales and lagers throughout the year. By focusing on the highest-quality grains and hops, Tucker and his brewing staff handcraft their flagship beers and a rotating variety of seasonal ones to create a draw to not only the local students and faculty but also all good craft beer consumers in the area. In fact, over the years, they have earned multiple awards for their beers. Among these was the prestigious silver medal at the 2007 GABF for an Irish red ale called **Crimson Phog**.[44]

In addition to its award-winning red ale, 23rd Street has inadvertently mastered the art of the unfiltered beer in a way that offers the consumer crisp, yet hazy beers, which are increasingly popular now. The brewers didn't really mean to focus on the unfiltered craft segment, and many of their offerings are quite clear, it's just that many of the original recipes came out of their system this way. The regular clientele likes them this way and, hey, if it's not broke, don't fix it, as they say. Tucker and the previous brewers decided that since the regulars appreciated the hazy beers, and have enjoyed them for years, they're not changing the recipes. In fact, most of their bestselling flagship offerings are all a little hazy. These are the **Wave the Wheat Ale**, the **Rock Chalk Raspberry Wheat** and the **Bitter Professor IPA**.

Its not just the hazy or interesting seasonal offerings Tucker creates that keep folks coming; the brewery has recently reached a unique agreement with Wood Hat Spirits of New Florence, Missouri, for a new barrel-aged beer line. 23rd Street brought in several bourbon whiskey barrels in a reciprocal collaboration of sorts whereby the brewery has agreed to use the wooden casks for barrel-aged craft beers and swap out barrels with the distillery for it to reuse to offer whiskey aged in beer barrels—very symbiotic and forward thinking for whoever thought that up!

23rd Street distributes to bars and restaurants across the entire state; however, most of the craft beers are sold in-house to meet restaurant demands. So, if you want to try the popular unfiltered year-rounds or the ever-changing seasonal craft beer offerings, you should trek over to taste them in person. Even if you're not a KU fan, you will have a genuinely unique and enjoyable experience here.

WAKARUSA BREWING COMPANY

Category: Microbrewery
Address: 710 Main Street | Eudora, KS 66025
Phone: (913) 256-5119
Web: www.WakarusaBrewery.com
Facebook: www.facebook.com/wakabrew
Hours: Thursday, 4:00 p.m.–9:00 p.m.; Friday, 4:00 p.m.–11:00 p.m.; Saturday, 1:00 p.m.–11:00 p.m.; Sunday 1:00 p.m.–9:00 p.m.

Tucked away in the small town of Eudora, midway between Lawrence and Overland Park, and located in the even smaller downtown is the

new home of Wakarusa Brewing. But don't be fooled into thinking it's not worth stopping. The brewers here make some seriously good craft beers considering the brewery's young age. Started in late 2017 by two homebrewing friends, John Radtke and James Hightree, it has some of the best craft beers in Northeast Kansas.

While John was living and working briefly in St. Louis a few years back, he was introduced to craft beers at a barbeque party and quickly became a Schlafly Brewing fan. Once he caught the craft beer bug, he returned to the Kansas City area and introduced James (his brother's best friend) to his Schlafly's addiction. James became hooked himself, and they both decided craft beer was what they wanted to drink at the end of a hard day's work. That turned into wanting to start making the craft beer themselves. Taking a different route, James had begun homebrewing just out of high school. As John tells the story about James with a wink, "You don't have to be 21 to buy yeast!" John followed suit a couple years later, brewing so many batches at home that he had, at one time, nearly fifty gallons' worth of different styles either fermenting or conditioning in his bedroom. Both began to create, and dial in, their own recipes to the point where they believed they had perfected them. With so many batches under their belts, the two longtime friends decided to take it to the next level and start their own brewery.

They looked for a place in the Kansas City, Kansas area only to find the properties either too expensive or with too many city regulations and oversight. In 2013, they stumbled on a small building in Eudora that could be picked up within their budget but required extensive rework. Not afraid of a little hard work, they purchased the property, rolled up their sleeves and went to it. It required a nearly complete rework, demolishing the old interior structures, adding new interior walls, installing new sewer and water lines, putting on a new roof and completing the new electrical lines. All of this was done to code (John is a licensed engineer in his day job) by the two entrepreneurs over the subsequent years.

John now handles most of the business end of things, while James takes on the head brewer roles most of the week. Although they currently have a three-barrel system, they tend to sell out anything they make relatively quickly. It's that good. They make a rotating variety of beers but usually try to keep their Oatmeal and Pale Ale on tap as flagships and will soon have the Belgian Wit and Chamomile Mead year-round too. Their seasonals tend to sell out quickly, especially their New England IPA and Raspberry Mead. They have six taps at the moment with several of their year-round beers plus whatever James last decided to brew.

John likes to make mead beer and will nearly always have some on tap each weekend. When asked about their customers' favorites, John remarked that you can't always match a customer to flavor preferences. "One time we had a large group of burly bikers show up. All had beards and looked as tough as you might imagine. Their whole table ended up drinking the Raspberry Mead the whole night!"

So, when traveling between Kansas City and Lawrence along Interstate 10, give yourself a treat and take a short departure up to Eudora and stop in on Wakarusa Brewing. It's a small but quiet place to kick back and enjoy some great fresh craft beer selections.

RADIUS BREWING

Category: Brewpub
Address: 610 Merchant Street | Emporia, KS 66801
Phone: 620-208-HOPS (4677)
Web: www.radiusbrewing.com
Facebook: www.facebook.com/radiusbrewing
Hours: Daily, 11:00 a.m.–11:00 p.m.

Radius Brewing is in a beautiful two-story brown brick building on the corner of Merchant and East Sixth Streets in downtown Emporia—just a few blocks south of Emporia State University. Every university town needs a good brewpub within walking distance. Radius Brewing provides just that and is the first brewery to be established in the city in over 125 years. The previous brewery, Fredrick H. Mackey Brewery on North Market Street, closed down in 1882. That brewery was also walking distance from the university, then called Kansas State Normal School.

Owners Jeremy Johns, Gus Bays and Chad Swift opened Radius Brewing in early 2014. Jeremy was a homebrewer with over seven years' experience and his friend Gus was a chef, having graduated from Le Cordon Bleu College of Culinary Arts in Arizona. As is the case in so many instances, Jeremy and Gus were hanging out drinking some of Jeremy's beers when they came to the idea to start a brewpub downtown. Gus was wanting to start a restaurant and asked Jeremy if he wanted to take his brewing to the next level—they could divide the load. Jeremy would handle the brewery end, and Gus would run the kitchen. A perfect recipe for success. They fine-tuned

Left: Radius Brewing in Emporia. *Bob Crutchfield*.

Below: American Gladiators Zap and Jazz knock out some great beer at Radius Brewing in Emporia. *Bob Crutchfield*.

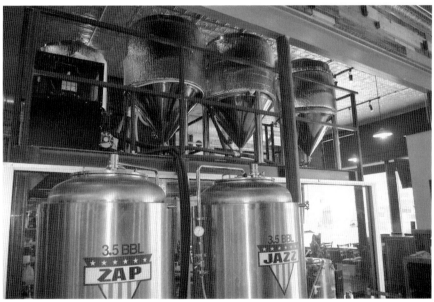

a business model, found a good location and successfully pulled together the funds to start it. The name "Radius" came from their notion that they wanted to focus on serving the nearby community—a small radius around Emporia. This would allow them to concentrate their efforts on quality chef-prepared cuisine and fresh craft beers for the local connoisseurs.

It took a lot of work to renovate and reconfigure the building for their new venture. Doing much of the work themselves, Jeremy and Gus purchased and installed a three-barrel system, placing part of their system behind glass right in the middle of the restaurant for patrons to observe. The brew

system also included some fermenters purchased from Tallgrass Brewing in Manhattan. Always up for a good time, many brewers like to have fun naming their kettles, brite tanks or fermenters. The ones they purchased from Tallgrass still proudly display "Zap" and "Jazz," from the *American Gladiators* TV series.

While Gus runs the kitchen, Jeremy handles the books and all of the brewing chores. A self-professed handyman, he also handles all of the maintenance, system improvements and, of course, brewing. Radius typically has three brew days a week to keep up with in-house demand. This puts it at around 400 to 450 barrels of craft beer per year on its comparatively modest system. This all translates in to a very busy brewing system, which, in turn, keeps Jeremy busy using both his brewing and handyman skills to keep everything smoothly.

Being relatively new to the scene, Radius is having surprisingly good reviews on social media and publications covering the craft beer scene. In fact, using the beer rating app Untappd.com as its guide, Yahoo Travel highlighted Radius in 2015 as being one of "The best 50 breweries in America." At the time, Radius had a rating of 3.5 out of 5.0 based on several thousand ratings cast.[45] Recently, Untappd listed over 6,000 individual ratings for all of Radius's beers, and the brewery's rating moved up to 3.73. In the craft beer world, this is a great vote of confidence from the beer-imbibing community out there. In 2018, Radius was honored by the Kansas Small Business Development Center as one of the top "Existing Businesses of the Year." Radius was selected from more than 2,400 businesses that received Kansas SBDC one-on-one business advising services in the previous year.

At Radius, the biggest seller is the **William Allen Wheat**—a pale wheat ale. The other popular flagship beers are the **Low 5 Pale Ale** (named after when the duo finally finished installing the last items on the brew system and Jeremy was too high up in the restaurant rafters to do a proper high-five) and the **Rumor Has It**… IPA. Their quickest-selling seasonal is their **Ryedius Rye Beer**. When this shows up on the chalkboard, you better get it "ryeght" away!

When in Emporia, you should find a one-stop combo of great chef-prepared meals and good craft beers on tap here. Look up daily specials and rotating seasonals on Radius's Facebook page.

GRINDERS HIGH NOON

Category: Brewpub
Address: 206 Choctaw Street | Leavenworth, KS 66048
Phone: (913) 651-1000
Web: www.grinderspizza.com
Facebook: www.facebook.com/GrindersHighNoon
Hours: Wednesday, 11:00 a.m.–11:00 p.m.; Thursday–Saturday,
11:00 a.m.–12:00 a.m.

Grinders High Noon is in historic downtown Leavenworth on Choctaw Street just a couple blocks west of the Missouri River. The city of Leavenworth, as most Kansans know, was the first city incorporated in the territory of Kansas back in 1854 when the U.S. government opened it up for settlement.[46] It had reliable transportation routes for supplies and equipment initially shipped overland up from Westport, a last stop for regular steamboat visits serving the settlers heading off on overland trails west[47] and eventually from their own steamboat and railroad stops directly in Leavenworth. It also had a secure and growing population watched over by long-established Fort Leavenworth a few miles north.[48] As a result of this, Leavenworth became a site for enterprising early entrepreneurs to make a go of starting up their own breweries. They aimed to serve the town's growing residents, soldiers and those settlers stocking up for destinations west. As discussed earlier in this book, Leavenworth records some of the oldest and most interesting breweries in the state. Records indicate the oldest brewery started in 1850s, about the same time as when the state was established.[49] Prior to having its own breweries, Leavenworth had most of its beer hauled up from Weston, Missouri, a few miles away. The city also had anywhere between eight[50] and eleven[51] breweries established and doing business prior to state prohibition in 1881.

Down now to only one brewery, the craft brewing tradition is gratefully being kept alive in Leavenworth by Jeff "Stretch" Rumaner, who purchased High Noon Saloon and Brewery and reopened as Grinders High Noon in October 2015. Located in the historic Great Western Manufacturing Company building, it boasts a horseshoe-shaped bar with an old railroad station coffee urn as part of the tap system for its beers as well as other guest taps. It has as many as thirty taps of craft beer at any given time with five dedicated to its flagship beers plus additional ones as seasonals come on line.

Stretch is a talented and notable Kansas City sculptor, restaurateur and TV personality who has gained worldwide notoriety for his creations such as the large sculpture at the H&R Block World Headquarters, sculptures for the Woods Weather Bridge and numerous other commissions for airports, college campuses and city parks around the country. His Grinders restaurants are famous for their house-made New York–style pizza, Philly cheesesteaks and death wings. He has appeared on hit shows such as *Diners, Drive-ins & Dives*, and the Travel Channel's *Pizza Paradise*. The name "Grinders" comes from the fact that Rumaner uses a grinder for much of his large metal sculpting work. With his talent and vision, he has kept much of the old look and feel of the two-story brick building while he remodeled the interior to fit with his other restaurants in the area. These include Grinders locations in the Kansas City Crossroads district, Grinders Stonewall in Lenexa and a new Grinders in Lawrence. The High Noon is the only location with its own brewery and provides craft beer to other locations.

The building was built in the late 1800s and had a long run as the Great Western Stove Company making cast-iron stoves for the settlers and pioneers headed west. For a while, during World War II, the Kramer Machine and Engineering Company was operating in this building. It made M7 tanks and ball turrets for B-25 bombers. Its latter years saw the building with various businesses before being purchased and artfully remodeled by Stretch. A juxtaposition of new and old confronts Grinders High Noon regulars on each visit. It seems like there is always something new to notice and appreciate about the artwork or antique interior. With the addition of his architectural creations, new bar design and metal sculptures, the brewery offers an interesting visual overlay to the historical interior's high ceilings, aged wood rafters, tall brick walls, wood floors and turn-of-the-century construction.

The brewery is currently operated by a very knowledgeable and experienced Jeff Horn and visible to customers toward the back of the bar. It's a beautiful copper-clad seven-barrel system with a main brew kettle that takes no time bringing the mash to a boil since it uses an electric coil with a steam jacket. It has a large twenty-two-barrel fermenter for double batches—primarily used for the popular cream ale. Because of Stretch's metalworking experience, much of the work needed to update and repair the current system is done in-house and with style. For example, instead of conventional fermentation blow-off hoses that might run into a barrel, it has a more aesthetic- and eye-pleasing stainless pipe running down the fermenters to bubble the gas off. This system stays busy all

week pumping out flagship beers and constantly changing newer recipes to feed the High Noon, Lenexa and Crossroads locations. The current flagships are **Grinders Pub Ale**, one of the only English Milds being brewed as a flagship in the state; **Grinders IPA**, American IPA; **Dark Honey Wheat**, a truly unfiltered hazy Hefeweizen; **Grinders Porter**, an American Porter; and **Grinders Cream Ale**. "It's sort of a 'lawnmower beer,'" as Jeff describes it. "It's a low rung on the craft beer ladder and is enjoyed by the everyday lager drinker in the area. But our crème Ale is so good, it outsells PBR in the Leavenworth area"

Grinders High Noon may get into regional distributing at some point. But currently it has the capacity to feed itself and their other sites. The ownership has plenty of room for expansion here and is looking to install a larger system next door once the Lawrence location of Grinders opens.

Yankee Tank Brewing

Category: Microbrewery
Address: 807 East Twenty-Third Street | Lawrence, KS 66046
Web: www.YankeeTankBrewing.com
Facebook: www.facebook.com/YankeeTankBrewing
Email: cheers@yankeetankbrewing.com

Yankee Tank Brewing was the brainchild David Heinz, who felt the need for an additional source of good local craft beer to support his and other local restaurants. Davis owns and operates the Henry T's in Topeka and in Lawrence. Not being a homebrewer like some of the other startups, he was able to visit many of the breweries in the state, asking questions and learning as much as possible before launching Yankee Tank. He eventually pulled together a great brewing team to help design the systems, craft great recipes and test out batches at his own restaurants before finally taking his beer to distribution in 2015. "In the beginning, we made good beer in several different styles. Some of those we only made a few times as we improved the recipes. Now we only make great beer," David said his initial years. Today, Yankee Tank has very experienced brewers, one of whom, Angelo Ruiz, had over ten years of experience in homebrewing, was the past president of the Lawrence Brewers Guild and won quite a few homebrewing medals in KC Bier

Meisters competition. Angelo tells an interesting story about how he was hired to eventually brew for Yankee Tank. "I strongly criticized one of Yankee Tank's original beers on Untappd.com, a popular beer rating site, and the current brewer here knew me and called me to come down and discuss their beer. He and I analyzed my critiques and largely agreed with my inputs." Not long after, Angelo was hired part-time, and now he is the full-time brewer. He's had a chance to improve and reworked many of the original recipes since then.

Keke Gibb spent time here as the quality-control manager and assistant brewer. She's an assistant professor at Baker University with homebrewing experience (how can you not when your graduate work was studying yeast?). She came on board to do anaerobic bacteria screening, shelf-life testing of the canned beers, pH testing on the brewing process, specific gravity measurements and dissolved oxygen determinations, among other things. She's the numbers person with the academic background necessary to help the team create magnificent craft beer.

Currently, Yankee Tank does not have a taproom, but it does have a large-capacity brewing system in south Lawrence. Right now, all the beers go into distribution in kegs and cans, and Yankee Tank serves its flagship beers to bars and restaurants in Lawrence, Topeka and, more recently, Johnson County. The canned beers are sold in the same big-city markets, but Yankee Tank is also getting a lot of intense local interest in the smaller cities in northeast Kansas. "We are seeing surprisingly hyper-local sales in some smaller town like Atchison, Wamego, Council Grove, and Baldwin." according to David. "Some of the smaller towns only have one or two stores, and they do better sales than some of the stores in the larger cities."

The name "Yankee Tank" and logo are quite interesting and unique but not exactly associated with each other. The name comes from a local artesian well located on land that was settled by Dr. Ezekiel Andrus Colman,[52] a transplanted doctor from Massachusetts, as part of the Kansas-Nebraska Act in 1854. He shared his well water and allowed neighboring ranchers and farmers to water their livestock at the well. The area settlers began calling it the "Yankee's Tank," and the name stuck. It's still there today, not far from the brewery site

The Yankee Tank diver keeps watch over the brewing operations in Lawrence. *Bob Crutchfield.*

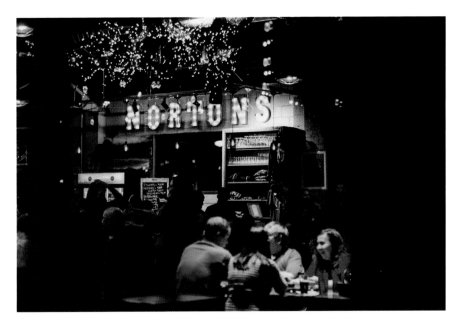

Night life at newly opened Nortons Brewing in downtown Wichita. *Courtesy Nortons Brewing Company.*

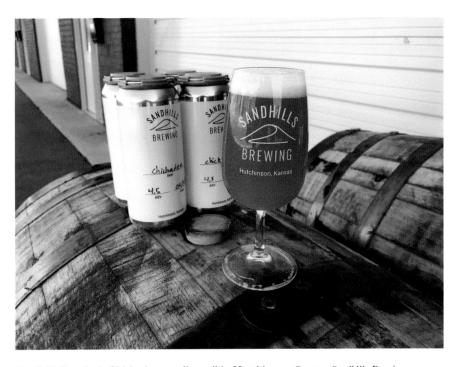

Sandhills Brewing's Chickadee standing tall in Hutchinson. *Courtesy Sandhills Brewing.*

Left: The taproom with Stretch's unique tap system at Grinders High Noon in Leavenworth. *Bob Crutchfield*.

Below: Gnomes keep watch over the taps at the Hopping Gnome Brewing Company in Wichita. *Bob Crutchfield*.

Brad Portenier owns and operates Kansas Territory Brewing in Washington, Kansas. *Bob Crutchfield*.

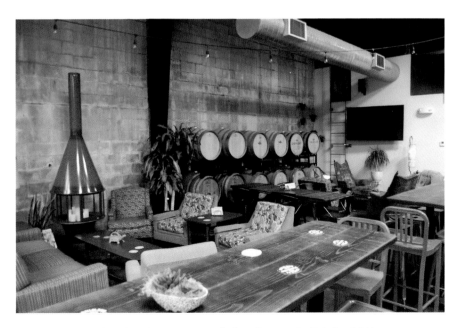

Central Standard Brewing vintage taproom before the crowds. *Bob Crutchfield*.

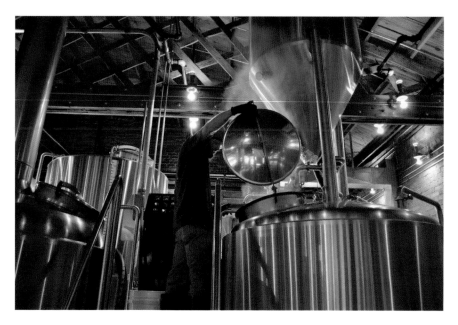

Assistant brewer Jesse Baker inspects the mash at Lb. Brewing in Hays. *Courtesy Lb Brewing.*

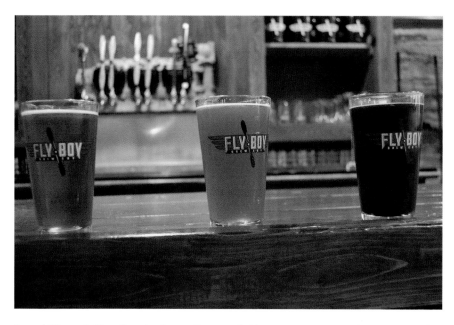

Ice-cold Props & Hops Brewing beers. Come early if you want to try out the popular craft beers and food. *Bob Crutchfield.*

Showing off the glassware at Wakarusa Brewery in Eudora. *Courtesy Wakarusa Brewery.*

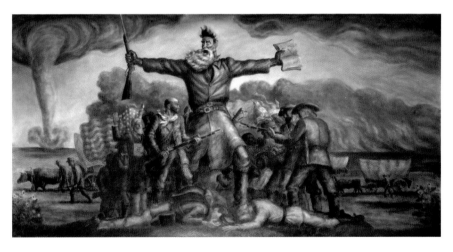

Famous John Brown mural at the state capitol in Topeka. *Courtesy Kansas State Historical Society.*

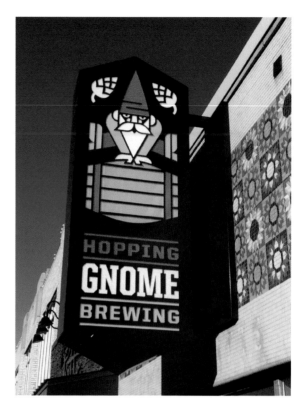

Right: The Hopping Gnome Brewing Company in downtown Wichita. *Courtesy Hopping Gnome Brewing Company.*

Below: Wichita Brewing Company's popular "beer-amid" takes a breather here. *Bob Crutchfield.*

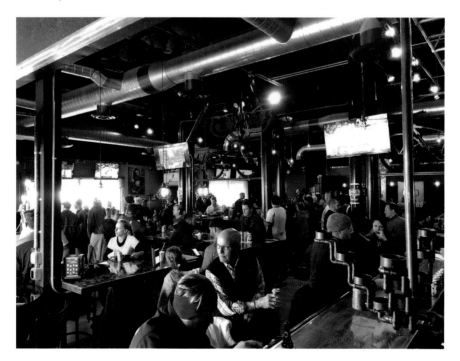

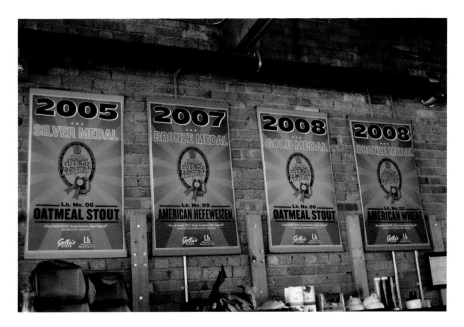

Some of Lb. Brewing's beer awards proudly displayed in Gella's. *Courtesy Lb. Brewing and Gella's Diner.*

Torrey and Stacy sharing some downtime at the Hopping Gnome in Wichita. *Courtesy Hopping Gnome Brewing Company.*

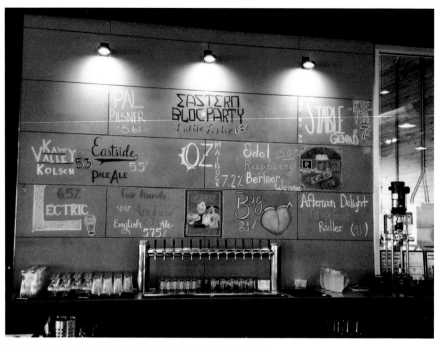

Above: The big board is always changing at the Lawrence Beer Company in Lawrence. *Bob Crutchfield.*

Left: Becky and Dan showing some love during a quiet moment at Nortons Brewing Company in Wichita. *Courtesy Nortons Brewing Company.*

Right: Bob *(left)* and Jim Crutchfield taking a selfie at Central Standard Brewing in Wichita. *Jim Crutchfield*.

Below: A number of brewers from across the great state got together at Wichita Brewing to make a collaboration beer called Prairie Land Delight 2018. It was a great time, and you can see they all worked quite hard that day. *Bob Crutchfield*.

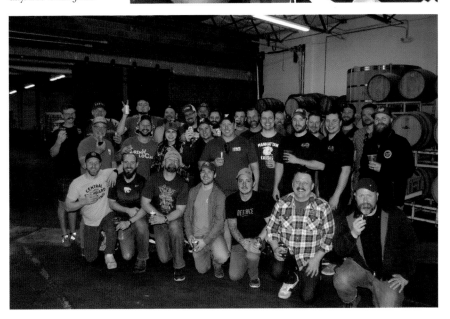

Left: Drawing fans from all over! A popular board at the Boiler Room Brewhaus in Fort Scott. *Bob Crutchfield*.

Below: Some of the crew at Wichita Brewing's main production facility in Wichita. *Courtesy Wichita Brewing Company*.

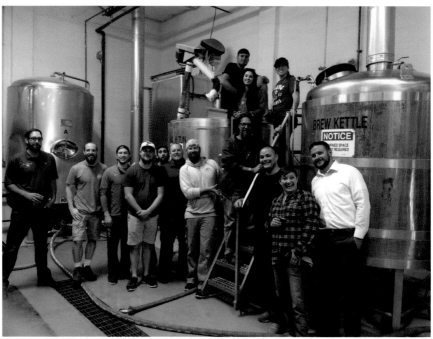

Part of the beer bottle collection on display at Hank is Wiser Brewery in Cheney. *Bob Crutchfield.*

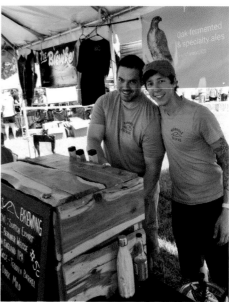

Left: Warbeard Irish Red getting ready to be canned at the Walnut River Brewing facility in El Dorado, Kansas. *Bob Crutchfield.*

Right: Joe Cizek (*left*) is helping brewer and co-owner Jonathan Williamson of Sandhills Brewing pour samples of their beers at the Kansas City Nanobrew Festival. *Bob Crutchfield.*

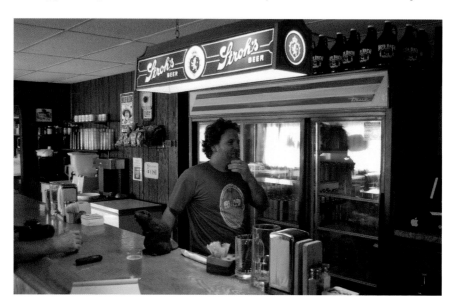

Brewer and co-owner Austin Bell at Beaver Brewing at Mo's Place in Beaver. *Bob Crutchfield.*

You can find great beer this way at the Three Rings Brewery in McPherson. *Bob Crutchfield*.

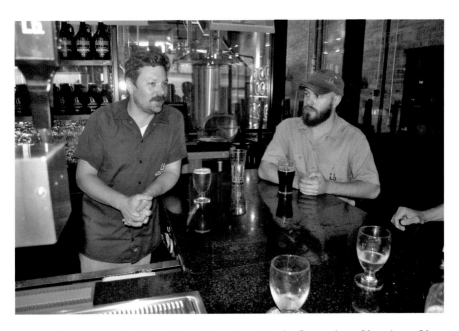

Brewers Brendan Arnold (*left*) and Jesse Baker discussing the finer points of brewing at Lb. Brewing in Hays. *Bob Crutchfield*.

Nortons Brewing get crazy busy on weekends, but the staff works hard to keep the customers served with some of the great beers Dan Norton creates. *Courtesy Nortons Brewing Company.*

The *N* meshed with a battle-axe on the logo is representative of the aggressive brewing style at Nortons Brewing in Wichita. *Courtesy Nortons Brewing Company.*

Head brewer Ryan Kerner proudly poses with one of his latest IPAs at River City Brewing in Wichita. *Bob Crutchfield.*

A V.6 IPA is always a home run in Wichita. *Courtesy Wichita Brewing Company.*

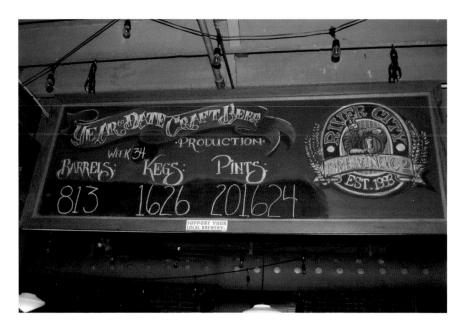

River City Brewing displays ongoing production numbers for the brewery. *Bob Crutchfield.*

You can find fresh hops growing in the courtyard at Central Standard Brewing in Wichita. *Bob Crutchfield.*

(just west of Fifteenth Street and South Lawrence Trafficway), and the same family still owns it. The logo is something that gets a lot of discussion and is often confused with either a robot or space alien. It's actually an engineering drawing in the patent application for an underwater diving suit, intended to be used for welding underwater on early metal ships. No one seems certain if the diving suit was ever put to use beyond being the logo for Yankee Tank's beers. No one is also saying that it was selected to be their frontman after a few drinks late one night either, but maybe.

You can find many seasonal beer creations at one of the Henry T's restaurants, as they act as a de facto taproom and will always have a varying suite of craft brews on tap. The most well-liked beers are being canned and are **Cloud 9** (a West Coast–style Double IPA and Yankee Tank's biggest seller in restaurants), the **Red Dirt Country Ale** (an American red ale), **Scissortail** (a cream ale that is very popular during the summer months) and **Rip Tide** (a Pale Ale dry hopped with an insane amount of hops). David and the team are currently planning on a potential stand-alone brewpub or taproom under the Yankee Tank name, so keep an eye on future announcements.

HAPPY BASSET BREWING CO.

Category: Microbrewery
Address: 6044 Southwest Twenty-Ninth Street | Topeka, KS 66614
Phone: (785) 640-3151
Web: www.happybassetbrewingco.com
Facebook: www.facebook.com/HappyBassetBrewingCompany
Email: craver.eric@bassetbrewing.com
Hours: Sunday, 11:00 a.m.–10:00 p.m.; Monday–Thursday,
3:00 p.m.–10:00 p.m.; Friday–Saturday, 11:00 a.m.–12:00 a.m.

Eric Craver opened Happy Basset in late 2016 after many years as a homebrewer doing five-gallon batches. But with an extensive background in construction and metalworking, he decided he could up his game and build a SABCO Brew Magic system by hand in his garage to enjoy the more control and options the larger system provides. But with the larger system came the larger volume of output. After brewing on this system for a while, Eric looked back on what he had done. "It was more than I could drink

myself," so his homemade craft creations ended up being "mostly for his friends. But now they have to pay!" he said with a little smile.

Eric installed a brand-new seven-barrel electric brew house and typically double batches into his fifteen-barrel fermenters to keep up with demand. Shortly after the opening, his craft beers became popular enough that he had to immediately expand into the adjacent space, allowing the taproom to accommodate his overflow crowds. Happy Basset's craft beers have become popular enough in Topeka that they can be found in as many as forty-five local bars and restaurants. In fact, his brewery recently won the city's Emerging Entrepreneur of Distinction award, beating out other new businesses in Topeka. The brewery's demand continues to be so strong that, at the latest check, Eric has his eyes on an auxiliary site in town to provide additional brewing capacity as well as canning capabilities. The plans are for it to also have a taproom and event space. Sounds promising!

Happy Basset was named after Eric's two bassets hounds and is in the Villa West shopping center in southwest Topeka. Along with Norsemen Brewing and the Blind Tiger, it is the newest addition to the area's craft brewing scene and part of the Topeka trifecta of breweries that crank out the Beermuda Triangle collaboration beers.

The brewery stays busy all week doing a surprising number of year-rounds and seasonals. For being a newer brewery, Happy Basset brews some of the best beers in the area. Their current year-round beers Eric has

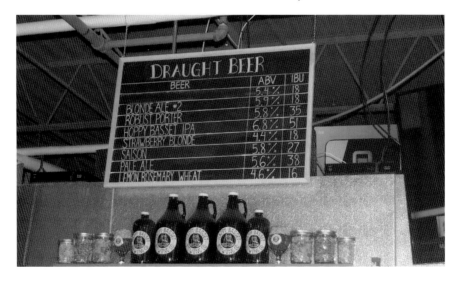

Topeka's newest brewery displays its latest beers on the taproom board at Happy Basset Brewing. *Bob Crutchfield.*

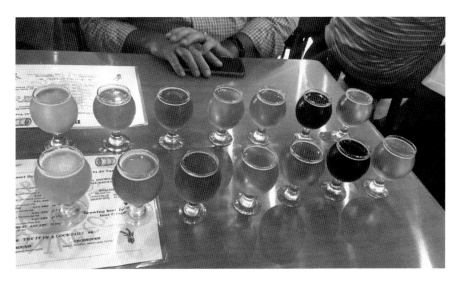

Showing off some of the great creations at the Happy Basset Brewing Co. in Topeka. *Bob Crutchfield.*

concocted are the **Belly Rub Brown Ale** (American brown ale), **Happy Basset IPA** (American IPA), **Gracie's Strawberry Blonde** (blonde ale), **Yellow Brick Blonde** (blonde ale), **Purebred Porter** (American porter) and **Rare Breed** (unfiltered American wheat). But it has a large number of interesting seasonal craft beers, so its always good to pop in and try them out when you can.

NORSEMEN BREWING COMPANY

Category: Microbrewery
Address: 830 North Kansas Avenue | Topeka, KS 66608
Phone: (785) 783-3999
Web: www.norsemenbrewingco.com
Facebook: www.facebook.com/norsemenbrewing
Hours: Tuesday–Thursday, 4:00 p.m.–9:00 p.m.;
Friday–Saturday, 11:00 a.m.–11:00 p.m.

Newly established in the North Topeka Arts District (NOTO) is the Norsemen Brewing Company. This area was, in its heyday of the 1940s, the

bustling downtown district that was the place to be seen, get your groceries and maybe see a movie. In 1951, Topeka had a historic flood that ravaged this area to the point it was not able to recover. The Kansas Avenue bridge collapsed only to be rebuilt farther east, diverting traffic from NOTO and helping trigger remaining businesses to lose sales and eventually move or go under. The area became neglected over the years. However, since 2010, many of the historic buildings were purchased by investors, and the area has been revitalized into an arts district with three thousand–plus people visiting every month.[53] Located in one of the original brick buildings from the early 1900s, Norsemen Brewing Company joined the district's ranks in 2015.

Norsemen Brewing Company's origins came about back in 2009–10 timeframe when Jared Rudy toured Boulevard Brewing and tried "everything they had." Previously being a "Natty Light" kind of beer consumer, he got the bug and started buying only craft beers from that time. Bottles, cans and even in kegs. Especially beers from Boulevard. He was hooked. Then came news that he was being laid off at his job, and to continue enjoying his craft libations, Jared started thinking, "How can I get my craft beer cheaper?" Homebrewing in his kitchen was his solution. As you might guess, it was not his wife Emily's solution, and the enterprise was promptly kicked out

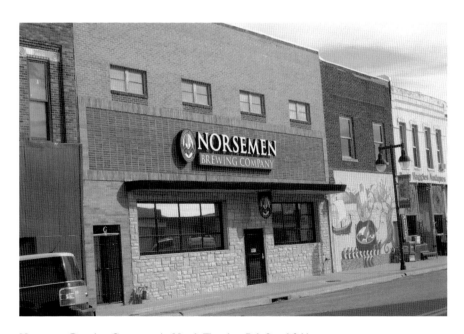

Norsemen Brewing Company in North Topeka. *Bob Crutchfield.*

Norsemen Brewing is the newest brewery, recently opened in a wonderfully restored turn-of-the-century building in North Topeka. *Bob Crutchfield.*

into their garage, where he continued to practice and perfect his hobby. He formed a group called the "Fat Back Brewery" with partners Adam Rosdahl and Andy Sutton. They joined the Hall of Foamers, the homebrewing club in Topeka. When Jared's job moved him to Lawrence, the partners joined the Lawrence Brewers Guild. They continued to practice their homebrewing recipes and grew their system from a five-gallon, to a fifteen-gallon, then up to a twenty-five-gallon system. Eventually getting their wives' blessings, Jared and Adam decided to get an SBA loan and start a seven-barrel system commercial brewery in the middle of NOTO.

Norsemen Brewing Company is in a beautifully refurbished building previously occupied by an establishment called the Rooster Club. It has a large brew house behind the bar and an event space upstairs with a large seating area. The whole of the brewery is very spacious, clean and comfortable. Jared and Adam wanted to have a name that reminded people of their North Topeka community. They eventually settled on "Norsemen," which was borrowed from a local junior high school mascot. The school has since closed, but the name lovingly lives on in with Norsemen Brewing. The unique mural and logo were designed by Jared's talented wife, Emily.

Jared and Adam admit beer brewing is a "rough science"; however, they are meticulous brewers and are careful to brew consistent beers. They have a spreadsheet and a process to control everything. Jared feels he understands the chemistry behind brewing, and if something deviates from the recipe, he will investigate and isolate the nuance. The Norsemen has two flagship beers: **Coffee Porter** (American porter) and **Odin's One EyePA** (IPA). It currently offers the following seasonals: **Freya's Wit** (Witbier), **Schwarzbier Black Lager** (Schwarzbier), **Menoken Harvest Pale Ale** (international pale ale), **Horton Drinks A Hefe** (Hefeweizen) and a Munich Dunkel.

The Norsemen team has the award-winning brewer John Dean from Topeka's Blind Tiger as their mentor. Jared appreciates his guidance and acknowledged that "John Dean is one of the best brewers" he knows. Along with Topeka's other new brewery, Happy Basset, Norsemen is part of the Topeka Beermuda Triangle and had a great time brewing an old-style lager they all shared. Norsemen served this inaugural brew at one of NOTO's First Friday events.

LAWRENCE BEER COMPANY

Category: Brewpub
Address: 826 Pennsylvania Street | Lawrence, KS 66044
Phone: (785) 856-0453
Web: www.lawrencebeerco.com
Facebook: www.facebook.com/lawrencebeerco
Email: info@lawrencebeerco.com
Hours: Tuesday–Thursday, 11:00 a.m.–11:00 p.m.; Friday–Saturday
11:00 a.m.–12:00 a.m.; Sunday, 12:00 p.m.–10:00 p.m.

Lawrence Beer Company (LBC) is a new brewery located in Lawrence, less than a mile east from the main downtown area in a recently designated area called the Lawrence Cultural District. It was started by Matt Williams, a Tonganoxie native and University of Kansas graduate. He brings ten-plus years of beer industry branding and marketing to LBC. With a dream of starting his own brewery, he developed a business plan back in 2015 and scouted out the best location for a microbrewery and restaurant in town. Not wanting to go the SBA loan route to finance it, he sought out partner/investors who were interested and would be a good fit. His bank

introduced him to a local named Adam Williams (no relation) who was also interested in starting a similar business, potentially in the Lawrence area. Adam comes with construction and management experience. Matt had also been talking with Brendon Allen, a Lawrence native and great-grandson of legendary KU basketball coach Phog Allen. Brendon has a double MBA and brings electronics experience helpful in the many systems needed to run a microbrewery and restaurant. Next to join was Ken Baker, who oversees daily operations for the restaurant. Ken was previously the chef at Pachamama's, a popular local restaurant that closed in 2015. Together, the four partners brought years of experience and passion to the venture.

Following Matt's business plan, they chose a building and location. In a nearly perfect fit, they acquired the old Barteldes Kansas Seed Company warehouse.[54] In this *nearly* two-story (the top half of the second story was demolished by a fire in the 1950s) brick warehouse, built in 1900, they had

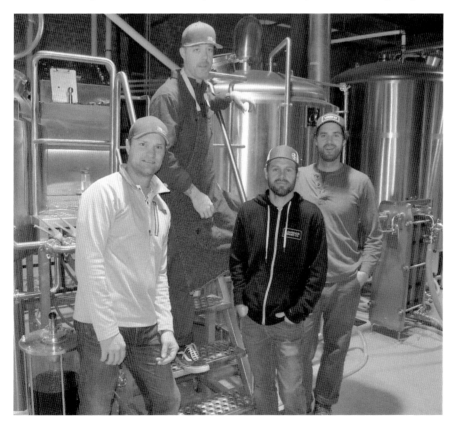

Left to right: Adam Williams, Ken Baker, Matt Williams and Sam McCain (not pictured, Brendon Allen) at Lawrence Brewing Company. *Bob Crutchfield*.

ample room for the brewery, kitchen, dining space and even an outdoor area. It already had a strong concrete foundation, averaging nine inches deep, and was more than sturdy enough to hold the brewing tanks. The team also acquired some old pine beams, which were repurposed into the sturdy tables populating the dining area. The building sits in Lawrence's "historic overlay district"; however, the warehouse has had enough changes to it since it was built that the city's officials considered it a "non-contributing" structure. Not being classified as "historic," the building was able to undergo the necessary modifications required to get it where the partners wanted. Keeping as much of the original character, the team

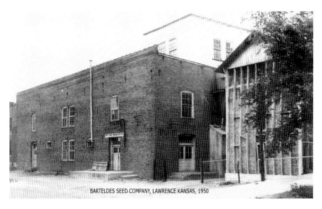

BARTELDES SEED COMPANY, LAWRENCE KANSAS, 1950

Left: Barteldes Seed Co., Lawrence. *Courtesy Paul Werner Architects.*

Below: Lawrence Beer Company, shortly after opening, 2018. *Bob Crutchfield.*

brought the building up to code, installed bright, open windows and added the brew house, bar and kitchen area.

Next up was to decide on the brew system for the brewery—it would have to be large enough to handle the taproom and restaurant demand. They selected a fifteen-barrel direct-fire two-vessel system (kettle and mash/lauter tun) with six fifteen-barrel fermenters from Alpha Brewing in Nebraska. They also added a smaller five-barrel fermenter for seasonal variants. Once the equipment was installed, the owners went about searching for a good brewer who would be able to work with the system. None of the partners had brewing experience, but luckily they found Sam McCain, an Abilene native, who had been working up at Half Acre Brewing in the Chicago area. He had just returned to Kansas and was working at Boulevard Brewing. After meeting the partners and seeing LBC, Sam joined up, bringing years of brewing experience and becoming the last piece to fit for the brewery.

LBC strives to be a comfortable neighborhood bar where customers can hang out on the patio and enjoy the vibe with a constantly rotating offering of craft beers. "You can sit on the deck and have a beer and watch the community roll in. People riding bikes or pushing strollers—we want to be that kind of center for the community," Williams said.

They don't have plans to produce for distribution, so everything brewed will be for in-house consumers. This gives the brewers the flexibility to experiment and constantly produce different styles of craft beers. To underscore this, they opened not only with the conventional craft beer styles other brewers might launch but also brewed a kettle saison beer of which they are particularly proud.

Part of the mission at LBC is to work with other breweries to offer collaboration beers and guest taps to add to the variety of beers and beer styles. The owners had help from Ska Brewing in Colorado for their launch party. Matt knew the guys from his past work, and they were gracious enough to come over and help with the kickoff party. In addition to Ska, LBC offered a guest tap—a Mexican lager that had recently won a gold medal at the Great American Beer Festival—from a small brewery south of Denver called Lone Tree Brewing. "We're not trying to fight for shelf space," Williams said. "We want make beer for the community." The biggest seller so far has been an IPA called 'Lectric—"a kind of Mosaic forward danky IPA," according to Matt.

11

NORTH CENTRAL KANSAS

KONZA PRAIRIE REGION

TALLGRASS BREWING COMPANY

Category: Major Regional Brewery
Address: Brewery: 5960 Dry Hop Circle | Manhattan, KS 66503;
Taproom: 320 Poyntz Avenue | Manhattan, KS 66502
Phone: (785) 537-1131
Web: www.tallgrassbeer.com
Facebook: www.facebook.com/tallgrassbrewingco
Email: info@tallgrassbeer.com
Hours: Monday–Thursday, 11:00 a.m.–11:00 p.m.; Friday–Saturday,
11:00 a.m.–12:00 a.m.; Sunday, 11:00 a.m.–10:00 p.m.

Tallgrass Brewing is Kansas's largest brewery and has its main production facility near the regional airport in Manhattan. It's an expansive sixty-thousand-square-foot facility with a large distribution network spanning much of the Midwest ranging from Texas to the Canadian border. Its associated brewpub in downtown Manhattan, Tallgrass Tap House, offers food and seasonal craft beers and serves as the brewery's test kitchen and pilot line for new beer styles and brews. Thoroughly tested by the city's K-State Wildcat fan base, if the beers prove popular here, the brewers often end up ramping production at the main site.

The brewery is the brainchild of owner Jeff Gill, who graduated with degrees in geology from Kansas State University and Oklahoma University.

He was working as an environmental geologist and discovered that his boss was making home-brewed beer. With his science background, Gill became fascinated with the whole brewing process. His family had been into winemaking, so he was no stranger to the yeast process involved, but the complexity and

Tallgrass Brewing in Manhattan, Kansas. *Courtesy Tallgrass Brewing.*

variety of the beers one can make with the same basic ingredients (malted barley, water, hops and yeast) drew him in to trying out homebrewing for himself. Soon, his home was stuffed with homebrewing equipment and he was off to making his own hand-crafted beers. It became an obsession for him. He had been brewing at home for six years, when, in 2006, he and his wife, Tricia, discussed the possibility of opening their own microbrewery. They both agreed to give it a shot back in Manhattan. With the financial support of friends and family, plus a lot of hard work, they launched Tallgrass Brewing Company in the spring of 2007 on Quail Lane just off Green Valley Road on the far east side of town. It was a five-thousand-square-foot brewery and sported a very cool copper-clad brew system. Jeff and a couple college student helpers produced their first batch of ale in August of that year. That was the beginning of it all.

Tallgrass produced some popular beers during its early years (8-Bit Pale Ale, Buffalo Sweat and Ethos IPA), resulting in great demand and the need for increased production. In 2013, when the brewery reached maximum output capacity—around 16,000 barrels per year—it was decided that, to keep up with demand and continue to grow, a new, much larger brewing space would be needed. After months of searching, an ideal space was found out by the regional airport and eventually acquired. It offered nearly sixty thousand square feet of office and brewing space with tall ceilings and room to expand. This provided Tallgrass with the ability to keep growing. Many of the existing brewing tanks were sold (Wichita Brewing and Radius purchased some of these), and large automated brew systems were installed. Initially, Tallgrass installed a four-vessel 50-barrel system but took a risk and expanded to eight 100-barrel fermenters and matching brite tanks. The facility's boil kettle has one of the few external calandria type systems in the state. It's a unique system whereby the wort is brewed outside of the main kettle through what seems like a vertical "jet engine"—it quickly hits the required boiling point and then flows

back into the larger kettle. Higher temperatures can be reached in this system, allowing for improved hop utilization and shorter boil times.[55] With room to grow, and the new systems at this facility, Tallgrass jumped from a microbrewery to a regional brewery classification and can now easily produce over 100,000 barrels per year—potentially leading to much broader national distribution.

Jeff and his wife opened Tallgrass Tap House at 320 Poyntz Avenue in booming downtown Manhattan. This stand-alone brewpub has a ten-barrel system and is as large as many other brewpubs in the state with over 5,900 square feet of space allocated to brewing and dining. It has a comfortably designed and contemporary interior that includes indoor seating for 260 and another 60 outside on the rooftop deck when weather permits. This makes it one of the largest eateries in the city. The Tap House also has a back-room bar for more intimate craft beer sampling experiences. The brewers here keep a rotating number of seasonal beers on tap to keep craft beer lovers coming back.

Jeff related one of the decisions they made really that helped Tallgrass beers take off: switching from bottles to only cans. The company calls this its "Canifesto" decision. It started when he got a call from a Tallgrass drinker out in western Kansas looking to recycle his empties. He had around twenty empty cases of IPA and didn't want to just toss the bottles. There was no recycler where he lived, and his only option was to take them all to the landfill. Jeff started researching the situation for a good solution. He learned, after some investigation, that bottles shipped in a paper or box container are probably the worst conveyances of beer. Canned beer keeps fresher than bottles over time, seals better and can be easily recycled. It's also less weight to ship, which reduces costs and is all in all better for the environment. In 2010, Jeff decided to switch all production to sixteen-ounce cans. For those beer drinkers who believe beer tastes better in a bottle, this may be true. But note most true craft beer connoisseurs will readily tell you that canned craft beer is supposed to be drunk from a glass anyway!

Tallgrass is a larger brewer, and its beers are always changing; however, its current core beers are **Buffalo Sweat**, an oatmeal cream stout; **8-Bit Pale Ale**, an American pale ale; **Raspberry Jam**, a raspberry Berliner Weissbier; **Moro St. Wheat**, an American pale wheat; and **Blueberry Jam**, a blueberry Berliner Weissbier. The top seasonals and taphouse favorites are **Vanilla Bean**, a vanilla oatmeal cream stout; **Velvet Rooster**, a Belgian-style Tripel; **Key Lime Pie**, an American sour blonde ale brewed with lime peel; **Strawberry Shortcake**, a wheat ale with a beautiful aromatic

One of the very powerful external calandria, which create just the right temperature for boiling the wort here at Tallgrass Brewing Company. *Bob Crutchfield.*

A variety of fine craft beers being conditioned in the barrel-aging room at Tallgrass Brewing Company. *Bob Crutchfield.*

strawberry flavor and a cake-like vanilla richness; and **King Buffalo**, an amped-up stout with scents of mocha, roasted malt and coffee bean.

Note: As this book was going to print, it was announced that Tallgrass Brewing's main production facility had suspended operations and was in contract negotiations with investors with hopes to restart as soon as possible. Tallgrass Tap House is still open under separate management.

LITTLE APPLE BREWING COMPANY

Category: Brewpub
Address: 1110 West Loop | Manhattan, KS 66502
Phone: (785) 539-5500
Web: www.littleapplebrewery.com
Facebook: www.facebook.com/LittleAppleBrew
Hours: Monday–Saturday, 11:00 a.m.–11:00 p.m.;
Sunday, 11:00 a.m.–9:30 p.m.

Little Apple Brewing Company's motto says it all: "Great Steaks and Great Beer!" It was the first brewery in Manhattan and is located in the West Loop Shopping Center, a few miles east of Kansas State University's main campus. Kelly and Russ Loub bought it from previous owners back in April 1995 and kept the name. They were looking for a change and wanted to do something different. Russ brings years of experience in the food and beverage business as the previous manager of Manhattan Country Club. When first opened, the restaurant struggled for over a year, unable to distinguish itself from the previous eating establishment, which had closed. Sticking it out, the Loubs were thrilled when the new phone books came out (remember there was no Yelp or Google Maps in the mid-90s) because the phone started ringing and customers finally found them. Good reviews of their steaks and craft beer began to spread, and the establishment began to turn around. From then on, Little Apple has experienced double-digit growth and a wider following.

Certified Angus beef is the current specialty and won the Loubs numerous beef- or Angus-related awards over the years. With his experience as a chef, Russ focuses on keeping the food experience top-notch while Kelly took charge of the front of the house, tackling the marketing and public-relations duties.

Flagship beers proudly displayed on the side of beef at Manhattan's Little Apple Brewery. *Bob Crutchfield.*

Little Apple Brewing successfully balances food and craft beer sales to a diverse yet faithful community of professors, international and domestic students as well as soldiers from the nearby Fort Riley base. Kelly noticed on a recent trip through Colorado that most breweries don't rely on food sales. However, she feels they are the best they've ever been on both food and beer. Kelly remarked, "The craft beer drinker often wants something different. When they come here, they want a good quality craft beer with their steak."

They know how to pour a good one at Little Apple Brewing Company in Manhattan, Kansas. *Bob Crutchfield.*

The restaurant and brewery came with the original, but constantly upgraded, brew system. It's a Canadian-manufactured system comprising a ten-barrel mash/lauter tun and similar-sized boil kettle, with six-barrel brite and serving tanks. Brewmaster Shawn Howard came on board with plenty of experience and desire to take craft beers to the next level. He has begun brewing experimental beers on a new SABCO pilot system that allows Little Apple Brewing to produce ten to twelve gallons of specialty beers every three weeks or so. This keeps the beer selection constantly fresh and interesting. Shawn and the Loubs have had a blast introducing these on their patio for weekend events.

Little Apple has six taps for its own brews. Five taps are for the flagship beers, which are **Wildcat Wheat**, **Prairie Pale Ale**, **Bison Brown**, **Angus Stout** on nitro and **Riley's Red**, and one for seasonals like **Hemp Ale**. "No buzz, but there is a flavor. Adds a nutty flavor to the beer," Kelly said with a grin. Wheat and pale are the biggest sellers "we typically run through one tank a week." The next most popular are the red, brown and stout.

Come on in and try Little Apple's fresh craft beers at the bar or relax on the patio. Shawn will always have a great beer selection for you to appreciate!

Down Under Brewery

Category: Brewpub
Address: 121 West Court Street | Beloit, KS 67420
Phone: (785) 534-1888
Facebook: www.facebook.com/DownUnderbeloitks
Hours: Monday–Tuesday 5:00 p.m.–11:00 p.m.; Wednesday–
Thursday, 5:00 p.m.–12:00 p.m.; Friday–Saturday, 5:00 p.m.–
2:00 a.m.

This microbrewery is an example of the industrious and hardworking can-do nature of Kansans. The Down Under is located on the ground level below the Plum Creek Restaurant in Beloit. The restaurant gets a 5-star rating on Facebook and a 4.5-star rating from both Yelp and TripAdvisor. In addition to the standard fare, Plum Creek offers one of those *Man vs. Food* kind of burgers called a Triple Outlaw, which only the hungriest can even attempt to put down. Buts that's OK, since you can wash it all down with one of the in-house craft beers. You can have it brought up from the brewery below or, if you want to skip the traditional sit down–style service, you can head on down under and experience craft beers at the source.

The industrious and hardworking part of this story comes from how the owner of both venues, Brett Wichers, came to be where he is today. Brett started working at Plum Creek back in 2002. At that time, it was located in a smaller space about a block from the current site. The restaurant wasn't doing well. It had a meat counter and cold sandwiches with a small limited kitchen. The food was good but wasn't bringing in enough customers. Brett had only worked there for a couple months when the owner made him an offer: "If you take over rent—I'll walk out the door." At the time, Brett was only nineteen years old. He weighed the offer and decided, "What the heck. I think I can turn it around and make something of it." He expanded the menu, got rid of the meat counter and improved the kitchen area. He also added a smoker outside and a wood-burning grill for steaks and burgers. The people started coming.

With the success from the first restaurant, Brett was able to expand to the current, and much larger, location in 2010. Renovating the lower level first, he moved and expanded the bar, added new furnishings and installed a cold room for the kegs. This became the Down Under. After that, he began remodeling the upstairs for the restaurant. He added a larger kitchen and expanded the food menu, reopening as the new Plum Creek Restaurant.

Main entrance to the Down Under Brewery in Beloit. *Courtesy Down Under Brewing.*

A couple years later, Brett and his friend and eventual business partner Clinton Offutt were discussing the feasibility of adding a brewery to the Down Under. Clinton, an entrepreneur at heart, had no prior brewing experience but had contacts in the industry and felt he could learn fast and make it happen. There was room to install a small system, so within about twenty minutes of agreeing to build it, Clinton was on the phone ordering a one-barrel system from Stout Tanks and Kettles in Portland. The new system, once it was delivered and Clinton installed it, comprised one all-electric boil kettle, four fermenters and eight brite tanks to service eight in-house taps at the bar. The building was built in the 1940s and had an unused underground duct system he could use to run the glycol-chilled

tap lines to the bar. Clinton also installed a state-of-the-art brewery control system. In early 2017, the duo received their Federal Brewer's Notice approval and brewed their first, and presently their most popular, craft beer, the American Amber.

Having craft beer and *selling* it are two different things. Getting more of the locals up the "craft beer ladder" in this area of Kansas was initially a challenge. Many are used to the readily available lagers they've been drinking for years. As an example, Brett tells the story of a guy who came in for his usual big-name commercial light beer. Brett asked if he wanted to try the recently brewed American wheat instead. The customer politely declined but, after some chiding from his wife, agreed to a small sample. "It was OK," he said. After about an hour, Brett checked back in on the couple. "The guy was just finishing his second tall glass of the stuff!" recalled Brett with a grin. "This is the typical 'first rung' on the ladder for our beers."

The Down Under keeps eight flagship beers without catchy names on tap. The IPA is just called **IPA**. The oatmeal stout is called **Oatmeal Stout**, and so on. In addition to the beers already mentioned, the Down Under offers a **New England Brown Ale**, a **Raspberry Cream Ale**, a **Bohemian Porter** and a **Bock**.

Blue Skye Brewery and Eats

Category: Brewpub
Address: 116 North Santa Fe Street | Salina, KS 67401
Phone: (785) 404-2159
Web: www.blueskyebrewery.com
Facebook: www.facebook.com/blueskyebrewery
Email: office@blueskyebrewery.com
Hours: Tuesday–Saturday, 11:00 a.m.–12:00 a.m.;
Sunday 11:00 a.m.–9:00 p.m.

The next stop along the brewery trail brings us to Blue Skye Brewery in Salina (population just shy of fifty thousand according to the 2010 Census). Blue Skye is about two and a half miles south of I-70 and located in an unassuming brick building in the heart of the historic downtown area. The building was once owned by the Anderson Luggage and Leather Company but was victim to a large fire that nearly destroyed the building back in

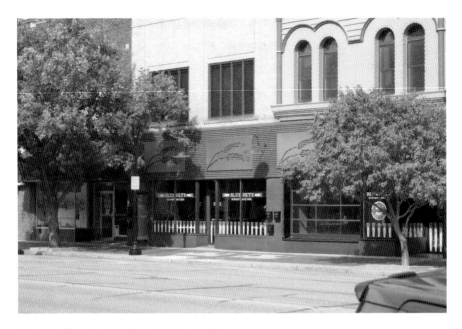

Blue Skye Brewing in Salina. *Bob Crutchfield.*

The brave firemen in Salina save the Anderson Leather building in 2008. *Courtesy John Goertzen, Blue Skye Brewery.*

2008. As fate would have it, one of the firemen called to the scene was John Goertzen, a twenty-year career firefighter who now runs the brewery. He's also the captain with the Salina Fire Department.

As it turns out, not long after the fire, the building's owner, Monte Shadwick, saw an opportunity to rebuild from the ashes a new restaurant and brewery. It was scorched, but still strong; John and the Salina firefighters had largely saved the interior's old rustic beams and century-old lumber. Knowing his friend John was a homebrewer with years of experience, Monte approached him with his idea to see if he could help him start up a brewpub and operate it. John agreed to the challenge. Like many homebrewers who want to go pro, it would give John an opportunity to start up a brewery from scratch and scale up his personal craft beer recipes for the public. The building was completely renovated and brought up to fire code (obviously) to allow for a brewery and restaurant and opened as Blue Skye Brewery and Eats. Taking advantage of the useable remaining lumber, they were able to repurpose much of the interior structure into the renovated restaurant and bar fixtures, including the large solid tables made from the building's floor joists. This all culminated into an open, airy and inviting experience to have great food along with some of John's craft beers.

Blue Skye was a brewpub concept from day one. The idea was to mix great beer and good but accessible food for the downtown Salina crowd as well as the local college students. The centerpiece for the restaurant is its large wood-fired brick oven that dishes out some of the best pizzas in the area. For the brewing system, John selected, and installed himself, a new seven-barrel system from Portland Kettleworks. The main four fermenters, which can be seen just behind the bar, are lightheartedly labeled with iconic images of the Beatles: John, Paul, George and Ringo.

John knows that he needs to keep their flagship beers on tap for return customers but isn't afraid to try some new recipes to expand customers' palates. He usually has four regulars on tap: **Fire Engine Red**, alternating IPAs (**Mugler's Revenge** and **Crankcase**), **B-17 Blonde** and **Dirty Ol' Stout**. The Red is Blue Skye's bestselling beer, but if you're just getting into craft beers, ask John to make you a radler with his blonde or watermelon ale and a bit of Sprite. When mixed this way, it gives an added a touch of sweetness and brings the berry flavor to the forefront. John picked up this idea at the Salina Brewers Guild a couple years ago. The latter is called the **Watermelon Crawl** and has become one of Blue Skye's most popular summer drinks.

John Lennon looks over one of the fermenters here at Blue Skye Brewery in Salina. *Bob Crutchfield.*

Some interesting notes on the alternating IPAs. **Crankcase IPA** is brewed on an alternating schedule with the **Mugler's Revenge IPA**. Crankcase is a collaboration IPA with the Land Institute that utilizes sustainably grown perennial wheat called Kernza™.[56] This sustainable wheat varietal was developed over many years and is grown in the Salina area. It is smaller than a regular wheat plant but does not require replanting. It can be cut and harvested several times a year on an ongoing basis without need for fertilizer or irrigation. (Kernza wheat roots can sometime reach as much as seventeen feet down into the soil.) The Kernza addition to the IPA recipe adds mouthfeel and enhances the citrus notes and is only the second craft beer in the country to use this kind of wheat.

The **Mugler's Revenge IPA** pays homage to Salina's original and successful brewery, Salina Brewery, which operated from 1877 to 1888. It was forced to shut down by the Kansas prohibition amendment in 1881. The owner, Peter Mugler, famously fought the forced closure and seizure of his property, valued at the time at $10,000, all the way to the U.S. Supreme Court (see *Mugler v. Kansas*)[57] but eventually lost in an 8–1 ruling. Salina's most famous brewery was gone for good. Other breweries in the state that silently remained open, hanging their hopes

on the success of this case, were watching closely. Unfortunately, this benchmark ruling took away any hope that they could *legally* fight the new Kansas amendment and remain open. The next brewery to open in Salina was Blue Skye—over 125 years later—on Main Street, not far from the original Salina Brewery a few blocks away, on Third Street between Mulberry and Walnut.

Blue Skye is mostly aiming at the downtown Salina population, being well away from I-70 traffic, but has become a bit of a destination stop for travelers who know where to get a good craft beer with their meal. It has a solid base of return customers who are craft beer drinkers but gets many who are new to craft beer. To the craft beer newbies, the biggest sellers are the lighter-bodied beers. But John says he is starting to change the beer drinkers' palates. As people discover craft beer, many become curious about other styles and flavor profiles they might not have tried before. This all keeps John, Paul, George, and Ringo busy!

There are always a rotating number of seasonals, so you'll have to check online to see what new craft creation John will have through the year.

Props & Hops Brewing at Fly Boy Restaurant

Category: Brewpub
Address: 105 North Main Street | Sylvan Grove, KS 67481
Phone: (785) 526-7800
Facebook: www.facebook.com/Fly-Boy-Brewery-Eats
Email: Flyboybrewery@gmail.com
Hours: Thursday, 5:00 p.m.–10:00 p.m.; Friday–Saturday,
5:00 p.m.–11:00 p.m.; Sunday, 11:00 a.m.–2:00 p.m.

One of the most interesting and exciting breweries in Kansas is Props & Hops Brewing and Fly Boy restaurant, located in the small northern-central Kansas town of Sylvan Grove. The town had a population of only 279 in the 2010 Census and, as of this writing, is the smallest town to have an active craft microbrewery and restaurant in the state.[58] Sylvan Grove is in the middle of a close-knit rural community of farmers and ranchers and a long drive from any place you would call a city. A few of the town's streets are paved—some are still gravel. If you want to drive your tractor into town, no

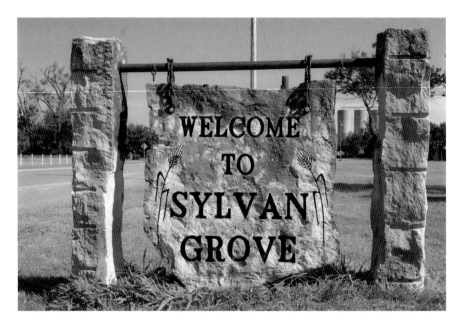

Welcome to Sylvan Grove, home to Props & Hops Brewing and Fly Boy Restaurant. *Courtesy Jim Crutchfield.*

one would bat an eye. It's that kind of a town. However, Fly Boy stands out as a popular family-run enterprise with strong support from the community. In fact, it has established itself as a revitalizing force in the town. The brewpub seats one hundred and regularly pulls in customers from Hays, Salina, Great Bend, Beloit, Tonganoxie, Topeka and other cities over two hundred miles away. It even has international visitors stopping by on brewery "beercation" tours. The restaurant and brewery's reputation is spreading by word of mouth, but it has also been featured on the *Sunflower Journey* TV show from KTWU in Topeka.

The brewery sits inside a wonderful renovation of S.M. Lawson's two-story brick hardware store, which sold plows and other farm implements from 1925 to 1993. The upstairs has served as an opera house, Masonic lodge and even a basketball court. The building even has a working hand-cranked lift that used to bring implements up from the basement. After the store sat unused for a while, current owners Clay and Linda Haring purchased the building, renovated it and opened up as the existing brewpub in October 2014. In a nice touch to keep the old with the new, the couple included many items left over from the implement store in their décor, including old parts boxes made into beer flights and paper towel holders. They even sanded the

top layer of the timeworn floors just enough to reveal the old gritty character from the hardware store, then gave it a nice clear coat.

But the overall theme of Fly Boy is aviation. Clay has been flying and operating his own crop-duster business for years. He also stays quite busy restoring numerous small aircraft, including old Stearman biplanes and other single-engine airplanes. He has pictures of many of his planes at the bar and is always willing to share stories with any aviation buffs over a cold one.

The Fly Boy restaurant does not serve your typical tavern fare. From its opening, Clay has been adamant that he will *not* serve pizza. Don't get him wrong, he appreciates a good pizza like the rest, but wants his place to be known for serving quality food that pairs well with his craft beers. Soon after opening, Clay reached out to a hometown friend who was a formally trained chef to see if he would leave his current, and hectic, chef position at a restaurant in Kansas City to come back and head up Fly Boy. Fed up with the fast pace there, he agreed to come back home with the freedom to prepare whatever creations he wanted in the quiet remotes of Sylvan Grove, Kansas. This worked out fabulously and has put Fly Boy on the map as the place to get exceptional prime

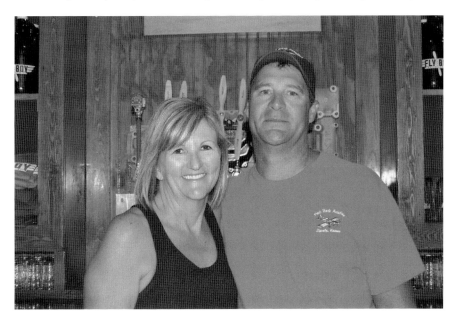

Linda and Clay Haring at the wildly popular Props & Hops Brewery and Fly Boy Restaurant in Sylvan Grove. *Bob Crutchfield.*

It's quiet now at Props & Hops Brewing and Fly Boy Restaurant in Sylvan Grove. *Bob Crutchfield.*

rib and thick-cut Kansas steaks. The restaurant's success and popularity has resulted in it often being difficult to get a table. People out here don't blink at driving one hundred miles for a great steak and superb craft beers. So, on weekend nights, it's not unusual to have every table filled and thirty to forty customers lined up outside waiting for a seat. Sylvan Grove effectively increases its population each weekend night by 50 percent with folks from all over. Steaks, craft beer and good people, you can't ask for a better spot to visit on a weekend night miles away from any big city.

Clay currently sells his beers only from his airplane-themed taps in the restaurant and purposely keeps the ABV in the 5 percent range so as not to overly intoxicate his customers, who will need to drive back home. (There really are no hotels in the area.) You can also get a growler and take back anything he has on tap. At the time of our visit, Clay was looking into the possibility of doing some distribution but easily sells all he can make through his location.

Fly Boy is currently making beer in a three-barrel all-electric brew system that takes up the back area of the main floor of the restaurant. Clay has a brite tank paired with each of his seven taps at the bar. He has to brew, ferment and chill his selections on a frequent basis to keep up with demand.

Clay started the brewery by brewing four beers: **Hotel Oskar Whiskey** (a honey orange oatmeal wheat), **Barnstormer Brown** (a full-flavored brown beer with a roasted barley and caramel aroma), **First Light Lager** (think of the image a pilot gets taking off just as the sun begins to rise) and **Lomcevak** (a robust stout with a hint of chocolate and coffee flavors). He has since added several other year-round beers. These are **Aviator Ale** (a light blonde), **Tail Spin IPA** (a medium-bodied IPA brewed with four different hop varieties) and **Round Engine Red** (a golden-red ale lightly hopped). The biggest sellers are **Hotel Oskar Whiskey** and **Aviator Ale**.

Despite being in the middle of the Kansas wheat belt, Clay is adamant about not brewing a stand-alone wheat beer such as a Weissbier or Witbier. However, he does offer beer with wheat as a component and, with a nod to his German heritage, does use a lot of German-style hops in many of his beers. This sets Fly Boy apart from many of the other up-and-coming craft breweries, which are all competing for the same popular, but hard to get, hops on the market. Clay usually keeps all seven of his craft brews on tap at any time and rotates his flagships and seasonals on a regular basis through the year. Props & Hops Brewing is clearly one of the most unique brewpubs in the state and well worth the drive.

KANSAS TERRITORY BREWING COMPANY

Category: Regional Craft Brewery
Address: 310 C Street | Washington, KS 66968
Phone: (785) 325-3300
Web: www.KansasTerritoryBrewingCo.com
Facebook: www.facebook.com/Kansas-Territory-Brewing-Company
Hours: Thursday–Friday, 5:30 p.m.–close; Saturday, 5:00 p.m.–close

Washington, Kansas, is the seat of the county of the same name and has a population of a little over 1,000 in the 2010 Census. In all ways, it seems like a typical unassuming little Kansas town. The nearest city with a population larger than Washington's is Marysville, twenty-two miles east, with around 3,300 residents at last count. In fact, driving into town, it's not apparent that much growth or activity has happened here in a while. In fact, it's been the opposite; like many small Kansas towns of Washington's size, it has had a

steady decrease in citizens since the 1970s. So, when you roll into the historic downtown area, you'll be amazed to find Kansas's northernmost and largest craft brewery, Kansas Territory Brewing.

This is all due to Brad Portenier, a local success story, who is very interested in allegiance to the part of Kansas where he was born and the surrounding communities where he grew up and worked. Brad had a number of interests before ending up where he is now. Early on, he worked for the railroad, then decided he'd get into the crop-dusting business. He bought a spray plane but sold it soon thereafter when he found out how many flying hours he was going to need to be insured. The money from that sale went to start up a welding business in Morrowville called Bradford Built. He, along with his wife, Linda, owned and ran this business building work beds for trucks and other items useful to Kansas farmers and ranchers. Over the years, this became a very successful enterprise for the Porteniers.

Now personally secure, Brad and Linda began thinking of all the towns in the area that were dying and what could be done. Brad met with Washington's director of economic development and explained what he was thinking, and after a few minutes of discussion, he was told not to do anything—the director would be right back. They decided right then and

Iconic water tank with logo above the Kansas Territory Brewery in downtown Washington, Kansas. *Courtesy Kansas Territory Brewing.*

there to call an emergency city council meeting. Wanting to get Brad into Washington on a good deal, the council agreed to construct a new building and lease it in a deal tied to rent, job growth and so forth. In return, Brad would open a restaurant there in downtown Washington. Brad and Linda felt it was a good proposal, and the city was bending over backward, so the deal was inked and a restaurant called Mayberry's was opened. Formally opened in 2015, it was popular and profitable enough that the Portniers were able to buy the building back from the city and eventually spread their success to additional space on either end of the store. They added an event space to Mayberry's, a women's boutique clothing store called Miss Donna's Doll House and Smoky Hill Boots, which carries over six hundred pairs of boots. Because of the city's initiative and the Portneirs' industriousness, Washington's downtown has begun to turn around, reversing the gradual trend of many Kansas towns.

Not content to sit on his successes, Brad began toying with what else he could do and came up with the idea of starting a microbrewery. This was partly a result of hearing that Boulevard Brewing had been purchased by a Belgium-based company called Duvel Moortgat in late 2013 and Coors was no longer a North American–held company by the end of 2015. Seeing too many foreign companies buying up U.S. brewers and distillers, he wanted to provide good American-made beer right there in Washington, Kansas.

After discussing this with a friend with homebrewing experience, he hatched the idea to start Kansas Territory Brewing Company, a brewery with Kansas roots making American-made craft lagers for the common man. His idea was for the brewery to be "sort of the Yuengling" of the Midwest. He wanted to provide the very best of the main-style beers and take care of Kansas beer drinkers first.

Without any brewing experience himself, Brad was willing to fund and manage this new venture if he could find someone to brew for him. After Brad's initial agreement with a homebrewing buddy fell through, Parker Harbaugh was recommended to him. It would be a pay cut from his current job, but Parker agreed to join with the stipulation that Brad install a good water system. Invested in craft beer quality, he insisted there needed to be a robust reverse-osmosis water system before anything was brewed. That sealed the deal for Brad. "Anyone interested in putting the quality of the beer ahead of his salary is in good standing with me," he said. With this agreed upon, Kansas Territory was off and running.

Although they are more difficult to make, the cornerstone beers for Kansas Territory Brewing are the lagers. Both **Life Coach** and **Roller**

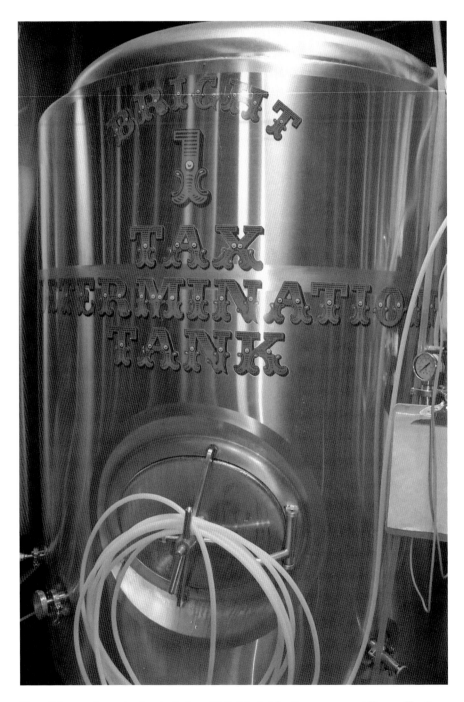

One of the tax determination tanks beautifully labeled for the revenuers at Kansas Territory Brewing. *Bob Crutchfield.*

Chain are popular lagers with a large following. These compete well with the Coors and Busch beers in heavy distribution. Life Coach is a light, crisp and refreshing beer and is an easy transition for guys who like light beer from the big three. This is exactly what he wanted to produce. "If everybody likes vanilla, we don't need to make a lot of chocolate," Brad emphasized. The other lager, Roller Chain, is viewed as a gateway or transition beer for those wanting to take a step up on the first rung of the craft beer ladder.

The bestsellers are **Roller Chain**, **Life Coach**, **Summer Breeze Shandy** and **Time Portal Brown Ale**. However, Brad's favorite is his own **Locomotion Stout**. As the consumer may notice, many of the beers refer to the history, events or machinery from the early days of Kansas. Locomotion Stout pays homage to the trains that ran along the Atchison, Topeka and Santa Fe Railroad. Aeroplane Pale Ale gives a nod to the great aircraft industry of Kansas. "Kansas makes the most personal aircraft in the country," Brad underscored. Roller Chain Lager refers to Dodge City's great motorcycle races in the early 1900s. (A "roller chain" is the high-speed chain on a motorbike.) Time Portal Brown Ale captures the feeling people experienced when the early diesel-powered trains were introduced to the country. As Brad explained, it took months to cross the Midwest before trains; eventually, with the Zephyr streamlined passenger trains, it only took a few days. It was like going through a time portal. Naming the beers has been both fun and challenging. A lot of companies are now "lawyering up" to protect their beer names and anything even close.

Without a sizable local population to reach through its taproom, Kansas Territory moves most of its craft beer through distribution. The main brewing location is larger than most in the state and located just across from Mayberry's. It's constantly expanded to both keep up with and drive demand. "Go big or go home" comes to mind when viewing the brew house. It has a twenty-barrel steam-powered boil kettle that constantly feeds multiple twenty-, forty- and sixty-barrel fermenters and brite tanks. In addition to the size, as compared to other breweries in the state, it has also incorporated an 8,500-rpm German-made centrifuge to filter beer between the fermenters and the brite tanks. Not many other breweries in the state have introduced this step into their process. It's an alternative to the conventional filtering process and doesn't "strip the good stuff" from the beer, Brad confided.

It well worth the trip to up to Washington to see the brewery and sample a few freshly made craft beers. Better yet, make a day trip by picking up a case of Life Coach then checking out the nearby Oregon Trail historical spots a few miles to the east between Washington and Marysville.

CENTRAL KANSAS

THE BEER CAPITAL OF KANSAS

Hank is Wiser Brewery

Category: Nanobrewery with full bar and restaurant
Address: 213 North Main Street | Cheney, KS 67025
Phone: (316) 542-0113
Web: www.hankiswiserbrewery.com
Facebook: www.facebook.com/hankiswiserbrewery
Hours: Friday–Saturday, 5:30 p.m.–11:00 p.m.

Just about twenty miles west of Wichita on U.S. Highway 400 (or U.S. 54, a.k.a. Kellogg Avenue) lies Cheney, Kansas, the home of Hank is Wiser Brewery. The first impression many notice driving into Cheney is that while it is certainly a small town, it seems to be thriving and has a vitality that sadly eludes other towns of its size in the Midwest these days. Cheney had a population of just over two thousand in the 2010 Census. Since the town is only a couple miles off the highway, local businesses attract customers from surrounding communities for the essentials without the hassle of driving into the big city—some of those essentials being great craft beer made by Hank Sanford and his son, Steve.

Hank is Wiser Brewery is located in historic downtown Cheney on the west side of Main Street between the Cheney Public Library and the U.S. Post Office. The building, known as the Collins & Joslyn Building, has stood since

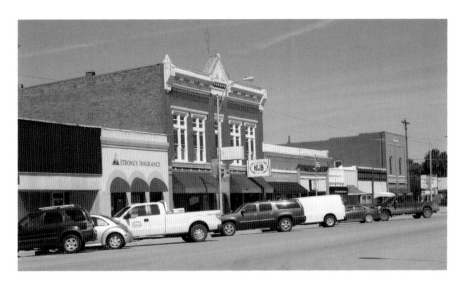

Above: Hank is Wiser Brewery, as seen today in downtown Cheney, Kansas. *Courtesy Jim Crutchfield.*
Below: Cheney Drug Company, Collins & Joslyn Building, as seen in the early 1900s. *Courtesy Kansas State Historical Society.*

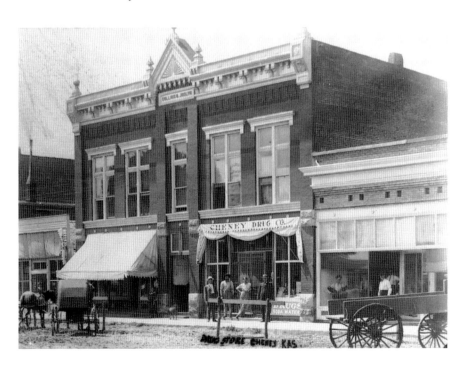

the late 1800s and was the first two-story structure in Cheney. Hank Sanford and his family live in Wichita and originally looked there for a location to bring their craft beer dreams to life. However, once Hank rolled up on the current building, he knew it was their brewery. "The minute I pulled up out front, I knew it was our brewery. That's what a brewery is supposed to look like." It was the only vacant building in Cheney, and it was for sale. It had sat empty for four or five years and already had a bar in addition to ample room to house the brewery, kitchen and seating area. The brewery has almost five thousand square feet on the main level, with the second floor of the same size empty for now. There is even a cellar below. The Sanfords purchased the property and got to work. After a year of renovations led by Hank and Steve, it was ready to open.

The painted and exposed brick interior of the restaurant and brewery is roomy and welcoming. Not including the patio out back, it seats 120 people but holds up to 300. The walls are covered with an assortment of both amusing and antique beer or brewing signs and several wide-screen TVs for watching sports. The décor certainly sets the tone for Hank is Wiser right off the bat, which is something like: "We are serious about beer here, but let's not take ourselves too seriously." The back bar has a 115-years-old soda fountain and mirror from the original Cheney Drug Company. The big, beautiful mahogany front bar came from a former pool hall located down the street.

This is a Friday and Saturday evening brewpub (restaurant and beer serving) operation for Hank, his wife, Jane, and son Steve. Of course, to be able to serve the beer when it's open to the public requires working some other days of the week to brew it and get it into the kegs for serving.

Hank retired from his job of over twenty years at Metal-Fab in Wichita at noon and opened Hank is Wiser in Cheney at 3:00 p.m. on the same day: April 1, 2005. It is one of the few remaining nanobreweries in the state with a full bar serving its own beers as well as some guest taps. The craft beers come from a homemade half-barrel (fifteen-gallon) brewing system, but the Sanfords have another twenty-gallon system ready to go for expansion once they can accommodate it. Hank said, "When we first started, we were not interested in getting into the food business. But we found, in a small town, you have to serve food if you want people to stay." Over time, Hank added a barbeque smoker to the mix. It's a family operation here. In addition to being head brewer, son Steve is head cook. Jane is the main waitress. "Mom works every weekend as waitress for the most part. People love the beer and love the food, but everyone loves my mother," said Steve. "It would take

three waitresses to replace her if she quits. She really likes people. My friends call her 'the cool mom.'"

Hank started as a homebrewer in the '90s. Like many others who started homebrewing, he wanted more flavor choices and a better-tasting beer than what was readily available, so he learned to brew his own. "I couldn't find good brew, so I had to make it!" Hank recalled. "At the time, River City was the only brewery in the area." His first homebrew was brewed and bottled for his son Steve's wedding. It was such a hit, the recipe is still being brewed and sold today as Wedlock Pale Ale. After the first year, Steve started brewing too. He had never done homebrewing but learned the craft from Hank and then picked up a part-time job as an assistant brewer for Dan Norton at River City Brewing in Wichita (Dan now has his own place in town called Nortons Brewing.) Since 2011, Steve has taken over all of the cooking and brewing tasks and still lives in Wichita.

The name *Hank is Wiser* came about as a result of how Hank ended up retiring and deciding to start the brewery. As Hank tells it, he went to work one day and the boss called him in to say the company had decided to "rearrange some things" and wanted Hank to take on a different role that would require more travel but no pay bump. Hank was already thinking to himself, "I'm sixty-one years old thinking of retiring next year." So he told his boss it might be better to find someone else to do this and he'd like to take an early out. When he got home, he told his wife he had essentially just quit his longtime job and to trust him; he had a plan, and "Hank is Wiser."

For the first seven years, Hank and Steve offered the following six standard beers: **Krippled Kangaroo IPA**, **Eh!** (Canadian lager-style ale), **Porter Potty Porter**, **Sanford and Son Stout**, **Wiseman Wheat** and the **Wedlock Pale Ale**. But what they found was that "our Wichita beer friends, and we count on those friends, after a few months had tried all our beers and they weren't coming out as often, especially with all the new craft beer options in Wichita." So now, "Steve just kind of brews what he wants to and people can call and see what's on or come and try the beers. When one style is out, we put on the next keg of the next style." Steve has a list of sixty to seventy beers he has brewed since they decided to change things up. The brewery has nine taps going and aims to keep on rotation "couple hoppy beers, some dark ones, and some lighter beers," said Steve. Because of its popularity, the IPA is available almost all the time alongside a guest tap with "big" (high alcohol, from 14 percent to 18 percent) beers as well. Also popular here are the fruity adjunct beers, which seem to sell out quickly. This mix seems to provide enough variety to keep people coming back. On

special occasions, the Sanfords have bottled beer to sell at the holidays, but "hand filling and capping sixty six-packs is a lot of work, and it just wasn't efficient," said Hank. They were often sold out in one day.

At this point, Hank doesn't see them adding to the brewery portion of the business, even though customer demand is high enough that they are just keeping up with it. They purchased a twenty-gallon SABCO brew system several years back that they may bring to life. But anything bigger would be too much. So, for now, Hank is Wiser is comfortable being only the second microbrewery in the state serving great craft beer and tasty barbeque by the coolest mom around.

WALNUT RIVER BREWING COMPANY

Category: Microbrewery
Address: 111 West Locust Avenue | El Dorado, KS 67042
Phone: (316) 351-8086
Web: www.walnutriverbrewing.com
Facebook: www.facebook.com/WalnutRiverBrewing
Hours: Tuesday–Friday, 3:00 p.m.–10:00 p.m.; Saturday, 11:00
a.m.–10:00 p.m.; Sunday, 12:00 p.m.–5:00 p.m.

Walnut River Brewing is located in a nicely refurbished early 1900s two-story brick building on Locust Avenue in El Dorado. About four miles southeast of Interstate 35, it sits along the original brick-paved road and shares a gravel parking lot with the old Santa Fe Freight Depot in the south end of downtown. Originally listed in the downtown El Dorado historical survey in 1920 as an auto repair shop, the building has had a varied and interesting history.[59] In 1923, there was a supply company on the ground floor and an establishment run by Goldie Reide on the second. This establishment was rumored to be a brothel the locals called Goldie's Place. While other companies opened and closed on the first floor, she quietly ran her business for twenty-plus years on the down-low. Apparently, Kansas authorities were more interested in keeping an eye on gambling and drinking than what she and her clients were up to. They largely left her alone until Mr. Smith, who owned and started S&H Bakery, finally decided to shut her upstairs business down. In due course, the building housed several different businesses until Rick Goehring and J.B. Hunt decided to launch Walnut River Brewing Co.

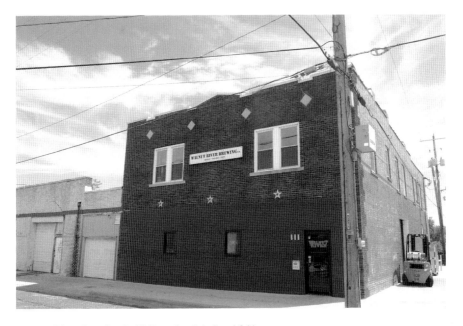

Walnut River Brewing in El Dorado. *Bob Crutchfield*.

Rick was a twenty-plus-year IT professional with a lot of computer engineering, physics and chemistry education. But he also had more than fifteen years of homebrewing experience and an obvious passion for craft beer. In what is usually the opposite of many "homebrew spouses," his wife actually pushed him to start his own brewery. With her go-ahead, he enrolled in the American Brewer's Guild's Craftbrewers Apprenticeship program, a six-month educational program that teaches the science and engineering behind producing superior craft beers as well as how to successfully run a brewery.[60] (This is a premier program, as all applicants must show transcripts proving completion of college-level mathematics and science courses to be admitted.) After Rick finished this program, he took college business courses before launching his own brewery. This was important to Rick because he wanted the confidence to be able to run a successful brewery and make good craft beer. He also knew he would need a partner to share the load.

Rick met B.J. Hunt through mutual acquaintances in the local beer scene. B.J. was also thinking of starting his own brewery in the Delano district of Wichita. With his executive MBA and over eighteen years' experience running a family-owned company, he had a lot of business experience and

education to bring to the table. Even though he didn't know how to brew beer at the time, he was confident he could bring the necessary marketing, sales and customer-relations expertise to the equation. But before B.J. could make the commitment to come on board, he had to try some of Rick's beer. They met and had a beer from Rick's old two-barrel brew system. "I tried one of his beers and thought—'Your beer does not suck!' That made the decision to invest much easier," BJ said with a grin.

They fine-tuned the beers and recipes from the pilot line and put out consistently great beers. Everything was coming together. The two hit it off and agreed to start the brewery. Where to put it though? B.J. was pushing for Wichita's Delano area (where eventually Aero Plains Brewing would start), but Rick had previously invested in the current two-story building in El Dorado. Knowing it had good potential, he had purchased it about ten years before the two met. But the deciding factor actually came down to the water. They needed a large amount of consistent water with the desired mineral content and pH. They both tested water from different potential locations and found that the water in El Dorado was perfect, so El Dorado won out. They spent a year trying to find investors but eventually decided to make a go of it themselves, largely with conventional financing. "We proved the concept to the bank, to ourselves, and most importantly our wives! Because if they're not on board, ain't nobody going anywhere!" laughed B.J. Soon, he and Rick also convinced Travis Rohrberg, a microbiologist who had been working there "for beer," to join as a full partner. They pulled their seed money together and, along with some additional investor money, secured financing to provide the necessary funds to launch a full-scale brewery. Walnut River Brewing was born in early 2015 as the first known production brewery in El Dorado history.

The brewery started out on a small pilot system next to the main building. The guys continued working out production recipes and were open on weekends to a small but growing crowd of locals interested in trying out their fresh beers. All the while, they were making plans to renovate the building, order and install the brewing system and generally get the brewery up and going. They have a taproom but decided not to have an on-site restaurant. Rick and B.J.'s business model, and main focus for all their efforts, is to build a multistate distribution enterprise providing terrific craft beer to all of Kansas and states beyond.

Nearly everything in the taproom is repurposed from the area and gives a nod to Kansas's historic past. For instance, the trim is from B.J.'s uncle's

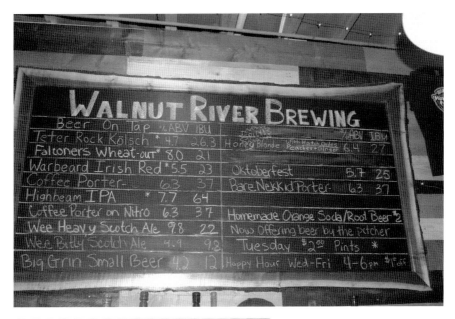

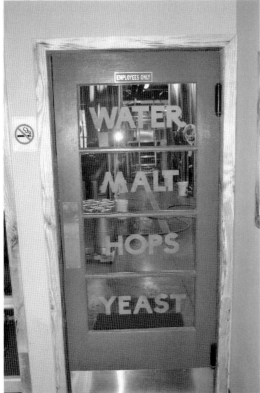

Above: There is an ever-changing taproom selection at Walnut River Brewing's main brewery in downtown El Dorado, Kansas. *Bob Crutchfield.*

Left: Beyond this door lies Walnut River's brewery house, where the German purity laws of Reinheitsgebot rule. *Bob Crutchfield.*

property in the Flint Hills. They made all the taproom furniture from various recycled items, including furniture from grain pallets, the crate that the glycol lines were shipped in, a walnut wood iPad holder from Greenwood County and a converted stainless-steel sink that was once used to feed cattle. The most unique piece of foraged Kansas furnishings is the sales counter. It's a three-inch-thick piece of Kansas white oak that is nearly nine feet long that anyone can sign when they visit. The door upstairs to their offices is believed to be from the Boeing B-52 plant in Wichita. Even the cool Kansas street signs in the taproom were procured locally (and legally). The one-hundred-year-old reconditioned door between the taproom and the brew house displays the Reinheitsgebot, sometimes called the "German Beer Purity Law" in English, to remind all who enter of their commitment to making good quality craft beers.

The current brew house is built around a large thirty-barrel brew system and has a large through-put capability. In a fun reference to the brew demand, each thirty-barrel fermenter is named after a car from the 2000 movie *Gone in Sixty Seconds*.

In addition to the variety of seasonals available at the brewery taproom, Walnut River's year-round, or flagship beers, can be found in many stores and bars across the state. Their most popular brews are **Warbeard Irish Red** (smooth, malt-focused beer with a caramel and toffee-like sweetness), **High Beam IPA** (a hoppy beer brewed exclusively with the **Falconer's Flight** hop blend), **Teeter Rock Kolsch** (a light beer with a mild pilsner malt and noble Czech Saaz hops aroma), **Coffee Porter** (a lighter robust porter) and **Falconer's Wheat** (a wheat beer with a bready, hoppy and lemon citrus note).

Already doing very well, Walnut River's business model shows continued growth and expanded distribution into other states. BJ asserted it must be nice, controlled growth. "If we grow too fast, the bank will freak out. If we grow too slow, we'll freak out! So, we try to stay on the nice middle-freak out road." One of the next endeavors being planned is to open a branch brewery in the Delano district of Wichita, where B.J. originally thought about starting the brewery. This auxiliary branch will be called Pour House and will open in early 2019.

THREE RINGS BREWERY

Category: Microbrewery
Address: 536 South Old U.S. 81 | McPherson, KS 67460
Phone: (620) 504-5022
Web: www.threeringsbrewery.com
Facebook: www.facebook.com/threeringsbrewery
Hours (taproom): Thursday–Friday, 3:00 p.m.–7:00 p.m.;
Saturday, 12:00 p.m.–5:00 p.m.

Three Rings Brewery and taproom is located near the airport, west of McPherson. It's set back from the road in a metal building that blends in with some of the other industrial structures in the area. The town has a population of only around 13,100, but its citizens should feel privileged to have their own microbrewery. And all should make a point to visit Three Rings to sample the splendid and unique craft brews made by owners Ian and Shayna Smith.

Ian comes from a family of brewers and is resurrecting its traditions, which go all the way back to the early 1500s. His twelfth great-grandfather Berend Brauer was a brewmaster in Einbeck, Germany. In fact, it was documented that Martin Luther's favorite beer was from Einbeck. The founder of the Protestant faith was so fond of Berend's beer that he arranged for a cask of it at his wedding.

The name *Three Rings* comes from Martin Luther's grand stein, which had "three rings" around it that stood for the Ten Commandments, the Creed and the Lord's Prayer. He allegedly boasted that he could encompass all three while drinking from his personal stein. It is this vision, of Martin Luther drinking Berend's beer, that was the genesis of Ian's brewery. The tradition and love of brewing and drinking good beer are undoubtedly in Ian's blood. He and Shayna looked around the state when deciding on siting their brewery and settled on McPherson because it's close to where Shayna was raised and the support of both the McPherson Chamber of Commerce and the locals for a brewery.

Three Rings opened in 2016 with a 7-barrel steam-fired brewing system with three 7-barrel fermenters, a 20-barrel fermenter, a 7-barrel mash/lauter tun and a 7-barrel brite tank. The Smiths estimate they could turn out between 1,000 and 1,200 barrels per year.

Ian started thinking of getting into brewing all the way back in high school and was able to actually start brewing during his time at Kansas

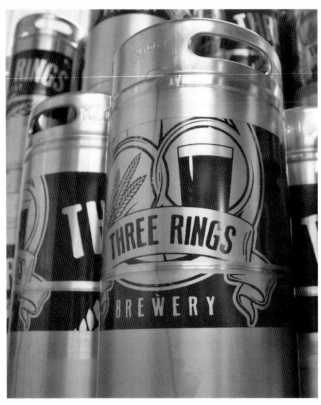

Left: The "Three Rings" remind all of their historic roots at Three Rings Brewery in McPherson. *Bob Crutchfield*.

Below: Ian's beautiful wood and brass tap handles are ready to pour at Three Rings Brewing. *Bob Crutchfield*.

State University in the food science program. While still in school, he got an internship at Boulevard Brewing in Kansas City in its quality department; after graduating, he went on to be one of the initial employees at Tallgrass, helping start up its quality department. Because of his experience in quality control at the previous breweries, one of the main aspects of this brewery is the focus on quality control in brewing—both in the process of brewing and in the consistent quality of the beers brewed. You will not often see this attention to detail and repeatability in a brewery of this size.

Three Rings brewery is generally open to the public Thursday through Saturday, and one can purchase fresh-brewed beer by the glass or thirty-two-ounce squealers. "It's not technically a 'taproom' per se, as there are no tables to sit around, but you can come in and stand there with a drink," Ian said lightheartedly. The beers can also be found in many restaurants in the central Kansas area. With a canning line up and going, you can also get a variety of their year-rounds and seasonals through distribution. Demand is high, so look for Three Rings to increase system capacity soon.

Three Rings has seven beers available year-round, with a seasonal Oktoberfest in the fall. The most popular is the **Yankee Rose** blonde ale, followed closely by an IPA called **Vertigo**. The most unusual is the smoky **Wiesenbock**, which some say smells a bit like bacon. From what Ian's family has been able to determine through research, this was as close as possible to the recipe Berend used to brew Martin Luther's favorite beer. (You can't beat both bacon AND beer!) Martin Luther had it right apparently.

River City Brewing Co.

Category: Brewpub
Address: 150 North Mosley Street | Wichita, KS 67202
Phone: (785) 404-2159
Email: chris@rivercitybrewingco.com
Web: www.rivercitybrewingco.com
Facebook: www.facebook.com/RiverCityBrewingICT
Hours: Sunday, 11:30 a.m.–10:00 p.m.; Monday–Tuesday, 11:00 a.m.–10:00 p.m.; Wednesday–Thursday, 11:00 a.m.–12:00 a.m.; Friday–Saturday, 11:00 a.m.–2:00 a.m.

If you want to see Kansas heritage while drinking great craft beers, this is a great place to visit. Opened in March 1993, River City Brewing holds the distinguished title of the first post-prohibition brewpub in Wichita and only the second brewpub established in the state. It can be found on North Mosley Street, a brick paved road just north of Douglas Avenue in the heart of Old Town. The brewery is situated in a beautifully restored two-story red brick building originally completed in 1909 as an expansion for Hockaday-Bennett Paint company.[61] It manufactured paint for the hot and dry climates of the Southwest and only remained in that location for a few years.[62] The building was subsequently occupied by a variety of proprietors and businesses over the years, including Lehman-Higginson Grocery Co. and tanners James C. Smyth and J.R. Johnston Hide companies. For several years after the brewery opened, you could still see faint signs for "hides," "furs" and "pelts" on the brick interiors beneath the second-floor windows. Unfortunately, these have faded and are no longer visible.

River City Brewing endeavors to keep the tradition of the old Kansas heritage and history appropriate for its location. In addition to being located in the historic Old Town district, the brewpub is like a museum of historic Kansas. Its entryway has repurposed leaded-glass windows from the old Vivkers Mansion in Wichita. The original bar was made from restored wood from the old Salvation Army building on Douglas Street. The wainscoting was recovered from the old Axtell House in southern Jackson County. The wood for booths was saved from homes on Quality Hill in Kansas City. The pews and lights came from a church in Cheney, and the bench just inside the door was supposedly reclaimed from a Dodge City saloon.[63]

In addition to a brewpub location at the Wichita Airport, where it's the only craft beer sold, River City Brewing offers sixteen taps as well as fresh food and a great relaxed environment at the main downtown location. The brewery has a seven-barrel steam-fired boil kettle from which batches feed into four corresponding seven-barrel fermenters or double-batch into one of four fifteen-barrel fermenters.

But back in 1993, it opened with only six taps. These were the five flagships and one dedicated to Bud Light—an impressive variety of craft beers for the time. Back then, especially in Kansas, about the only beers offered, or most people were familiar with, were the Budweisers, Millers, Coors and other similar lager-style beers. In fact, longtime owner Chris Arnold tells of the early days here when it was difficult to sell house-made beers because no one really understood craft beers and had not yet tasted or experienced the offerings we are accustomed to today. "Back then, we couldn't hardly give

Brewer Ryan Kerner takes a breather next to artwork from some of the favorite beers at River City Brewing in Wichita's Old Town. *Bob Crutchfield*.

One of the kegs from River City Brewing, Wichita. *Bob Crutchfield.*

the craft beer away," said Chris. So, as a way of introducing its brewed beers, every time customers ordered a Bud Light or bottle of domestic light beer, the servers were instructed to give them a sample glass of wheat beer to let them experience what real beer tastes like. Over time, more and more patrons came in for the craft beer to the point where Chris decided to get rid of all the commercial beers. The staff brought everything out, stacked it up, took a picture and publicized to all that it was no longer going to be sold here. If you come in and want a beer, you're going to have to choose one of River City's.

As a result, there was no noticeable downturn in beers sales. In fact, River City's craft beer sales kept growing, and in 2006—at the urging of longtime brewer Dan Norton—the offerings expanded to ten taps and eventually increased to sixteen. These include eleven rotating beers and five flagships. Dan, who has since started his own brewery in town, relayed that it's a lot of work keeping up with sixteen taps, but the brewers here have fun offering their customers a large variety of seasonal and different beers through the year.

The flagship beers available here are **Harvester Wheat**, the bestseller, light and easy to drink with the brewpub's food offerings; **Tornado Alley**

IPA, an aggressive, hoppy and bitter West Coast–style IPA; **Rock Island Red**, a red ale with a good malty character and a small amount of hop backbone to it; **Old Town Brown**, an American-style brown ale; and **Emerald City**, a biscuit stout on nitro.

The current brewmaster is Ryan Kerner. He was the assistant brewer here with Dan for five years. Ryan is looking to continue the consistency and quality of the beers on tap while creating some new seasonal offerings along the edges of the craft beer drinker's palate. His target offerings are expected to be fruity citrus IPAs, big and bold stouts and different sour beer options.

CENTRAL STANDARD BREWING

Category: Microbrewery
Address: 156 S. Greenwood Street | Wichita, KS 67211
Web: www.centralstandardbrewing.com
Facebook: www.facebook.com/centralstandardbrewing
Hours: Tuesday–Thursday, 3:00 p.m.–10:00 p.m.;
Friday, 3:00 p.m.–12:00 a.m.; Saturday, 12:00 p.m.–12:00 a.m.;
Sunday, 12:00 p.m.–5:00 p.m.

To many, including the owners of this young brewery, Central Standard Brewing is a story of unanticipated accomplishment in the world of microbreweries. Located south of Douglas Street just across from Wichita's Hyde Park is one of the area's most popular and up-and-coming breweries—with a recent national beer award under its belt. Opened in August 2015, Central Standard has become a big hit in Wichita's craft brew scene. The beers are so popular with the craft aficionados in the region, the brewers are constantly obliged to push their brewing systems to the max to keep up with the strong taproom demand. With the sure-to-be-expanded, in-house seven-barrel brew system, the owners surpassed their three-year plan within the first year and are busy trying to catch up with their success. A couple years after Central Standard opened, it leased a seven-thousand-square-foot warehouse for additional production, focusing initially on barrel aging and bottling limited-release beers.

It all started when high school buddies Andy Boyd and Ian Crane began brewing beer together on weekends as a hobby. Ian's day job at the time

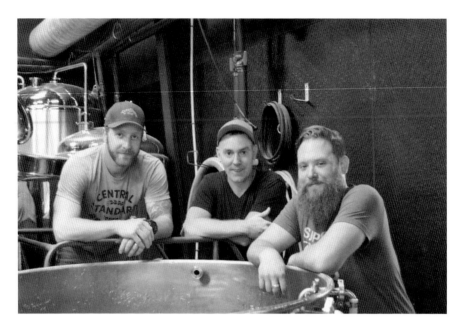

The owners/brewers of the wildly popular Central Standard Brewing in Wichita (*left to right*): Ian Crane, Andy Boyd and Nathan Jackel. *Bob Crutchfield.*

was in commercial real estate, and Andy was a broker dealing in gas and oil leasing. On most weekends, they brewed together on a system they shared, constantly perfecting and varying their recipes. They did this for about ten years, eventually hosting a yearly party with friends to share their latest batches. Everyone loved their beers. After a while, as is the case with so many homebrewers, they began to talk about moving their craft to the next level and starting their own brewery. In 2010, they began putting their plans on paper and created a business plan. The plan was to keep their day jobs and, with their wives' help, just brew on their off hours and run the place by themselves and maybe hire some part-time help if it got busy.

In December 2013, Andy and Ian found a good spot with a building that should be perfect for their plans. Andy disclosed that the building "had previously been a scuba shop, drive-thru fish market and more recently owned by a roofing contractor." But the large window-paned garage doors were perfect for their brewery-concept plans. The only issue was that it was directly across from a park. The Wichita City Council would have to weigh in on allowing them to run operations there; a zoning variance would be needed. The guys made their pitch, and with enthusiastic support from local businesses and craft beers fanatics, they were able to persuade the

council in their favor so long as they restricted their evening hours and did not sell hard liquor. That was a deal to Andy and Ian, but it did delay the start by about six months. After approval from the city, construction and remodeling of the building began, and Central Standard Brewing finally opened in August 2015.

Fashioned after other similar microbreweries the two had experienced while doing research, the brewery has an open space with the brew house kettles on display, front and center, as patrons walk in the door. The garage doors open to a beer garden in front with hop plants growing along poles and trellises. Ian's wife, Sumer, is a fan of vintage furnishings and began decking the seating space with old 1970s orange and green chairs, couches and dining tables. Despite the description, the interior has a relaxed and fun look and feel. One can't help but think of sitting in grandma's dining room enjoying family and stories while drinking a great craft brew. Emily Boyd stays busy managing events, while Sumer manages the taproom.

When asked about how they chose the brewery's name, Andy said they whittled it down from a list of about two hundred. Many of the ideas they considered had already been taken. Central Standard ended up their preferred choice and turned out to be an ideal name for a brewery here in the heart of Kansas.

The brewery offers many mainstay beers but excels in brewing some of the trendier and increasingly popular craft beers like hazy IPAs and intentionally tart beers called sours and "Bretts." These are tricky beers to make well (which they do) and require a lot of care and patience to produce. Sometimes taking months to mature, they are brewed by adding fruit to spur a secondary fermentation or, for the sours and bretts, by adding *Lactobacillus* or *Brettanomyces*.

With the initial success and popularity of the brewery, Ian and Andy almost immediately needed help to keep up with the brewing. They asked Nathan Jackel, a friend who had been an assistant brewer under Dan Norton over at River City Brewing, to come on as a partner. Nathan has a love for the sours along with Ian and Andy, so it was a perfect fit.

Not long after they were up and running, Central Standard decided to take a road trip to Denver for the Great American Beer Festival. It's a yearly event started by the godfather of homebrewing and founder of the Brewers Association, Charlie Papazian. Like a call to Mecca for the faithful, each year, breweries and craft beer enthusiasts converge on Denver for a three-day competition in mid to late September. It is a festival and competition celebrating anything and everything craft beer–related. The event attracts

thousands of visitors from all around the world to sample thousands of different American craft beers. The main event is the beer competition, which pits brewers of all walks against one another. Over one hundred certified beer judges select medals for the ninety-two (as of 2015) different beer styles. The beer the team from Central Standard entered, and won a silver medal for, was a Belgian-style ale. It was one of the first beers they brewed and represented a nearly forgotten kind of beer. It was originally made in the Belgian-French region years ago as the workingman's beer. It is a farmhouse ale purposely brewed with a lower alcohol level so as to be consumed by workers pretty much any time of the day. Bringing back a silver medal in a brewery's first year was almost unheard of. (Lb. Brewing in Hays also did this back in 2005.) No other entrants from Kansas medaled that year. It just proves the team's ability to bring first-rate and diverse beers to its customers. The team's most recent win at the 2018 GABF was for a beer called **Pushing Trees** in the historical beer category. It's a unique style called a Norwegian Raw Ale and is made using an "open fermentation" process with juniper branches for essence.

When in Wichita, stopping in at Central Standard, or as everyone calls it, CSB, is a must. The taproom will always have the fabulous **Wizard of Hops** IPA on tap, as well as the **Girlfriend** hoppy wheat. The biggest hit these days is the **Yard Games** fruited gose-style beers. The brewers have a rotating fruit selection that keeps everyone coming back. In the past, they've made an Arnold Palmer, a Piña Colada and a strawberry-banana version. Every time they brew, the brewers keep it interesting by change up the fruit flavor.

AERO PLAINS BREWING

Category: Microbrewery
Address: 117 North Handley Street | Wichita, KS 67203
Phone: (316) 448-2811
Web: www.aeroplainsbrewing.com
Facebook: www.facebook.com/aeroplainsbrewing
Hours: Monday–Tuesday, 3:00 p.m.–9:00 p.m.; Wednesday,
3:00 p.m.–10:00 p.m.; Friday–Saturday, 12:00 p.m.–12:00 a.m.;
Sunday, 12:00 p.m.–8:00 p.m.

Aero Plains has a slogan: "We are at the crossroads of history and innovation," according to owner Lance Minor. "The Delano area is where Chisholm Trail came through, and Wichita's Travel Air was one of the first aviation companies in the area. The name Aero Plains celebrates the history and confluence of both." It's been a remarkable journey right here in Wichita. Riding horses along the trail to the advent of air travel in 1925 took less than fifty years. The people in this area were open to lots of risk but were ultimately successful. Lance and fellow founders Ryan Waite and Brent Miller are following in this tradition by creating a new brewery in Wichita's historic Delano District.

There's a lot of Wichita's historic and cultural imagery greeting patrons entering Aero Plains. The taproom reflects on the area's German history and offers modern seating for a more industrial look. The highlight is a bar made out of a wing from a Wichita-manufactured 1954 Beechcraft model 18. Part of this wing/bar top will automatically lower to accommodate those in wheelchairs. The room also serves as a small art gallery. Brent Miller, Aero Plains' chief operating officer, wanted to have a place where local artists could promote their works, and the taproom floor was finished with advanced epoxy made to look like a stormy Kansas sky.

The concept of Aero Plains Brewing was Lance's brainchild. He is a retired operations and mobility planner for the U.S. Marine Corps. Upon retiring from the service, the corps offered him the opportunity to take advantage of the Boot to Business program, which allowed him to intern at a business to learn how to transition out of military life and into the world of civilian businesses. Lance had a friend open a brewery, and since he was also a homebrewer and a certified beer judge (www.BJCP.org), Lance decided to intern for a brewery in San Diego called Black Market Brewing. He enjoyed his time there and picked up a lot of practical knowledge on how a brewery operates. Once he finished and returned to Wichita, Lance immediately began planning (something he is well trained to do) his own brewery. After the planning phase was completed, it still required ten months of construction to prepare the building, purchase and install the brewing systems and finish the place.

Aero Plains Brewing is located in the Delano District in Wichita. *Bob Crutchfield.*

Part of the wing from a Wichita-manufactured 1954 Beechcraft model 18 is now repurposed to serve craft beer here at Aero Plains Brewery in Wichita. *Bob Crutchfield.*

Aero Plains launched in 2016, helping to bring increased vibrancy to the Delano District.

Aero Plains Brewing sits in an industrial building large enough to hold both the brewery and taproom. It was previously owned by Huber Industrial Supplies until Lance and his partners bought and converted it into the robust and thriving brewery. The facility was designed with the capability to drive a significant portion of their output for distribution. The brewers currently have two twenty-barrel steam-powered brewing tanks, forty-barrel fermenters and a matching forty-barrel brite tank. Lance learned from other breweries that the cold room has always been a choke point, so he installed a massive cold room right behind the bar taps. Aero Plains also has built-in capacity to expand and a business model projecting a production output approaching seven thousand barrels per year.

The taproom has twenty taps, including at least one nonalcoholic option and a couple ciders. The rest are Aero Plains' craft beers. The number-one seller is **Dove Runner** red wheat beer. It contains over 50 percent red

wheat and roasted barley, giving it its red hue. As Lance described the beer, "It proves that not all dark beer is heavy." **Bingo's IPA** was another initial success. It's a classic hoppy IPA made with both German and American hops. It has a nice balance between piney and floral, appealing to a broad segment of "hop-heads" out there. In addition to these two flagship beers, the taproom offers the **Friendly Aviator** German pilsner on a year-round basis. This leaves a lot of taps available for seasonals and experiments to keep the faithful returning.

It's not difficult to find Aero Plains around Wichita and the state. In 2017, the brewery began canning its most popular beers for sale in stores across Kansas, and in 2018, it partnered with Hartman Arena to open its first off-premises taproom. But it's not always about the business, Lance confided. No matter where you purchase Aero Plains' fine craft beers, he wants customers to create memories and experiences with their friends.

Hopping Gnome Brewing Company

Category: Microbrewery
Address: 1710 East Douglas Avenue | Wichita, KS 67214
Web: www.HoppingGnome.com
Facebook: www.facebook.com/HoppingGnome
Email: contact@hoppinggnome.com
Hours: Sunday, 12:00 p.m.–5:00 p.m.; Tuesday–Thursday,
3:00 p.m.–10:00 p.m.; Friday, 3:00 p.m.–12:00 a.m.;
Saturday, 12:00 p.m.–12:00 a.m.

Hopping Gnome is located on popular Douglas Street in downtown Wichita. Started in May 2015 by Stacy and Torrey Lattin, it joined the growing list of breweries in Wichita's downtown sector serving the ever-thirsty craft beer enthusiasts in the city.

Torrey started out homebrewing back in 2009, brewing beer in his kitchen, as many do (until he or she gets kicked out). Torrey kept working on his recipes and perfecting them batch by batch. Eventually confident enough in his craft, he started entering some regional homebrewing competitions. In 2012, he won a regional gold medal at the fifteenth annual Masters Championship of Amateur Brewing for his Extra Special Bitter (ESB) style. This, in turn, qualified him to go to nationals. Surprisingly, his ESB won

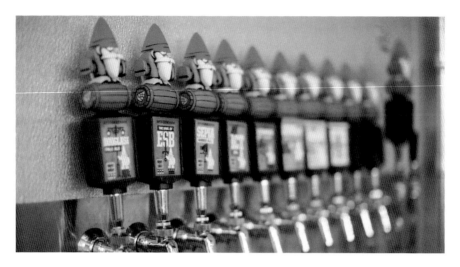

These little guys watch over the beer here at the Hopping Gnome Brewing company in downtown Wichita. *Courtesy Hopping Gnome Brewing Company.*

gold there as well. To top it off, he also won second place (silver medal) of all the beers entered that year. After doing so well at nationals, he joked to his wife, "Well, I guess we should start a brewery then, ha ha!" To which, she surprised him with a supportive, "Sure!" At the time, there were only two breweries in town, River City and Wichita Brewing, so the Lattins were fairly confident the demand for another brewery was there.

While still working full-time, Torrey and Stacy began developing a potential business model, looking for the right property and coming up with financing. The financing was supported in part by a successful social media campaign with Kickstarter. Torrey says of those contributing on Kickstarter, "90 percent were from Wichita, the rest from all over the country." The balance came from conventional sources, with no outside investors. They knew they wanted to locate the brewery in the heart of Wichita on Douglas Street, as this area was becoming more and more revitalized and was an obvious place to plant roots to grow their business. They bought the 1930s-era building where they are currently located and gutted everything unnecessary. They still wanted to show the building's natural character and structure, so they kept the unique and interesting stuff that would fit well in a brewery taproom. An example is the old air-defense map from the Korean War era still visible on one of the walls. The customer base loves the aesthetics here, and patrons threaten Torrey on a regular basis not to redo any of it.

As for the name, Stacy and Torrey labored for a while to come up with a unique one that would fit well with their concept of a small microbrewery. Brewery and beer naming is becoming increasingly competitive and difficult these days due to the thriving craft beer scene. Checking with the patent office database system, they discovered many of the names they landed on had been taken. One day, they started in the morning 9:00 a.m. and spent four hours typing names into the system. Around noon, Torrey went down to the basement to get an IPA. While drinking the beer, he saw on his bar a promotional gnome figurine he had acquired from one of the KC Royals all-star games. As he was drinking his hoppy beer, he had a eureka moment. With *hoppy beer* and *gnome* in his head, he ran upstairs and typed it in—no one else had it. He knew that folklore images showed gnomes drinking. It just fit so well, and the name was a hit. The taproom is now covered with gnomes—all gifts from patrons.

The Lattins decided that a five-barrel brewing system would be perfect. It would crank out enough to meet the taproom demand plus offer some up for distribution. When they opened on May 29, 2015, Torrey's plan was to keep his existing job and come in after hours and on weekends to brew. He thought to assess how the business was going in 2016 and maybe reduce hours or quit to focus full-time on Hopping Gnome. As has been seen so many times here in Kansas, the brewery demand quickly outstripped production. Torrey kept running out of beer in the initial weeks and months after opening. Being the only brewer, it demanded so much more of his time that he had to quit his "real" job and focus exclusively on his new and increasingly popular brewery. The brewery has been expanding its output ever since. To keep up, Hopping Gnome added additional brite tank capacity to the original setup and recently opened an extra day, leaving Mondays for the gnomes to rest.

The taproom keeps six taps dedicated to flagship beers plus two additional taps for rotating seasonals. Hopping Gnome generally offers up one or two different seasonals a month along with firkins on the third Thursday of each month. (A firkin is a small keg made of metal or wood containing around seventy-two pints. It's usually a fun/messy process to open these, as the tap is driven into the keg horizontally and a breathing hole is then tapped on top through the bunghole. Lots of fun if you're not directly in the range of fire when the beer starts spewing!) The year-round offerings are **Douglas Ave. Pale Ale** (a Belgian pale ale, hopped with Jarrylo hops), award-winning **Earl of ESB** (English Special Bitter), **Sepia Amber** (amber ale), **ICT IPA**, **Steampunk Saison** (Belgian) and the **HBIC Sour** (kettle sour beer apparently made for the Head *Beauty* in Charge). On your next visit, ask for the 2018 GABF silver award–winning beer **Sepia Amber**.

NORTONS BREWING COMPANY

Category: Brewpub
Address: 125 North St. Francis Street | Wichita, KS 67202
Phone: (316) 425-9009
Web: www.nortonsbrewing.com
Facebook: www.facebook.com/nortonsbrewingcompany
Email: info@nortonsbrewing.com
Hours: Tuesday–Thursday and Sunday, 11:00 a.m.–10:00 p.m.;
Friday–Saturday, 11:00 a.m.–12:00 a.m.

The newest addition to the Wichita brewing mecca is Nortons Brewing Company. Dan and Becky Norton are the owners and general managers of what is one of the larger brewpubs in the historic Old Town section of the city. It's built on the site of the old Aldrich pharmacy, which was in business in the late 1800s and sold bottles of cure-all elixirs of the day. Several bottles, along with other turn-of-the-century artifacts, were unearthed on the site as Nortons Brewing was being built and can be found on display in the brewery.

In addition to owning and operating this new brewpub, Dan Norton is the head brewer. He comes with many years of experience, having been the assistant, then head brewer, for River City Brewing. He started brewing when River City's brewer was tapped to become a brewer for Boulevard Brewing in Kansas City back in the early 2000s. Since Dan's grandfather had taught him how to brew beer just after he was out of high school, Dan was the only one with any kind of brewing experience when the brewer left. The brewer asked all of the staff if anyone had brewing experience, and Dan was the only one who raised his hand. He taught Dan the system and recipes and had him go through an internship at the now defunct 75th Street Brewery for a while. After completion there, he was handed the reins of River City. Being the only brewery in town, that made Dan the only brewer in the area until 2005, when Hank is Wiser opened up in nearby Cheney. Being the OG brewer in town, he remains a humble guy with years of brewing know-how and has always been available to new brewers in the area when they need advice. He prides himself on his experience and passion about brewing. Now it's his turn to jump in with his own brewpub.

The brewpub has a restaurant that serves great pub dishes, a separate bar area for top-shelf mixed drinks—"no crazy mixology stuff, just good drinks everyone will like," per Dan—an outdoor beer garden with a stage for live music, and a twelve-tap brew area he expects to be the main focus of the place.

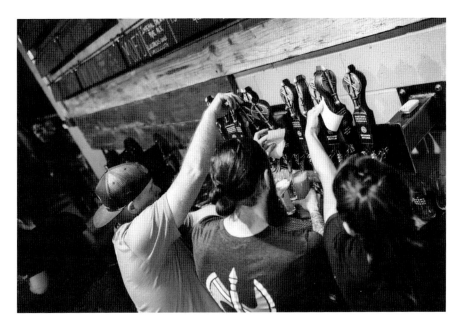

Nortons staff attempts to keep up with demand. *Courtesy Nortons Brewing.*

Becky is running the restaurant end of things and comes from a family of entrepreneurs. She also brings many years successfully operating a local pizza franchise and knows how the food establishment business works front and back. It was Becky who led discussions with Dan for years, sitting on their front porch after the kids were in bed, of how they should open their own brewery. She had confidence in her business skills and experience and Dan's many years of brewing. With this confidence, they both knew they would be able to launch Nortons Brewing successfully.

Dan has a zeal for brewing acquired over the years he brewed at River City. "I've never seen anyone so passionate about brewing. I've been with him over thirteen years and he's never hated his job," commented Becky. Dan started "at the bottom," so he knows from experience about all of the dirty jobs and hard work that goes on behind the brewery walls. He promises not to make any of his staff do anything he hasn't already done. As an example, washing kegs is a necessary but tedious entry-level job, but his staff can take solace in the fact that Dan has done this many times in his career. "Let me know when you've done this a thousand times," he says with a wink. Dan's not above any task in the brewery that needs to be done.

Like many brewers, Dan loves to brew and play with new recipes and challenge the boundaries of what fresh and noteworthy kinds of craft beers

he can concoct. He understands today's craft beer drinkers want to try out "the new stuff."

That's what's so fun about craft beers. There's so many breweries putting out so many different kinds of beers. And even if they're putting out the same beer, often it's a little bit different because different brewers won't make it the same each time. The fun part is going to the store and seeing what's new and bringing it home. Then you can't wait to open it up and smell it and try it!

Nortons Brewing wants to have a constantly changing offering of craft beer so that when you walk in, there will always be something new you haven't tried. "The days of the 'fridge beer,' where someone has the same beer all the time, are largely over. Craft beer drinkers want to always be trying something new," declared Dan. Nortons does not plan to stick with any one flagship beer for long so that Dan can keep things new and exciting for his customers. To understand the aggressive brewing style, just look to the logo. It's a letter *N* made into a battle-axe, which represents their determination to fight, scrape and claw with this life we are given.

A large beer garden was something Dan and Becky had always dreamed of with owning their own place. They initially wanted to build a countryside beer garden destination brewery on the outskirts of town. But they learned it would be significantly more expensive. It needed a steady stream of customers to stay solvent. "What would the Monday lunch crowd look like?" Dan confided. They eventually got pulled into the downtown Wichita craft beer resurgence and vibe but kept focusing on what might give the same look and feel. Luckily, the property they found would allow them to offer the cool beer garden vibe they always wanted. Keeping the shell of the existing building and reconfiguring almost everything inside resulted in a different sensation and energy compared to other breweries in the area. The main brew house and restaurant area sports a large domed roof and a nicely furnished interior with ample seating. The beer garden opens up to allow several hundred customers to enjoy the weather and occasional live music. The whole place is made to be family friendly inside and out. Dan and Becky were insistent about this. They have their own small children and don't want anyone to feel like they can't bring the whole family.

Dan installed a state-of-the-art fifteen-barrel system from Alpha Brewing Operations. The system has matching mash and lauter tuns with fifteen-barrel fermenters and brite tanks sufficient to keep the twelve taps up front

busy as well as additional capacity to support distribution. The building also has space allocated to expand or install an in-house canning line. Look for Nortons to offer special bottle releases (bourbon-aged, kettle sours and more) through the year.

Being a family-run brewery, it's natural to have select beers already established for each member of the family. These are slated to be brewed on special events or birthdays. Each member has picked his or her own named beer and associated artwork. Becky's is the **Hoppy Heffe**, which is a doubled-hopped Hefeweizen. The kids selected **Polka Dot Princess**, a Belgian gold strong ale aged on peaches; Milo's **Sparkly Eyes**, a West Coast IPA named after their son's dog; **Don't Poke the Bear**, an imperial milk stout with coffee, chocolate and vanilla additions. Dan doesn't really have one just for him—"They're all my babies," he said with a proud smile.

WICHITA BREWING COMPANY

Category: Microbrewery and Brewpub
Address: East: 535 North Woodlawn Street | Wichita, KS 67208; West:
8815 West Thirteenth Street North Suite 100 | Wichita, KS 67212
Phone: (316) 440-2885
Web: www.wichitabrew.com
Facebook: www.facebook.com/wichitabrew
Email: jhorn@wichitabrew.com
Hours: Sunday–Thursday, 11:00 a.m.–10:00 p.m.;
Friday–Saturday, 11:00 a.m.–11:00 p.m.

To say that Wichita Brewing Company (WBC) has been adopted by local craft beer enthusiasts is an understatement. WBC started brewing craft beers in August 2011 on West Thirteenth Street. At the time, it was the second brewery to start up in Wichita. The locals now refer to it as "Wichita Brewing West" because the owners opened an additional brewery location on the east side of town on Woodlawn called "Wichita Brewing East." Both locations brew and serve their own draughts as well as some of the best award-winning wood-fired pizza found in the city. In fact, demand is so high for its beer, a few years ago, the owners smartly constructed an eighteen-thousand-square-foot production brewery just

Famous John Brown would have been better off had he dropped his gun and picked up a couple steins of beer, as depicted here by Wichita Brewing Company in Wichita, Kansas. *Courtesy Wichita Brewing Company.*

south of downtown to keep up with the demand. The brewers can create and distribute their beer across the state and beyond. Acknowledging that local demand has been so high for beer and pizza, WBC is expanding again to a new nine-thousand-square-foot site across from the east location that can be used as a venue for parties, weddings, corporate events and other social functions. This makes good sense because WBC has been catering parties and events for several years with its Hopperoni Express food truck delivery business.

Wichita Brewing is the brainchild of Jeremy Horn and Greg Gifford. They have known each other for many years and are brothers-in-law. Greg was the founding partner; he had the initial idea and vision to open a brewpub and craft beer distribution business. Like many startup brewing ventures, one of the team is usually a longtime homebrewer, and in this case, Greg knew Jeremy was a great homebrewer and thought, with his brewing skills and knowledge, they could make a go of it. After discussions on what the business prospects might be for this venture, the kind of brewery they would try to open, location and so forth, they both agreed to take a leap of faith and launch WBC as a brewpub on West Thirteenth Street with Jeremy as the head brewer. Obviously, it was a great decision.

The company likes to have fun with different beer styles and a wide choice of pizzas. But in addition to the great craft beer and food, Greg loves to design and build copper pieces for the restaurants. He made the bar tap handles, the unique sculpture of John Brown holding two steins of beer outside the restaurant and something called a "beer-amid." This is an insanely interesting copper beer contraption that holds sixteen sampler glasses of the restaurant's craft beers delivered table-side. It costs about twenty-five dollars and holds up to eighty ounces of beer. This is a great way for the table to try out many of the different beers on tap at one time. This serving carriage is tremendously popular, and once the "beer-amid" makes its debut for the day, the wait staff is typically put on notice that its appearance at someone else's table is requested at the very next opportunity.

Patrons making their own Wushock Wheat beer-amid at Wichita Brewing. *Courtesy Wichita Brewing Company.*

Wichita Brewing Company didn't start that fast according to partner and operations manager Kyle Banick. "We're beer people," and although production and distribution were part of the original plan, "we grew the brewery part of the business to meet demand." As previously mentioned, Wichita's demand for craft beer has grown immensely over the past few years, and WBC's capacity now exceeds it. WBC essentially has a 15-barrel brew house but can do 20-barrel brews to feed into nine 60-barrel and 30-barrel fermenters. At full tilt, WBC could do up to 14,000 barrels per year from all of its brewing sites combined. However, the brewery is operating with excess capacity for the future and is seeking to maintain a 2,500-to-3,000-barrel annual production. Some of the tanks used in its expansion came from Tallgrass Brewing up in Manhattan. Tallgrass was going through its own expansion, and WBC got wind of this and offered to buy any excess tanks. Tallgrass agreed and helped deliver them to Wichita. "Tallgrass has always been good to us," remarked Kyle. "Their owner, Jeff Gill, helped us out a lot. It was interesting to install these huge tanks, as they had to be transported sideways from Manhattan to our central brewing facility, then

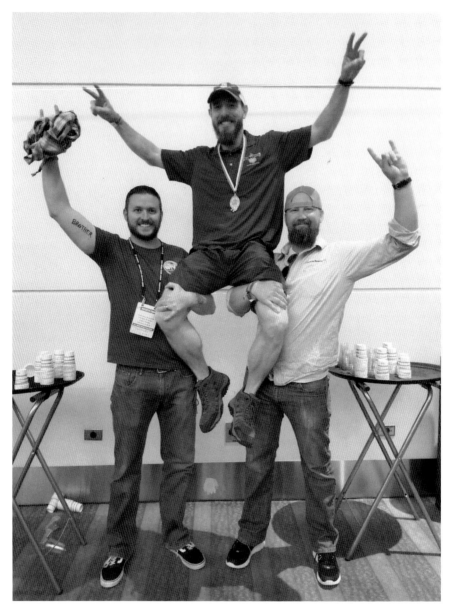

The team from Wichita Brewing Company (*left to right*) Jeremy Horn, Ned Vahsholtz and Kyle Banick celebrate their win at the Great American Beer Festival in 2017. *Courtesy Wichita Brewing Company.*

hoisted up vertically down into the brew house." It's fun to note that, like at Radius Brewing in Emporia, many of the fermentation and other huge tanks still have Tallgrass's naming scheme and artwork on them. In the central brewing facility, you'll see tanks labeled with large images and names of different albums, bands or artists on the side of them.

Canning at the central brew facility is cranking out the most popular and bestselling flagship and seasonal beers. The owners have no plans to go into bottling. "Too big an investment," said Kyle. This follows the trend of many breweries moving away from bottles and falling back to cans. WBC has also begun offering barrel-aged beers and is planning to introduce sours very soon. The brewers keep the quality high with their in-house beer quality assurance program assisted by a local Wichita State University microbiologist, who takes plate samples and studies samples on an ongoing basis to make sure the beer is consistent and within specifications to intended recipe profiles.

On top of WBC's success in Wichita, it joins the prestigious ranks of only a handful of nationwide brewers to bring back a medal at GABF. In 2017, the team came back with a silver medal in the English-style brown ale category for a beer they call Shaven Yak.

Besides WBC's ever-changing seasonal offerings, the biggest seller in its brewpubs is the **WBC Wheat**, an American-style wheat beer. However, the biggest overall seller is the **V.6 IPA** sold in cans through distribution. It's a Cascade- and Amarillo-hopped India pale ale. Their other flagship beers available year-round are the **Valleyview Vanilla Porter**, **Half-Wit Wheat**, **Thunder Blonde**, **Belgian Dubbel**, **5:02 Amber**, **English Mild** and **One Hopper Pale Ale**.

THIRD PLACE BREWING

Category: Microbrewery
Address: 630 East Douglas Suite 150 | Wichita, KS 67202
Phone: (316) 833-2873
Facebook: www.facebook.com/ThirdPlaceBrewing
Hours: Wednesday–Thursday, 4:00 p.m.–10:00 p.m.; Friday, 4:00 p.m.–11:00 p.m.; Saturday, 12:00 p.m.–11:00 p.m.

Third Place Brewing opened in August 2016 on Douglass Street in historic downtown Wichita and is the inspiration of local eye surgeon Dr. Tom

"Home, Work, and Beer" at Third Place Brewing in Wichita. *Bob Crutchfield.*

Kryzer and professional test pilot Jason Algya. Their concept for this microbrewery was to create a space for customers to enjoy their "third place" in life. As made popular by Ray Oldenburg's book *The Great Good Place*, a person's third place is a social surrounding separate from his or her usual settings of home ("first place") and work ("second place"). Tom and Jason's desire is to have a place where customers can come in, relax to some good music, have a great craft beer and enjoy the company of friends and neighbors while getting away from the other demands of the first and second places in life.

Like many others in the business, both Tom and Jason were homebrewers for many years. They met while Jason was coaching Tom's daughter's soccer team and talked about the concept of having their own third place in life. After discussing with their wives, they gained permission and soon began to discuss creating a brewery. However, their wives imposed one essential edict on them: no loans were to be taken to establish their brewery. This meant no banks and no crowdfunding. They had to find a good spot and build it all on their own. This did not stop Tom and Jason but did slow them down, as they had to construct the bar, furnishings and actual brewing system from scratch. The bar top was made from repurposed

local wood and the 1.5-barrel brewing systems was largely made from a variety of vessels, plumbing supplies and electronics purchased or picked up from numerous sources. They even made their own glycol chillers by retrofitting a window air-conditioning unit. The outcome of their efforts has been very fulfilling, as they now have a system for which they know every aspect in great detail.

An interesting coincidence was found out after they selected the location of their brewery. They knew, of course, that their street-level location in the three-story brick building on the 600 block of Douglas Street had been originally built in the early 1900s by a large and successful cigar manufacturing company called Schnoor Cigars and housed a variety of businesses over the years. They did not realize that it was once the same location as one of the oldest saloons in Wichita, the Jack Eckert Saloon, or the "Jack Eckert property," as the newspapers referred to it. It turns out that Third Place Brewing unintentionally came full circle back to its roots as a brewery.

Another fascinating incident turned up at this location back in April 1922. Schnoor Cigars had outgrown this location and moved out. As described by the *Wichita Daily Eagle*, the new owner had workers demolishing some of the interior spaces when they discovered a "Booze Cache" of two cases of liquor stashed away at the end of "a winding tunnel more than 40 feet long, which twisted and turn in all directions. In several places doubling back upon itself."[64] Just two years into national Prohibition, this cache was obviously secured to keep it away from the eyes of any local revenuers (agents from the Bureau of Prohibition), and its discovery was certainly upsetting to whoever went through all of this effort to secure it.

As for the beers on tap here, "We brew pretty classic to style," said Tom. Third Place has eight taps and will usually keep **Black Toro** milk stout on nitro, **Ali's Pale Ale**, **Spring Board** blonde ale (first rung on Third Place's craft beer ladder) and **Red Truck IPA** on tap. Tom and Jason are also working on iterating their seasonal, **Nimrod IPA**, into a hazy New England–style IPA and like to create different dark beers for the cooler/ winter months. They are also looking to grow organically into a larger brewing system on the same historic property.

LIMESTONE BEER CO.

Category: Brewpub
Address: (Inside Sweet Allie B's restaurant) 707 North Waco Avenue
Suite 105 | Wichita, KS 67203
Phone: (316) 729-6200
Facebook: www.facebook.com/limestonebeerco/
Hours: Sunday–Wednesday, 10:30 a.m.–4:00 p.m.;
Thursday–Saturday, 10:30–12:00 a.m.

Located just across the river from Wichita's Central Riverside Park is Limestone Beer Co. Opened in April 2017, it's one of the latest breweries in Wichita's flourishing and constantly expanding craft beer businesses. The brewery is located inside Sweet Allie B's restaurant (www.sweetalliebs.com), providing patrons the opportunity to enjoy the great food served here with fresh craft beer. A wonderful new wooden patio allows craft beer drinkers to step out and enjoy a good brew when weather permits.

Alex Lent is Limestone's owner and brewer. Born and raised in Wichita, he became interested in starting his own brewery after many family trips he and his wife had taken through Colorado. While there, they made a point to visit many of the smaller breweries and soon began to prefer these over the larger, more hurried, ones. The science of brewing particularly interested Alex. He bought a homebrew kit and started cranking out his own beers. He read a lot and watched instructional videos to dig deep into the chemistry of beer making. "It's chemistry and biology," he properly noted, "and I fell in love with the complexity of it. It so unique and intriguing." Constantly digging into the chemistry of brewing, he worked to understand many of the more advanced concepts of brewing. "What is the best temperature to mash a specific style of beer? What kind of grains to use? What are the effects of different types of yeast strains on beers?" Finally, after he had reached the necessary level of competence, he decided the time was right to bring some of his recipes to the market with his own operation.

Alex installed a three-barrel brew house, which is perfectly sized for this setting. He brews some conventional clean American- and German-style ales but loves to brew something different and appealing each brew day. He is particularly interested in mastering some of the more difficult brews like sours, Belgians, saisons, Wits and basically anything which can be fermented with *Brettanomyces*. Many of these brews are what he calls the "wild, mixed

fermentation stuff." He further explained that he's "done maybe thirty different kinds of craft beers so far. I love brewing different beers." Some of his beers have a higher "Kansas content" then others you'll find from other brewers in the state. He buys hops from recently established Kansas Hop Company and is beginning to get grains from another local supplier/farmer west of Wichita who started a malted grain company called Amber Waves Malt and Grain.

Limestone Beer Company has ten taps and will generally have these three flagship beers on tap on a regular basis: **Bret the IPA** (American wild ale), **El Hefe** (Hefeweizen) and **The Keeper** (a sour "Biere de Garde" as described on Untappd.com). All beer is sold on premises, but based on the success he is receiving from his current beers, Alex is looking to expand into a larger brewing system to feed local demand.

AUGUSTINO BREWING

Category: Brewpub
Address: 756 North Tyler Road | Wichita, KS 67212
Phone: (316) 721-5554
Web: www.augustinobrew.com
Facebook: www.facebook.com/augustinobrew
Hours: Sunday, 12:00 p.m.—9:00 p.m.; Monday—Thursday,
3:00 p.m—9:00 p.m.; Friday—Saturday, 12:00 p.m.—10:00 p.m.

If you want to try a new place that offers fantastic food, great beer, a nice cup of coffee and a relaxing place to hang out after work or on the weekends, you should stop by Augustino Brewing, opened officially on November 18, 2017. Owners and co-founders Geoff Finn and Augustino Iacopelli (ah-coh-PEHL-ee) are working hard to provide a place you can feel at home away from home or work, a *Cheers* (long-running television series from 1982 to 1993) environment where you can meet your neighbors and socialize.

Both co-founders met at the award-winning local Derby Brew Club meeting, which was hosted, at the time, in Augustino's home.[65] Geoff had recently earned his certificate in the business of craft brewing from Portland State University and was planning to start his own brewery until his potential partner dropped out. Augustino (or "Stino" as some call him) had sworn to himself that he would never open his own brewery. "Why would I make

Augustino Iacopelli (*left*) and Geoff Finn enjoy their latest brew at Augustino Brewing. *Bob Crutchfield.*

my hobby my job?" he often said, but he eventually came around after discussions with Geoff. Through the homebrew club and the other breweries in town, he figured they knew all the right people and had the contacts to make a successful go of it.

Although both owners have a solid personal history in brewing, Geoff has taken the role as VP over brewery operations and production while Augustino manages the front-of-house operations, overseeing the restaurant and marketing.

The name *Augustino Brewing* ended up as it is only because other names they liked were too close to those of other breweries. Geoff suggested they name it after Iacopelli's name as it was unique here in Kansas, and after all, "Hey, look at Augustiner in Munich Germany—they do a good job there, should work here!"

Geoff said they are still searching for their flagships. "We just want to make solid beer. We want to produce a number of different beer styles to help further educate the market." That said, he feels the year-round beers will probably be the **Bad Squirrel Nut Brown** ale, confidently described as being similar—but vastly superior to—a Newcastle; a yet unnamed dependable IPA; and a specialty beer such as their **Cold Case Imperial**

coffee stout or **Liquid Deception** vanilla hazelnut porter. Iacopelli offered, "In the space we've created here, we want to create an environment that provides 'moments of escape' as it's more about the experience we are trying to produce than to lock in too early on any one type of beer."

Augustino Brewing has also launched a mug club different from others. Customers can buy a membership, get a nice ceramic mug and come in for either a beer or a hot cup of coffee, depending on their mood. The owners feel it's another good way to create an escape for people to drop in and enjoy a drink and the company of others.

They brew on a three-barrel system with six matching fermenters supporting the ten taps at the bar. They plan to rotate their craft beers on a regular basis, always keeping one guest tap open for El Dorado's Walnut River Brewing as a nod to them for the help they gave Geoff during his time there as an apprentice brewer.

SANDHILLS BREWING

Category: Nanobrewery
Address: 111 West Second Street, Suite D | Hutchinson, KS 67501
Web: www.SandhillsBrewing.com
Facebook: www.facebook.com/SandhillsBrewing
Email: hello@sandhillsbrewing.com
Hours: Thursday, 3:00 p.m.–8:00 p.m.; Friday–Saturday,
11:00 a.m.–8:00 p.m.

Sandhills Brewing is tucked away in a nondescript building just off Main Street in downtown Hutchinson. It is the second, and most recent, brewery to open in the city, in 2018. Starting small and building on its successes, the brewers produce not only the exceptional flagship beer styles to which Kansas craft beer lovers are accustomed but also stand out from other Kansas breweries in that they specialize in "mixed fermented in oak" aged sour beers. These beers start out being brewed in the same conventional manner as other craft beers; however, midway through the brewing process, their beer, while still in its wort stage, is added directly to one of many wooden barrels along with brewer's yeast and specialized bacteria (usually *Lactobacillus* or *Pediococcus*), which creates the sour beers quite popular today. Then there's the wait, often for months and months, before

the beer is ready to be tapped from its barrel. After sampling to ensure the brew has transformed into the desired flavor profile, it's chilled and canned or bottled for consumption. For those who are sour beer fans, this is your place. There are only a few places in Kansas specializing in sour beers made on-site, and Sandhills is currently one of the best.

Sandhills was started by brothers Jonathan and Charles Williamson, who grew up north of Hutchinson in the Sandhills State Park area (hence the company name). Each brother had experience from hundreds of homebrewing batches, separately and together, before deciding to go pro and open this brewery. "We have consistent preferences in most beers we brew", said Jonathan. Over time, each brother learned to master brewing his preference of beer and worked to dial-in that style. Now, with their own brewery, they have taken to trading off brewmaster roles when it's time to make beer. Charles usually brews their Scotch Export and Berliner Weisse beers, while Jonathan has perfected their hazy and citrusy New England IPA and sour saisons.

Brewing sours is a risky process and takes a lot of patience because you don't really know how it's going to come out for quite a while after its been put in the barrel. In addition, each specific barrel gets its own bacterium inoculation once, after which that barrel is used to make a particular kind of sour beer. Brewers need to keep the beers below 70 degrees Fahrenheit during the entire fermentation period to prevent any *Acetobacter* (a form of acetic acid bacteria) from producing vinegars. If the sour beers begin to go in a direction they don't want, there is no turning back to fix it. The bad barrel can only be retired and another one started because once the wood from that barrel is inoculated, it can not be eliminated. But that's also a good thing if they produce good sours because they'll never need to reintroduce any souring bacterium for the life of that barrel.

The brothers' plans for the brewery are to go slow, like the barrel-aged beers they have aging, and grow their business without taking on a lot of debt. They soon plan to add a large wooden *foeder* (pronounced FOOD-er) for their brewing system and are still acquiring new barrels from whiskey, wine and tequila producers. As new batches are brewed in these barrels, they'll be set aside to be released to the public at a late date. They figure they'll reach a plateau when they reach one hundred barrels and then may look to increasing their brewing capacity up to a three-barrel or maybe larger system.

Right now, Sandhill beers are not available for consumption on premises, but you can come by on most weekends and pick up a growler or sixteen-

ounce cans of their beers to go. To expand their presence and availability to the market, the brothers also plan to open a taproom and nanobrewery in Mission, Kansas. These flagship beers will be available most weekends: **Chickadee** Berliner Weisse, **Wren** New England–style pale ale, **Junco** New England-style IPA, **Sparrow** dark mild and the **Barred Owl** Scottish Export. But they also have other styles and variants of their year-rounds available as well. Just check their website or Facebook page for the latest.

EASTERN KANSAS

WHERE JOHN BROWN GOT HIS START

BOILER ROOM BREWHAUS

Category: Nanobrewery
Address: 10 South National Avenue | Fort Scott, KS 66701
Phone: (620) 644-5032
Web: www.Boileroombrewhaus.com
Facebook: www.facebook.com/fortscottmicrobrew
Hours: Sunday, 2:00 p.m.–7:00 p.m.; Thursday–Friday,
4:00 p.m.–10:00 p.m.; Saturday, 2:00 p.m.–10:00 p.m.

"It wasn't always a lifelong dream to do this, but sometimes when destiny knocks on your door, you need to answer," said Bryan Ritter. He and his wife, Barbara, opened up the newest nanobrewery in the state in early 2018, joining Mo's Tavern in Beaver and Hank is Wiser in Cheney. It was launched in the basement boiler room of an old 1920s building in the historic downtown district of Fort Scott. The story goes that a few years before launching the Boiler Room Brewhaus, Scott and Barbara moved from the big city (Kansas City) and purchased a farm outside of Fort Scott, where they grow and sell all sorts of farm goods. But their main product, and the real purpose they moved here *Green Acres* style, was to have a virtual bee farm or, technically, a virtual bee apiary. The *virtual* part of this bee farm means they allow others to purchase bee hives. The Ritters build, populate

Boiler Room Brewhaus in Fort Scott. *Courtesy Boiler Room Brewhaus.*

with bees and take care of the hives and then harvest the honey for their customers from all over the country.

Both Ritters joined the Fort Scott tourism board with the notion to help promote theirs and other unique and interesting farms in the area. The board was constantly looking for ways to promote the downtown area and had "microbrewery or brewpub" on its list of businesses that might be beneficial to jump-start the area's growth. When the board found out Bryan was a homebrewer out at his farm, the members asked if he might try to open his own microbrewery downtown. He said he'd think it over. About the same time, he was asked the same question by a friend who ran a local winery. When the ad agency the Ritters used for the apiary offered to help them out with a logo and beer design work, it seemed like destiny was knocking, so the Ritters decided to make a go of it. With all of this support and encouragement, why not?

Along with the city and the winery friends, they found a good spot for the brewery under the old Western Casualty and Surety Co. insurance building. The boiler room offered a large open area, providing ample room to set up a small brewery and taproom. The formerly installed infrastructure was actually perfect for brewing beer, as it was already set up to handle large amounts of water and gas with good ventilation. The name was now unique and obvious.

The Boiler Room Brewhaus opened in January 2018. Bryan brewed up his best recipes for the opening and had everything ready. As the ribbon-cutting time approached, he stepped out to check on who might have shown up and was surprised to see a line of people down the sidewalk and around the corner waiting in the freezing weather. "We just skipped the ribbon-cutting and opened the doors. People were freezing," Bryan recalled. The Boiler Room Brewhaus had over seven hundred customers that weekend. All the beers he had brewed ahead were gone by Monday. To keep the grand opening weekend alive, he kept beer flowing with guest taps from a local distributor. After this opening weekend, he knew then the brewery was going to be a big hit in Fort Scott.

The original, and very popular, Boiler Room Brewhaus in Fort Scott. *Courtesy Boiler Room Brewhaus.*

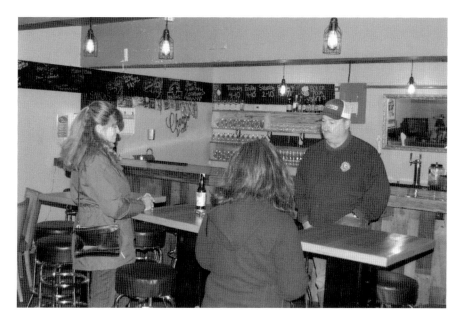

Brewer Bryan Ritter discusses both brewing and beekeeping with some customers at the original taproom and brewery at the Boiler Room Brewhaus in Fort Scott. *Bob Crutchfield.*

It's apparent from the opening day turnout that Fort Scott had pent-up demand for a good brewery. The town used to have three breweries before Kansas prohibition kicked in. In fact, just prior to prohibition in 1880, Fort Scott was one of the larger cities in the state. Being near the Missouri border and with its own army fort, it was briefly larger than Kansas City.[66] With the long drought finally over, it's almost like the city was saying, "What took you guys so long? We missed you!"

Trying to purchase ingredients for its fresh-brewed beers from the great state of Kansas, the Boiler Room Brewhaus uses hops grown locally from Kansas Hop Company in as many of the beer styles as possible. These are purchased in dry whole-leaf form and added to the latter stages of the brewing process such as the whirlpool or conditioning phases. Bryan laughed when he recalled driving back from Ottawa, Kansas, with a pickup truck full of the very aromatic hops leaves in back. Seeing a large amount of vacuum-sealed leafy material might be enough to raise suspicions. "All the way I was worried about being pulled over by some unknowing back-road sheriff who might confuse it with marijuana!"

The flagship beers you will find here are **Mother Clucker IPA**, **Hives Secret Hefeweizen** (which contains fresh honey from the bee farm), **Bah Bah Big Stout** (a sweet milk stout), **Miss Delaware** pale ale and **Farm Dog Pils** (pilsner).

Bryan currently brews on a one-barrel SABCO system, which keeps him very busy keeping up with demand. Think of this as a pilot system, as community demand continues to knock on his door for his craft beers. He and Barbara are already preparing to expand to a larger system and next-door restaurant space.

FINALLY, WHERE WOULD WE BE WITHOUT HOPS?

KANSAS HOP COMPANY

Ottawa, KS 66067
www.KansasHopCo.com
Phone: (785) 915-9771
Facebook: www.facebook.com/kansashopco

The economics of the craft beer boom in Kansas has led to opportunities for local farmers to supply the state's breweries with fresh ingredients such as malted barley and hops. One successful startup venture, Kansas Hop Company, has taken advantage of this new demand to begin cultivating farmland outside of Ottawa with some of the main hop varietals needed in brewing all craft beer. The demand for hops in recent years has surged with the increase in consumption of hoppy craft beers over traditional lagers and light beers. These hops are used to counter the sweetness of the malt and give the drinker a more balanced flavor and aroma. They also provide an antimicrobial property as well as giving the beer head retention and a variety of bitterness and aroma aspects.

Ryan Triggs, the entrepreneur behind this operation, got the idea after visiting a brewery in Kansas City back in 2015. The owners were growing hop plants up the side of the brewery, and it got him thinking about whether he

Many breweries in the state are supplied by their own local hop producer, Kansas Hop Company in Ottawa, Kansas. *Courtesy Kansas Hop Company.*

could convert some of his family's farmland near Ottawa into hops. The farm had been growing soybeans, corn and seed genetics but was looking for something else—maybe hops would be a good fit. Ryan started doing research on whether hops would even grow in this area or not. Hops are a daylight plant and need long summer days for vegetative growth and reproductive activity, and most of the world's hops are grown at higher latitudes with longer summer days than exist in Ottawa. For example, Yakima Valley, in Washington State, has an extra one and a half hours in the day than is experienced in northern Kansas. Maybe he would not get the full yield of the hops growers in Washington or Nebraska, but it was worth a try, Ryan figured.

He formed a joint venture with several others and prepped some land with nearly twenty-foot-tall trellis poles and hop starter plants in the spring of 2016. Of course, hops grow wild in nature, but these are typically not suitable for brewing and Kansas has no history of growing hops on a large scale, so he started doing trials to see which commercial strains might grow and produce the hop cones area brewers could use. Based on recommendations from nurseries that sold hop seedlings, he started with some of the workhorse hops. Those were the four Cs: Cascade, Chinook, Columbus and Centennial. He planted these plus a variety of others, including species such as Crystal, Comet, Neo-1, Amalia, Sorachia ace and Nugget. Some did well on the farm, others did not. For example, the Cascade, Chinook and Columbus all did quite well. However, the Centennial did not, and he had to rip out all of the plants after the initial growing season. "It just did not produce many hops and did not grow well overall," Ryan remarked.

The following year, he planted additional trellis poles and doubled the acreage, producing twice as many hops as his initial year. Using drip irrigation and treating the plants with the correct mix of needed fertilizer minerals, he was able to maximize his hop production, and for the first couple years, he recruited friends and family to harvest all of the hops by hand. It was a long process, taking almost three hundred man-hours (not including beer breaks).

Each year, the hop bines (often mistakenly called *vines*, but they are different in that they do not use tendrils or suckers to climb—they climb

solely using their shoot) are pruned back and regrow the next spring. Once they are long enough, the plant shoots are trained onto long coconut fiber strings to begin the summer-long trek to the top. In late summer or early fall, it's time to harvest. Each hop type is harvested at the same time based on when the cones are ready. Ryan sends his cone samples up to a lab in Omaha for testing, and once the lupulin glands, an oil-rich glad found at the base of the hop fold, have bulked up and are round, they are ready for harvest. There are hundreds of different compounds found in hops, but it's their essential oils that are sought after by brewers to provide the bittering agents and flavors all craft beer drinkers crave.[67]

Kansas Hop Company has been very successful since starting and is expanding its acreage to include additional hop plants and varieties. It now has a suitable commercial harvester, purchased from one of the leading hop harvester companies in Germany. These machines are capable of processing up to 150 plants an hour and significantly reduced the man-hours (and beer consumed by Ryan's buddies) needed to get the hops into the barn.

To process hops for sale, they are either quickly brought to the brewer as fresh "wet" hops or, more typically, air dried to a target dryness. These are pelletized and sealed for sale.

Kansas Hop Company has had great acceptance from the state's breweries. Its hops were initially used in seasonal beers by Free State and Wichita Brewing Company in a collaboration with Defiance Brewing Company. It has also been picked up as a supplier by Radius Brewing, Aero Plains, Blind Tiger, Limestone Brewing and many others in the state. There's a good chance that you have already had a seasonal beer with Kansas hops!

NOTES

Chapter 1

1. Brewers Association, "State Craft Beer Sales & Production Statistics, 2017," accessed May 15, 2017, www.brewersassociation.org/statistics/by-state.
2. New Albion Brewing, "Our Story: The Rise and Fall of New Albion Brewing Led the Way for the American Craft Beer Revolution," accessed May 15, 2017, http://newalbionbrewing.com/our-story.

Chapter 2

3. A.T. Andreas, *History of the State of Kansas: Containing a Full Account of Its Growth from an Uninhabited Territory to a Wealthy and Important State* (Chicago: A.T. Andreas, 1883), 419.
4. Jesse A. Hall and Leroy T. Hand, *History of Leavenworth County, Kansas* (N.p., Historical Publishing Co., 1921), 128.
5. Andreas, *History*, 435.

Chapter 3

6. *The Union Army, A History of Military Affairs in the Loyal States 1861–65: Records of the Regiments in the Union Army—Cyclopedia of Battles—Memoirs of*

Commanders and Soldiers, vol. 4 (Washington, D.C.: Federal Publishing Co., 1908), 190.

7. Thomas' Legion: The 69th North Carolina Regiment, "Kansas Civil War History," Accessed May 15, 2017, www.thomaslegion.net/americancivilwar/kansascivilwarhistory.html.

8. David A. Norris, "Forty-Rod, Blue Ruin & Oh Be Joyful: Civil War Alcohol Abuse," Warfare History, September 20, 2015, http://warfarehistorynetwork.com/daily/civil-war/forty-rrod-blue-ruin-oh-be-joyful-civil-war-alcohol-abuse.

9. Tom Acitelli, "The Civil War's Effects on American Beer," *All About Beer*, May 6, 2015, http://allaboutbeer.com/the-civil-war-effects-on-american-beer.

10. Kansas Memory, "Permits Issued from Colonel R.N. Hershfield, Oct 1864," http://www.kansasmemory.org/item/225947.

11. Gregg Smith, "Beer in the Civil War," Realbeer.com, accessed May 15, 2018, www.realbeer.com/library/authors/smith-g/civilwar.php.

12. United States Census Bureau, "Kansas—Number of Inhabitants," https://www2.census.gov/library/publications/decennial/1940/population-volume-1/33973538v1ch05.pdf.

13. Louis Reed, "Railroads in Kansas," Kansas Heritage, May 15, 2018, http://kansasheritage.org/research/rr/rrhistory.html.

Chapter 4

14. Jennie Chinn, *The Kansas Journey* (Layton, UT: Gibbs Smith, 2005), 133.

15. Norman E. Saul, *The Immigration of the Russian-Germans to Kansas* (N.p., Kansas Historical Society, 1974), 38–62.

16. Gary R. Entz, "Religion in Kansas," *Kansas History: A Journal of the Central Plains* 28 (Summer 2005): 131. www.kshs.org/publicat/history/2005summer_entz.pdf.

17. Smith, "Beer in the Civil War."

18. Old Breweries, "List of Kansas Breweries," accessed May 15, 2018, www.oldbreweries.com/breweries-by-state/kansas. New breweries were started during the 1870s in Atchison, Baxter Springs, Beloit, Cawker City, Chanute, Chetopa, Concordia, Ellinwood, Emporia, Eudora, Fort Scott, Hanover, Highland, Humboldt, Hutchinson, Independence, Iola, Junction City, Kansas City, Kinsley, Kirwin, Lawrence, Leavenworth,

Manhattan, Marysville, Ogden, Oswego, Paola, Salina, Seneca, Topeka, Waconda Springs, Wathena and finally Wichita.

19. Kansas Memory, "Bismarck Grove, Lawrence Kansas," www.kansasmemory.org/item/227516.

20. "Court Martial," *Wichita Weekly Beacon*, September 8, 1880, p. 3, col. 4.

Chapter 5

21. Albert J. Nock, "Prohibition in Kansas," *North American Review* 204, no. 729 (August 1916): 254–66.

22. Mugler v. Kansas, 123 U.S. 623 (1887) Argued April 11, 1887, decided December 5, 1887, https://supreme.justia.com/cases/federal/us/123/623.

23. Nock, Review, "Prohibition in Kansas."

Chapter 6

24. Diana Lambdin-Meyer, *Myths and Mysteries of Kansas: True Stories of the Unsolved and Unexplained* (Lanham, MD: Rowman & Littlefield, 2012), 116.

25. "Fined Carrie Nation," *Kansas City Gazette*, April 16, 1901, p. 1, col. 1.

26. "Served Her Right—Atchison Globe's Editor Thinks Carrie Nation a Disgrace to Womankind," *Fort Scott Daily Monitor*, April 18, 1901, p. 4.

27. "The Bone Dry Law Will Go into Effect Tonight," *Topeka Daily Capital*, February 23, 1917, p. 1, col. 2.

Chapter 7

28. Drinking Cup, "Speakeasies and Blind Pigs: The Influence of the Illicit Prohibition Bar," accessed May 15, 2018, www.drinkingcup.net/speakeasies-blind-pigs-influence-illicit-prohibition-bar.

Chapter 8

29. "Legal Liquor Makes Quiet Debut in State," *Hutchinson News*, March 9, 1949, p. 1.

30. Kansas Legislative Research Department, "Kansas Liquor Laws," February 24, 2003, http://cdm16884.contentdm.oclc.org/cdm/ref/collection/p16884coll8/id/300.
31. "Kansans with Vices to Be Hardest Hit with New Laws," *Salina Journal*, June 29, 1987, p. 1.
32. "Man Hopes to Brew Up Beer Approval," *Salina Journal*, January 3, 1987, p. 3.

Chapter 9

33. Brewers Association Great American Beer Festival Winners List [hereafter GABF Winners] September 29–October 1, 2005, www.greatamericanbeerfestival.com/wp-content/uploads/2017/05/gabf05_winners_1.pdf.
34. GABF Winners, September 24–26, 2009, www.greatamericanbeerfestival.com/wp-content/uploads/2017/05/gabf09_winners_1.pdf.
35. GABF Winners, September 16–18, 2010, www.greatamericanbeerfestival.com/wp-content/uploads/2017/05/gabf10_winners_1.pdf.
36. GABF Winners, October 11–13, 2012, www.greatamericanbeerfestival.com/wp-content/uploads/12_GABF_winners.pdf.
37. GABF Winners, October 10–13, 2013, www.greatamericanbeerfestival.com/wp-content/uploads/13_GABF_winners.pdf.
38. Andy Kryza, Matt Lynch and Lee Breslouer, "The Most Underrated Brewery in Every State," Thrillist, May 25, 2017, www.thrillist.com/drink/nation/craft-beer-the-most-underrated-brewery-in-every-state.
39. Andreas, *History*, 762.
40. Bill Murray, "If cold beer and pizza can't fix your problem, ask yourself if it's a problem that really needs to be fixed," Twitter, August 7, 2014, https://twitter.com/biiimurray/status/497463299588759553?lang=en.

Chapter 10

41. Revolvy, "Definition of Blind Tiger," accessed May 15, 2018, www.revolvy.com/main/index.php?s=Blind%20tiger&item_type=topic.
42. Blind Tiger Brewery and Restaurant, "Blind Tiger Brewery Awards," accessed May 15, 2018, www.blindtiger.com/blind-tiger-brewery-awards.
43. High Plains Brew Hoff, http://highplainsbrewhoff.com.

44. 23rd Street Brewery, "Our Beers," May 15, 2018, www.brew23.com/index.php/beers.

45. Melinda Crow, "Drink Up! The 50 Best Breweries in America," Yahoo Travel, December 2, 2015, www.yahoo.com/lifestyle/drink-up-the-50-best-breweries-1312062649417782.html.

46. United States Senate, "The Kansas-Nebraska Act," www.senate.gov/artandhistory/history/minute/Kansas_Nebraska_Act.htm.

47. David J. Wishart, "River Towns," Encyclopedia of the Great Plains, accessed May 15, 2018, http://plainshumanities.unl.edu/encyclopedia/doc/egp.ct.043.

48. Keith Stokes, "Fort Leavenworth," Kansas Travel, accessed May 15, 2018, www.kansastravel.org/fortleavenworth.htm.

49. Leavenworth County Historical Society, "John Grund & the Kansas Brewery," May 28, 2013, https://leavenworthhistory.wordpress.com/2013/05/28/john-grund-the-kansas-brewery; Hall and Hand, "History of Breweries in Leavenworth, Kansas," from *History of Leavenworth County*, http://history.rays-place.com/ks/lea-breweries.htm.

50. "John Grund & the Kansas Brewery."

51. "List of Kansas Breweries."

52. Kansas Memory, "Ezekiel Andrus and Mary Jane Wendall Colman," accessed May 15, 2018, www.kansasmemory.org/item/312876

53. North Topeka Arts District, "History of Noto," accessed May 15, 2018, www.notoshopping.com/about.

54. Victory Horticultural Library, "Kansas Seed Company," www.saveseeds.org/company_history/barteldes/kansas_seed.html.

Chapter 11

55. I.H.L. Ormrod, "Centenary Review: Modern Brewhouse Design and Its Impact on Wort Production," *Journal of the Institute of Brewing* 92 (March–April 1986): 131–36, https://onlinelibrary.wiley.com/doi/pdf/10.1002/j.2050-0416.1986.tb04386.x.

56. Land Institute, "Kernza Grain: Toward a Perennial Agriculture," accessed May 15, 2018, https://landinstitute.org/our-work/perennial-crops/kernza.

57. *Mugler*, 123 U.S. 623.

58. Mo's Tavern over in Beaver, Kansas, is classified as a "microbrewery."

Chapter 12

59. Kansas Historical Society, "El Dorado– Downtown Historic Survey," accessed May 15, 2018, www.kshs.org/resource/survey/eldoradosurveyreport06052012.pdf.
60. American Brewers Guild, "Craftbrewer's Apprenticeship," http://abgbrew.com/index.php/programs/cba#.WnDF4ExFyM9.
61. Wichita State University Libraries' Department of Special Collections, "Tihen Notes Subject Search, p. 1—Hockaday Paint," http://specialcollections.wichita.edu/collections/local_history/tihen/pdf/People&Places/hockaday_paint.pdf.
62. Oldtown Wichita, "History," accessed May 15, 2018, www.oldtownwichita.com/oldtown-history.
63. River City Brewing, "About Us," accessed May 15, 2018, http://rivercitybrewingco.com/about-us.
64. "Uncover Booze Cache of Olden Days Thursday," *Wichita Daily Eagle*, p. 5, col. 2, April 21, 1922.
65. Smallest homebrew club to win AHA Club of the Year, in 1997. www.homebrewersassociation.org/attachments/0001/1996/AHA_HomebrewClubWinner_2012.pdf

Chapter 13

66. U.S. Census, "Kansas 1940," accessed May 15, 2018, www2.census.gov/library/publications/decennial/1940/population-volume-1/33973538v1ch05.pdf.
67. Chris Pagnotta, "20 Things You Didn't Know about Hops," *Men's Journal*, September 9, 2014, http://www.mensjournal.com/food-drink/drinks/20-things-you-didnt-know-about-hops-20140909.

INDEX

ABOUT THE AUTHOR

Bob Crutchfield was raised in Coffeyville, Kansas, during the time when 3.2 beer, or cereal malt beverage, as it was officially known, was all you could get. Bob benefitted from the privilege of consuming this stuff before the drinking age was raised to twenty-one and consequently practiced his beer drinking at every opportunity through high school and eventually perfected it while attending Kansas State University during the early 1980s.

Bob earned a bachelor's degree in engineering from K-State and went on to earn his MBA while working most of his professional career at Motorola Semiconductor in Austin, Texas. He left the high-tech industry and started—and recently sold—his own company, which has given him more free time to enjoy beer. He is married to a wonderful wife and has two amazing children. If only he could get his wife and daughter to like beer, his life would be complete!

Bob discovered craft beers like many other people did over the past decade or so by climbing the proverbial beer ladder. After arriving in Texas and being out of the gravitational pull from Manhattan's Aggieville, he stepped up from the Coors Light rung for a Shiner, then climbed up to a pale ale; then there was the dark German beer phase, eventually ascending

to IPAs, where he is currently perched. With instruction from his Wichita brother, he and his son began homebrewing several years ago, learning from each batch. When his wife permits it, he's allowed to expand and upgrade his brewing setup. Bob is a solid member of the hop-head alliance of beer drinkers who will always check out the IPAs on the brewery boards. He's a member of the American Homebrewers Association and has the nickname "Sdmundis" on Untappd.

Visit us at
www.historypress.com
...